Play It Again, Sam

Play It Again, Sam: Repetition in the Arts

Samuel Jay Keyser

The MIT Press
Cambridge, Massachusetts
London, England

The MIT Press
Massachusetts Institute of Technology
77 Massachusetts Avenue, Cambridge, MA 02139
mitpress.mit.edu

The MIT Press would like to thank the anonymous peer reviewers who provided comments on drafts of this book. The generous work of academic experts is essential for establishing the authority and quality of our publications. We acknowledge with gratitude the contributions of these otherwise uncredited readers.

This book was set in ITC Stone Serif Std and ITC Stone Sans Std by New Best-set Typesetters Ltd. Printed and bound in the United States of America.

Library of Congress Cataloging-in-Publication Data

Names: Keyser, Samuel Jay, 1935- author.
Title: Play it again, Sam : repetition in the arts / Samuel Jay Keyser.
Description: Cambridge, Massachusetts : The MIT Press, [2025] | Includes
 bibliographical references and index.
Identifiers: LCCN 2024024727 (print) | LCCN 2024024728 (ebook) |
 ISBN 9780262552325 (paperback) | ISBN 9780262383110 (pdf) |
 ISBN 9780262383127 (epub)
Subjects: LCSH: Repetition (Aesthetics) | Arts—Psychological aspects.
Classification: LCC BH301.R46 K49 2025 (print) | LCC BH301.R46 (ebook) |
 DDC 700/.41—dc23/eng/20250103
LC record available at https://lccn.loc.gov/2024024727
LC ebook record available at https://lccn.loc.gov/2024024728

10 9 8 7 6 5 4 3 2 1

EU product safety and compliance information contact is: mitp-eu-gpsr@mit.edu

The craft of oral storytelling in the popular tradition is shaped by functional concerns; it omits pointless details and insists on repetition, as when, for example, a fable consists of obstacles that must be overcome. Part of a child's pleasure in listening to stories is in the anticipation of certain kinds of repetition: situations, expressions, stock phrases. Just as rhymes help mark the rhythm of poems and songs, events can rhyme in prose narratives.

—Italo Calvino, *Six Memos for the Next Millennium*

Contents

Introduction

In 2020 I published a book entitled *The Mental Life of Modernism: Why Poetry, Painting, and Music Changed at the Turn of the Twentieth Century*.[1] I wrote (p. 207n4):

> [R]epetition might play a role in music as a way of enhancing its grouping component. I suspect that something more profound is at work, something hardwired that makes repetition in music [melody], painting (fractals), and poetry (rhyme and meter) especially pleasurable.

This book sprang from that note. Inspired by an experiment by Elizabeth Margulis, to which I return shortly, I began to look at repetition in earnest. I found a vast literature on the subject. This presented a problem for me, coming as I have to this issue rather late in my scholarly life. The problem was compounded by my wanting to examine repetition in not one but three separate art forms. There was no way that I could see myself mastering that literature and still have the energy, to say nothing of the time, to write. I decided, as I suppose everyone must, to do the best I could.

But there was another reason why I encouraged myself perhaps foolishly to rush in. Most of the literature that I encountered did not make use of abstract representation in examining repetition. Linguistic theory has made extraordinary progress in shedding light on the abstract representations underlying the human ability to speak. Given that good example, it seemed worth trying to view repetition in terms of abstract representations that have been proposed for the sister arts.

In what follows, I have tried to relate abstract representations in art to various experimental studies meant to reveal some (relevant) aspect of brain function. For example, I discuss mimetic painting in relation to areas of the brain that respond when subjects are shown stimuli of one kind—say, a

face—but remain dormant when they are shown stimuli of another type—say, a car or an apple. The dedicated areas are faces (the fusiform face area), places (the parahippocampal place area), and bodies (the extrastriate body area) (see chapter 13). It is no accident that most mimetic painting from Giotto and Cimabue all the way through to Meissonnier and beyond is devoted to depictions of face, place, and body.

In a sense, then, the greatest strength of the book is also its greatest weakness. I have chosen the so-called sister arts of music, poetry, and painting because—thanks to the work of hosts of researchers—the abstract representations that appear to govern creation in these art forms have been lucidly described. In poetry, theories of rhyme and meter are well worked out. In music, the same is true thanks to seminal analyses like that of Lerdahl and Jackendoff (1983a,b). And I have already mentioned the hardwired connections between mimesis and dedicated areas of the brain. Other art forms have been studied in great depth—architecture, dance, theater, and narrative. But I am not aware of any accounts that match the specificity of abstract representation available for the sister arts. For readers invested in the former genres, I apologize. I simply do not know enough.

Indeed, while writing this book I have often asked myself whether narrative construction is a dedicated function of the brain like the fusiform face area. Are we hardwired to put disparate events together to tell a story? To use an example that I will return to in my discussion of Hebrew parallelism, consider these sentences:

(1) a. The car hit the wall.

 b. The headlights went out.

Now connect them with *and*, first (a) before (b), then (b) before (a):

(2) a. The car hit the wall and the headlights went out.

 b. The headlights went out and the car hit the wall.

Each one tells a different story, even though the elements are the same. Only the order is different. Apparently, we not only parse the sentence grammatically but also connect its conjuncts causally. But is that hardwired? Or is it a property of general intelligence, trying to make sense of the order? Indeed, it is virtually impossible to read those sentences as unconnected events, as compared, for example, with *My mother did the shopping and my father washed the car*. Either order tells the same story, that is, the null story. It is as

if the brain automatically looks for a story, and if there is one to be had, it will tell it to itself. But how it does this—or more specifically, how the ability to do this is represented mentally—is a mystery. Answers to questions of this sort may show themselves at some point in the future. But because so little is known now, I have not included narrative in this study.

I mentioned above that the impetus for this book was an experiment reported by Elizabeth Margulis. It is described in her book *On Repeat* (2013b). Margulis doctored compositions by Luciano Berio and Elliott Carter, acknowledged masters of atonal music. Specifically, using nothing but a computer's copy-and-paste functions and without any creative agenda, she introduced repetition into compositions where none existed. She played the original and doctored versions to unsophisticated and sophisticated audiences. She asked them which they preferred. The results were significantly in favor of the doctored versions. In other words, through the device of repetition she had enhanced the likability—that is, pleasurableness—of the original compositions, much the way a chef might improve a dish by adding just the right amount of salt.

Margulis (2013b, 16) concluded that

> [t]he simple introduction of repetition, independent of musical aims or principles, elevated people's enjoyment, interest, and judgments of artistry. This suggests that *repetition is a powerful and often underacknowledged aesthetic operative.* (Italics mine)

It seemed to me that Margulis's experiment successfully linked repetition and pleasure. I wanted to understand why that might be so. My curiosity led me to look carefully at how repetition is instantiated in poetry, painting, and music. In the course of that exploration, I came across three separate concepts that seemed promising. The first came from a survey article by Martin J. Pickering and Victor S. Ferreira entitled "Structural Priming: A Critical Review." The authors describe the phenomenon like this (2008, 427):

> In the past couple of decades, research in the language sciences has revealed a new and striking form of repetition that we here call structural priming. When people talk or write, they tend to repeat the underlying basic structures that they recently produced or experienced others produce.

The experimenter asks someone a question—say, about the time of day—using different constructions with different subjects, as in this study described by Pickering and Ferreira (2008, 429):

Experimental work on structural repetition began with Levelt and Kelter (1982), who in one experiment asked Dutch shopkeepers *Om hoe laat gaat uw winkel dicht?* ("At what time does your shop close?") or *Hoe laat gaat uw winkel dicht?* ("What time does your shop close?"). In the former case, replies tended to include the preposition, for example *Om vijf uur* ("At five o'clock"); in the latter, replies tended to exclude the preposition, for example *Vijf uur* ("Five o'clock").

The assumption is that the syntactic structure of the question remains in the mind of the listener long enough to be used in the construction of an answer. It is an exercise in efficiency. Priming is a labor-saving mechanism, at least with respect to speech production. In his book *The Sense of Style* (2014), Steven Pinker offers another use for it:

> *Structural parallelism.* A bare syntactic tree, minus the words at the tips of its branches, lingers in memory for a few seconds after the words are gone, and during that time it is available as a template for the reader to use in parsing the next phrase. If the new phrase has the same structure as the preceding one, its words can be slotted into the waiting tree, and the reader will absorb it effortlessly. The pattern is called structural parallelism, and it is one of the oldest tricks in the book for elegant (and often stirring) prose.

Pinker is commenting specifically on rhetorical flourishes of the following sort from Prime Minister Winston Churchill's speech to the British House of Commons on June 4, 1940:

> We shall fight on the beaches, we shall fight on the landing grounds, we shall fight in the fields and in the streets, we shall fight in the hills; we shall never surrender.

It was the repetition of phrases like *We shall fight on the beaches* that priming was meant to foster.

The second idea that seemed promising to me was from Roman Jakobson, himself commenting on a remark by the striking nineteenth-century English poet Gerard Manley Hopkins. Here I quote a passage from Jakobson's *Language in Literature* (1987, 82) that I return to later:

> Rhyme is only a particular, condensed case of a much more general, we may even say the fundamental, problem of poetry, namely *parallelism*. [He goes on to quote approvingly from Gerard Manley Hopkins who,] in his student papers of 1865, displayed a prodigious insight into the structure of poetry:
>
> > The artificial part of poetry, perhaps we shall be right to say all artifice, reduces itself to the principle of parallelism. The structure of poetry is that of continuous parallelism, ranging from the technical so-called Parallelisms of Hebrew

poetry and the antiphons of Church music up to the intricacy of Greek or Italian or English verse.

The insight here is that parallelism is at work not only at the sentential level as in Hebrew poetry, but also at other levels like end rhyme in English verse and even in music. We will see that this insight is borne out.

I am indebted to several scholars for the third idea, one that opens the door to a relationship between problem solving and pleasure. Thomas Bever (1986, 325) writes:

> The emotional force of problem solving is interesting in its own right. This discussion so far has presupposed that it is a basic property of human cognition to get a thrill from solving a problem. . . . [W]hat is important is that the first intuition that a problem is solved evokes a burst of pleasurable energy. Whatever its source, we know this to be true.

Anjan Chatterjee (2014, 106) writes in the same vein:

> We experience pleasure when we figure things out, an effect that the developmental psychologist Alison Gopnik fancifully called "explanation as orgasm" [Gopnik 1998]. Babies purse their lips and wrinkle their brows when presented with problems that are confusing. When they figure out the answer, they smile and look radiant. . . . So we have this reverberating cycle of pleasure helping us learn and what we have learned giving us pleasure. These cognitive pleasures may be the reason we experience pleasure with some conceptual art. Figuring out what they mean tickles our reward systems.

Given Margulis's experiment, supplemented by the notions of (1) priming, (2) parallelism applying at all levels of artistic artifice, and (3) the possibility that discerning repetition in a work of art is a form of problem solving, I came up with what I call the P^4 Conjecture: *Parallelism, Priming, Prediction, and Pleasure.* It is based on the idea that the link between repetition (i.e., parallelism) and pleasure proposed by Margulis is mediated by priming working not as a means of processing efficiency but as a form of prediction that, if fulfilled, gives rise to the pleasure that Margulis talks about.[2] In chapter 14 I describe this process in detail, spelling out as best I can how I think it works. But as a foretaste here so that you will have a sense of where I am headed, let me offer a first pass.

Priming supposes that you begin by generating a structure—say, a syntactic tree culminating in the terminal string *we shall fight on the beaches*, as in (3):

(3)

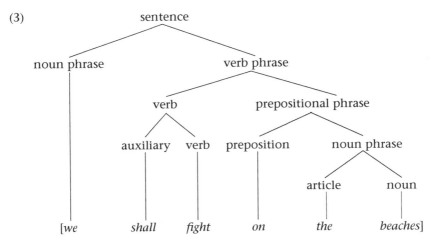

Once you have internalized it, the terminal string (the one between brackets at the bottom of the tree in (3)) disappears but, like the smile on the Cheshire cat, the tree itself lingers. You begin to read the next string of words, namely, *We shall fight on the landing grounds*. However, instead of constructing a new tree for those words, you see whether a perfect fit might be provided by the lingering tree.

Suppose that when we are in an "artistic frame of mind," we view that matching task as a "problem" to be solved. Can the word string *We shall fight on the landing grounds* be made to match the constituent structure of the lingering tree? If the answer is yes, then solving that problem brings the pleasure that Bever and Chatterjee speak of. Processing the ubiquitous repetitions that one finds in the sister arts, then, can be seen as a multitude of problems set by artists knowing that their solutions will bring the problem solvers pleasure. That, in a nutshell, is the story of this volume.

At this point it seems worth stopping for a moment to consider two notions that are central to the discussion thus far, repetition and pleasure.

Let's start with repetition. To begin with, *repetition* is the name of a relationship between two objects whereby the second one is judged to be a reoccurrence of the first. Repetitive items can be very long, for example, [*aaaaaaaa* . . .]. To simplify things, let's take the items—call them A and B—pairwise. How do we determine that B is a repetition of A?

As we will see in chapter 1, *Homo sapiens* comes hardwired to make these kinds of judgments. That is why it is incredibly easy to do. Consider these two figures:

(4) a. b.

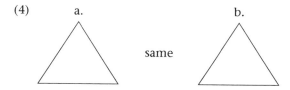

same

We have no doubt that (4b) is a repetition of (4a), even though intellectually we are aware that at some level they must be different.[3] I made them by using Margulis's copy-and-paste method. After I constructed (4a), I copied and pasted it into the text as (4b). I am willing to bet the price of this book that if you look closely enough, you will find minute differences between the two images, especially at the microscopic level—in the thickness of the ink brought about by tiny changes in the rate of ink flow onto the page, in distortions of the line brought about by tiny differences in the thickness of the paper under each image, and so on. None of that matters because we aren't wired to perceive at the microscopic level. Our judgment of repetition depends on what we can readily perceive visually or aurally (or in all the five senses, for that matter). In (4) there is a clear and distinct pattern: (4b) repeats (4a). Why? Because our brain tells us that, just as surely as it tells us the world is three-dimensional.

A judgment like the one in (4) is what participants were making in Margulis's experiment. She did to segments of music what I did with (4a) and (4b), namely, copy and paste. In poetry, specifically end rhyme, the counterpart of Margulis's aural examples and my visual example in (4) would be determining if *ham* 'overacting actor' and *ham* 'a kind of meat' were identical as in, for example, a couplet like this:

(5) Monty Woolley was such a ham

 That all he ever ate was ham.

There is a lot packed into this simple example. For instance, why am I talking about the words that end the couplet and not, say, those that begin it: *Monty* and *That*? After all, there are poems that attend to the first word. Alfred de Musset (French poet, playwright, and novelist, 1810–1857) wrote this alexandrine poem of praise to George Sand (French novelist, 1804–1876). If you read the first word of each line, you will see that they form the sentence *Quand voulez vous que je couche avec vous?* 'When do you want me to sleep with you?'

(6) Quand je mets à vos pieds un éternel hommage
 Voulez vous qu'un instant je change de visage?
 Vous avez capturé les sentiments d'un cœur
 Que pour vous adorer forma le Créateur.
 Je vous chéris, amour, et ma plume en délire
 Couche sur le papier ce que je n'ose dire.
 Avec soin, de mes vers lisez les premiers mots
 Vous saurez quel remède apporter à mes maux.

Sand replied in kind:

(7) Cette insigne faveur que votre cœur réclame
 Nuit à ma renommée et répugne à mon âme.

The two words starting the lines of her response are *Cette nuit* 'Tonight'.[4]

This kind of pattern, a so-called acrostic poem, is a far cry from repetition. It is much more like a crossword puzzle. It demonstrates that repetition is not the only kind of pattern one finds in poetry. Indeed, in chapter 12 we will look at a poem based on gematria, the practice of assigning numbers to letters, among other things, and building a secret message into the work, in this case, Psalm 23. There are other kinds of poetic devices, for example, shape poems or "calligrams" (from the term *calligramme* coined by Guillaume Apollinaire). Here is an example from George Herbert (1593–1633) called "The Altar." Its shape resembles its title.

(8) A broken ALTAR, Lord, thy servant rears,
 Made of a heart and cemented with tears:
 Whose parts are as thy hand did frame;
 No workman's tool hath touch'd the same.
 A HEART alone
 Is such a stone,
 As nothing but
 Thy pow'r doth cut.
 Wherefore each part
 Of my hard heart
 Meets in this frame,
 To praise thy name:
 That if I chance to hold my peace,
 These stones to praise thee may not cease.
 Oh, let thy blessed SACRIFICE be mine,
 And sanctify this ALTAR to be thine.

A similar picture poem is discussed by Nigel Fabb and Morris Halle (2008, 179–183), who show that the varying line lengths of Psalm 137 make a design such that, turned on its side, the psalm reveals the outline of the second temple in Jerusalem, which was destroyed by the Romans in 70 CE.

That said, far and away the dominant mode of poetic form, certainly in premodernist English and very likely universally, involves repetition, and this is why I am talking about the ends of lines rather than the beginnings. Consider the artifice known as end rhyme. It is a convention, like the height of women's skirts from year to fashion year or the width of men's jacket lapels. There is no reason why lines of a poem must end in rhyme other than its acceptance as a convention by poets. Indeed, John Milton eschewed rhyme when he wrote *Paradise Lost* but, because the end rhyme convention was so heavily entrenched in English poetry, he felt he had to defend his decision in a preface (see Keyser 2020, 56ff. for discussion). But within that convention, the hardwired ability of human beings to identify repetition kicks in. So, let's take a quick look at typical end rhyme.[5]

The kind of end rhyme that (5) exhibits is called "identical rhyme." It is rare in English poetry. Rather, the typical end rhyme is of this variety:

(9) Monty Woolley was such a ham

 That all he ever ate was Spam.

It can be represented in this fashion:

(10) a. b.

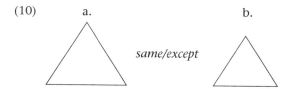

The triangles are the same except that (10b) is smaller than (10a). This is another kind of repetition. It says that we can tell whether two objects are the same except for a small difference. The rhyme in (9) is the aural counterpart of what we might call the visual rhyme in (10). The two words are said to rhyme because some parts are the same and some parts must be different. And we can perceive that relationship as quickly as it takes to read the words.

This is an important point. Telling whether two words rhyme is instantaneous. Telling whether a poem is an acrostic takes work. Indeed, many

readers might miss the point altogether. Here is a poem by Edgar Allan Poe called "A Valentine":

(11) For her this rhyme is penned, whose luminous eyes,
 Brightly expressive as the twins of Leda,
 Shall find her own sweet name, that, nestling lies
 Upon the page, enwrapped from every reader.
 Search narrowly the lines!—they hold a treasure
 Divine—a talisman—an amulet
 That must be worn at heart. Search well the measure—
 The words—the syllables! Do not forget
 The trivialest point, or you may lose your labor!
 And yet there is in this no Gordian knot

 Which one might not undo without a sabre,
 If one could merely comprehend the plot.
 Enwritten upon the leaf where now are peering
 Eyes scintillating soul, there lie perdus
 Three eloquent words oft uttered in the hearing
 Of poets, by poets—as the name is a poet's, too.
 Its letters, although naturally lying
 Like the knight Pinto—Mendez Ferdinando—
 Still form a synonym for Truth—Cease trying!
 You will not read the riddle, though you do the best you can do.

The stanza tells us that the name of the woman for whom the poem is written is hidden in the lines. But if you are like me, you will need someone to tell you where. You can take a stab at it if you like. I'll put the key in this note.[6] My point is that this aspect of the poem poses a cryptographic problem that you have to work at to solve. On the other hand, determining that the poem uses end rhyme is a no-brainer: *eyes:lies, treasure:measure,* and so on. And this explains why end-rhyming poems are so much more popular than acrostic poems. The brain lends an unconscious helping hand in determining if two words rhyme. It is no help at all in finding the key to encoded names. And while deciphering the acrostic and finding the rhyming words are both problem solving of a sort that carries with it a sense of

pleasure, the critical difference is that while the former is not part of a pattern, the latter is.

Notice that unlike acrostic poems, calligrams employ a technique that is also hardwired in the brain, namely, the ability to discern the identity of objects from their silhouettes. Authors often aid the identification with the name of the poem, as Herbert did in calling his poem in the shape of an altar "The Altar." The French poet Charles-François Panard (1689–1765) wrote a bottle-shaped poem called "La Bouteille," and the American poet John Hollander (1929–2013) wrote a poem called "Swan and Shadow." But even though calligrams cater to something the brain is hardwired to help with, they, like acrostics, are nowhere near as ubiquitous in the literary canon. I think there are two reasons for this. The first is that such devices don't add that much. At best it is a novelty, at worst a gimmick. In the end what counts in a poem is how it says what it says, not what the outline of the lines resembles. The second is that, unlike what we find with end rhymes, there is nothing repetitive about the outline. As I have already said and will try to explicate in what follows, there is something special about repetition—namely, its inextricable connection with pleasure—that makes it an ideal device in a work of art.

From the perspective of processing effort, the rhyme in (5), *ham:ham*, is easier than the *ham:Spam* rhyme in (9) because the sounds of the words are identical. On the other hand, in deciding if *ham:Spam* rhyme as in (9), the reader must determine not only how the sounds of the words are the same, but also how they are different. So there are two kinds of repetition that play an important role in the arts: identical repetition and *same/except* repetition. As we will see, identical repetition abounds in Homeric epic poetry and in the alliterating verse of the *Beowulf* poet. In poetic rhyme in the English premodern metrical tradition, *same/except* repetition dominates. Both kinds are operative in music, as well as in painting and photography where image symmetry is very common. While identical rhyme is rare in metrical poetry, it is quite common in music and painting. If I had to speculate why, I would guess that the rarity of identical end rhyme is due to its processing efficiency. It is too easy.

The relationship between *same* and *different* goes as far back as Plato's *Phaedo* and is explored by William James in his *Principles of Psychology* (see quotations from James 1890 and Gombrich 1979 in chapter 1). And indeed, there is a significant literature (see quotations from Margulis 2013b and

Endress, Nespor, and Mehler 2009 in chapter 1) establishing that *Homo sapiens*, along with other creatures, comes equipped to detect not only things that are identical (e.g., Margulis's segments) but also things that are nearly identical (rhymes in English poetry). Peter Culicover and Ray Jackendoff (2012) call attention to a distinction in the English language that they label *same/except*. It shows up in expressions like these:

(12) a. This vase is the same as that one except it is red.

 b. This song is identical to that one only it is in the key of G.

 c. My salad is just like yours except that it has walnuts instead of almonds.[7]

They note that this *same/except* relationship applies in other modalities as well (aural and visual) and suggest that it was coopted by the language faculty. I make considerable use of this relationship in what follows.

An important claim in this book is that discerning repetitions like those in (4) and (10) carries with it a component of pleasure. So we need to pay a bit of attention to what we mean by pleasure. The *Oxford English Dictionary* defines *pleasure* this way:

> The condition or sensation induced by the experience or anticipation of what is felt to be good or desirable; a feeling of happy satisfaction or enjoyment; delight, gratification. Opposed to **pain**.

And if you look up *delight*, for example, you are taken right back to *pleasure* in the circular dance so common to dictionaries.[8]

So, what is one to say? One might resort to something "scientific" like reference to dopamine and serotonin, neurotransmitters that make up our so-called reward system. According to contemporary neurologists, reward system drug release creates a feeling of pleasure when we do the things necessary to keep ourselves alive so that we can contribute to the gene pool. We keep on doing those things to reexperience that pleasure. But do reward system drugs have anything to do with what one experiences when listening to a lovely piece of music, reading a moving poem, or looking at a painting by Jackson Pollock? There is indeed some evidence suggesting that if the brain's reward system initially evolved for survival, it has been coopted by the arts (see Aviv 2014, Kaimal et al. 2017).[9] These studies suggest that it is not implausible to think of viewing at least visual art as stimulating reward pathways in the brain.

Marcus (2008, 13–14) argues that many of our cognitive functions—for example, memory—are the result of a kind of haphazard evolutionary remodeling of the kind just alluded to. He puts it this way:

> Over the course of evolution our brain has become a bit like a palimpsest, an ancient manuscript with layers of text written over it many times, old bits still hiding behind new. Allman [1999] referred to this awkward process, by which new systems are built on top of old ones rather than begun from scratch, as the "progressive overlay of technologies." The end product tends to be a kluge.[10]

Perhaps the pleasure associated with art is a kluge resulting from repurposing for artistic ends the output of a pleasure center built on top of an evolutionary mechanism (or mechanisms) originally meant to guide an organism along a path called survival. Artistic pleasure would then mostly likely be the result of reflective reasoning (a latecomer) in cahoots with reflexive systems (earliest additions) siphoning off reflexive engendered pleasure into the realm of artistic form by means of a kluge labeled "aesthetic operative" à la Margulis (see the quotation at the start of this introduction). Marcus sums up this kind of functional reciprocity in this way (2008, 142):

> In biological terms, the neurotransmitters that underlie emotion, such as dopamine and serotonin, are ancient, tracing their history at least to the first vertebrates and playing a pivotal role in the reflexive systems of animals including fish, birds, and even mammals. Humans, with our massive prefrontal cortex, add substantial reflective reasoning on top, and thus we find ourselves with an instrument-fooling kluge.

But even this interesting and provocative suggestion doesn't get us very far in helping to describe just what it feels like when the brain experiences aesthetic pleasure. Imagine trying to describe how you feel when you experience something that gives you pleasure. John Keats took a famous (and lovely) stab at it in his sonnet "On First Looking into Chapman's Homer":

(13) Much have I travell'd in the realms of gold,

 And many goodly states and kingdoms seen;

 Round many western islands have I been

 Which bards in fealty to Apollo hold.

 Oft of one wide expanse had I been told

 That deep-brow'd Homer ruled as his demesne;

 Yet did I never breathe its pure serene

Till I heard Chapman speak out loud and bold:

Then felt I like some watcher of the skies

When a new planet swims into his ken;

Or like stout Cortez when with eagle eyes

He star'd at the Pacific—and all his men

Look'd at each other with a wild surmise—

Silent, upon a peak in Darien.

Great analogies only go so far. Keats very likely had William Herschel in mind when he wrote this sonnet. Herschel discovered Uranus in 1791. Keats wrote the sonnet twenty-five years later, but I have no idea how Herschel felt or Keats after him.

This, I think, is indicative of a deeper problem. In *The Mental Life of Modernism* (2020, 177) I wrote about cognitive limits:

> The idea of cognitive limits is not a new one. Colin McGinn (1993) discusses it in connection with long-standing philosophical problems of consciousness, the self, meaning, free will, knowledge, reason, truth, and philosophy itself. He considers the possibility that, unlike most scientific problems, these "philosophical" conundrums have been intractable for so long because we simply don't have the mental equipment to deal with them.

McGinn quotes from John Tyndall, a 19th-century scientist, and then comments (1993, 36–37):

> "The passage from the physics of the brain to the corresponding facts of consciousness is unthinkable. Granted that a definite thought and a definite molecular action in the brain occur simultaneously, we do not possess the intellectual organ, nor apparently any movement of the organ, which would enable us to pass, by a process of reasoning, from one to the other." . . . My general thesis, in these terms, is that philosophical bafflement results from the lack of an "intellectual organ" suitable to the subject.

Perhaps the reason why it is so hard to put one's finger on precisely what one feels when one feels pleasure is the reason why the word *pleasure* is, strikingly, absent from so many discussions of the importance of repetition in music, in poetry, and, as we will see, in painting. Even Leonard Bernstein, a repetition booster of the first water, talks only of repetition as a way of providing poetry with its musical qualities (see below). Pleasure is not in the picture, at least not overtly. Nonetheless, it is the elephant in the room. We do so many things because we like them, and we like them because they

release a shower of neurotransmitters of a certain sort into our brains. But that doesn't help shed light on explaining what we feel when we are taking that shower.

In other words, I think there is a very real possibility that we don't have the cognitive wherewithal to study ourselves to the extent that we can pass from a "molecular action in the brain" after listening to Mozart's "Bird-Catcher Song" in *The Magic Flute* to being able to express what it feels like when we take pleasure in a melody or what Keats says he felt like when he first looked into Chapman's Homer.[11]

Throughout this book I use the word *pleasure* to refer to something that we feel when we like something even though I can't exactly say what it feels like and even though liking, say, a painting may produce quite a different feeling in me than liking a poem or a symphony and even though my liking a painting may not—in fact probably does not—feel the way your liking the same painting does. Perhaps the best I can do is to paraphrase Supreme Court Justice Stewart Potter's comment about pornography. "I know it when I feel it."[12] In the case of pleasure it is what makes me choose almond mocha over vanilla, Mozart over Salieri, the first version of *The Invasion of the Body Snatchers* over its three remakes. Whatever it is, I assume that we share it even though I can't define it. And it is that shared feeling that I have in mind when I write about pleasure.

Armed with these takes on repetition and pleasure, let us look at the battle plan for the book.

Summary of Chapters 1–14

Chapter 1 argues that Margulis's experiment strongly suggests that the process of determining whether two events are related by virtue of one being a repetition of the other is something the brain finds pleasurable. I call attention to a specific kind of repetition where two events are the same except for a small difference, what Culicover and Jackendoff (2012) call *contrast* (see chapter 1, (3) and figure 1.3). This specific form of repetition is extremely important in the arts to be investigated. I give it the name *same/except*.

Chapter 2 demonstrates that the *same/except* relationship is precisely what characterizes end rhyme in traditional English poetry as well as alliteration in Anglo-Saxon poetry.

Chapter 3 shows how *same/except* can be extended to music and that tunes like "Satin Doll" are musical rhymes tout court.

Chapter 4 looks at the Rule of Three as it occurs in idioms, jokes, cartoons, and fairy tales. The ubiquity of this form of repetition is notable because it is pleasurable.

Chapter 5 introduces Music's Rule of Three and a constraint imposed on repetition for the sake of pleasure that doesn't apply to the Rule of Three explored in chapter 4.

Chapter 6 examines the tension that arises when one wants to treat music as having semantic content as language does. The evident lack of semantic content led Kant to describe music as wallpaper. Peter Kivy (1993) explores the conflict engendered by Kant's aesthetic judgment, ultimately agreeing with Kant yet taking refuge in thinking, "But what divine wallpaper it is." I conclude that what Kant took as music's greatest weakness, its lack of meaning, is in fact its greatest strength. It is the natural art form in which to express repetition for pleasure's sake without interference from meaning.

Chapter 7 is devoted to poetic meter. It attempts to show what it is about sophisticated metrical poetry such as Shakespeare's sonnets that is being repeated. It is clearly not the patterns made by the stressed syllables themselves; rather, it is something more abstract, a correspondence between the physical properties of the line and the abstract representation of the metrical pattern.

Chapter 8 is an excursus that addresses the question, Why is there meter in the first place? I advance the view that meter defines the metrical line. It is the line that is being repeated. Meter shows how two lines, vastly different in stressed-syllable distribution, are in fact exact repetitions of one another. That is the source of metrical pleasure.

Chapter 9 discusses Milman Parry's (1930, 1932) revolutionary view that the Homeric epics are oral poetry made up of small fragments that he labels *formulas*, independent bits of Homeric hexameter used by the oral poet to improvise a tale. Francis Magoun (1953) adopted Parry's hypothesis for Anglo-Saxon poetry and concluded that the entire Anglo-Saxon poetic corpus is formulaic. Parry and his student, Albert Lord, showed that it lives today in the oral practice of Macedonian guslars. The use of formulas as a mnemonic device was thus established. My contribution is that this usage has a salutary and unexpected side effect. It brought with it the pleasure that accompanies the recognition of repetition.

Chapter 10 is devoted to the work of Robert Gjerdingen (2007), who demonstrates that the galant style of music consisted essentially of stringing together separate and distinct musical figures with names like Romanesca, Prinner, Fonte. This illuminates a fundamental process in the making of art: namely, smaller structures combine to create larger ones. It is also a form of repetition that induces pleasure. And it is a description of how the Homeric epics were constructed.

Chapter 11 points out that Gjerdingen and others have long seen a parallel between galant composition and jazz improvisation. It suggests that one should also include oral poetry, such as the Homeric epics and Anglo-Saxon poetry, in this list of parallels. Each of these genres produces works of art by taking specific formulas and linking them together into more complex structures. Two things are going on. Small chunks are being combined to make larger ones. These necessarily involve repetition, which, by its nature, is pleasurable.

Chapter 12 is devoted to an explication of biblical parallelism, the art form par excellence in discussions of repetition. Here I draw attention to James Kugel's (1981) argument that in biblical parallelism the basic structure is the half-line, as in *Beowulf.* The two half lines have a narrative relationship, what Kugel calls *seconding,* but that is not what is essential. The half line is what is essential. Repetition through seconding links the two half lines in biblical passages just as alliteration does in Anglo-Saxon poetry.

Chapter 13 is devoted to repetition in the visual arts: two paintings, Andy Warhol's *Campbell's Soup Cans* and Gustave Caillebotte's *Paris Street; Rainy Day,* and several photographs, including Lee Friedlander's *Albuquerque, New Mexico,* two from Roni Horn's *Becoming a Landscape,* a Calvin Klein ad, a photograph from a friend, and the world's highest-grossing photograph, Ormond Gigli's *Girls in the Windows.* All are instantiations of the *same/except* relationship. The chapter also explores the relevance of parerga to Caillebotte's *Paris Street; Rainy Day.*

Chapter 14 returns to the discussion in chapter 1, presenting a formally specific rendition of the material in this introduction in terms of what I call the P^4 *Conjecture: Parallelism, Priming, Prediction, and Pleasure.* I suggest that repetition in the sister arts of the kind discussed in this book is in fact based on priming and the consequences thereof. The chapter recalls the position in *The Mental Life of Modernism* that in premodernist eras art consisted in

large part of a sharing of rules between the artist and the artist's audience. It views the abandonment of this sharing as having an unexpected side effect, the abandonment of repetition as a form of artistic pleasure. It observes that painting seems to have held its place in the minds of its audience while atonal music and poetry lost ground. It suggests that this is because, although all three art forms changed radically, only painting retained repetition as part of its technical arsenal—witness Picasso and the cubists, Pollock, and Warhol. As different as they all are, they share repetition in their creations. Finally, the chapter gives the last word to the same person who began this book, a critic of incredible sensitivity, insight, and imagination, Italo Calvino.

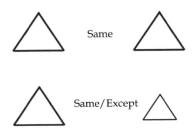

1 Same/Except

In this book I will try to explain how the linkage between repetition and pleasure works.[1] A major assumption I make is that the mental act of identifying something as a repetition necessarily entails a component of pleasure. To understand the arguments that follow, you must grant that, when the brain is in its art appreciation state, it is looking for repetition and hence for pleasure. The reason for the qualification *when the brain is in its art appreciation state* is this. Imagine speaking to someone in a normal conversation and they repeat every sentence:

(1) I saw Gloria today.

 I saw Gloria today.

 She looks as young as ever.

 She looks as young as ever.

 She said to give you her best.

 She said to give you her best.

You would certainly find that annoying. The function of a conversation is to exchange information. Under ordinary circumstances, once is enough. Not so if you are listening, for example, to Robert Johnson singing "They're Red Hot" (1936):

(2) Hot tamales and they red hot,

 Yes, she got 'em for sale.

 Hot tamales and they red hot,

 Yes, she got 'em for sale.

 I got a girl, said she long and tall.

 She sleeps in the kitchen with her feets in the hall.

Hot tamales and they red hot,

Yes, she got 'em for sale.

Yes, she got 'em for sale.

What's the difference? In a normal conversation, the expectation is the efficient exchange of information. Repetition gets in the way. In listening to music, the expectation is that we will encounter repetition and that it will be a source of pleasure. We might make that even stronger and say that when experiencing music, metrical poetry, and visual art, we are looking for repetition. I will try to unpack the various kinds of repetition one encounters in the sister arts and analyze them. In many cases the audience may not even be aware of the mechanisms at work, any more than a speaker is aware of the rules of grammar guiding utterances in a conversation.

That said, I don't want to imply that the goal of art is solely to elicit pleasure. After all, an artist might want to protest as in Picasso's antiwar masterpiece *Guernica*, or mystify as in Duchamps's *La mariée mise à nu par ses célibataires, même* (*The Bride Stripped Bare by Her Bachelors, Even*), or instruct as in Milton's *Paradise Lost*, or amuse as in Lewis Carroll's "Jabberwocky," or tell stories as in Chaucer's *Canterbury Tales*. But whatever the goal, if repetition is part of the process of artistic creation, pleasure will be a component of the result mixed in with whatever fear, awe, amusement, or befuddlement is part of the artist's agenda.

One reason why we look for repetition is that we are good at it. It appears to be a cognitive function developed for one purpose and coopted into the arts for another. What does it do for us? In the second preface of his book *The Sense of Order: A Study in the Psychology of Decorative Art* (1979, xii), E. H. Gombrich offers a possible explanation for the origin of repetition as a basic cognitive function:

> I believe that in the struggle for existence organisms developed a sense of order not because their environment was generally orderly but rather because perception requires a framework against which to plot deviations from regularity. To anticipate the simplest example of this relationship, it is the break in the order which arouses attention and results in the elementary visual or auditory accents which often account for the interest of decorative and musical forms.[2]

Here the idea is that some activity—to take Gombrich's example, walking down a flight of stairs—is experienced as an orderly process, a repetition of events. It is a "framework against which to plot deviations from

regularity." The deviation of a step down that is deeper than the others provides a break in the order that consequently "arouses attention." It is the "except" in a series of samenesses. It can act as an attention getter, telling stair descenders to pay attention lest they fall. Such deviation is also, as Gombrich implies, the source of pleasure in decorative or musical forms of art.

Whatever its origin, I want to explore with you how repetition has been conscripted into the service of art. I start with music because that is where Elizabeth Margulis's all-important experiment takes place.

Leonard Bernstein (1976, 147, 149) makes the following plea for the importance of repetition in music:

> I cannot stress this point strongly enough. In fact, it has been authoritatively suggested that the main reason a serious theory of musical syntax has been so slow to develop is the refusal of musical theorists to recognize repetition as the key factor. . . . The point must be clear by now: that it is repetition, modified in one way or another, that gives poetry its musical qualities, because repetition is so essential to music itself.

That is what Elizabeth Margulis did in the experiment she describes in *On Repeat* (2013b, 15):

> I asked participants without special musical training—everyday music listeners—to listen to excerpts from challenging contemporary art music (atonal pieces by Luciano Berio and Elliott Carter . . .). Unbeknownst to the participants, mixed in with the original excerpts were adaptations of them. In these adaptations, segments of music had been extracted and reinserted to add repetitions of some material; repetitions that could occur immediately or after some other music had intervened.

Figure 1.1 indicates where Margulis placed the repeated material. She goes on to say (2013b, 15):

> Listeners rated the immediate and delayed repetition versions as reliably more enjoyable, more interesting, and more likely to have been composed by a human artist rather than generated randomly by a computer. Even roomfuls of PhD-holding music theorists, when presented these examples at a meeting of the Society for Music Theory (Minneapolis, 2011)—an audience sympathetic to Berio and Carter if ever there were one—confessed to finding the repetitive versions more likable on first pass. This is a stunning finding, particularly as the original versions were crafted by internationally renowned composers and the (preferred) repeated versions were created by brute stimulus manipulation without regard to artistic quality.

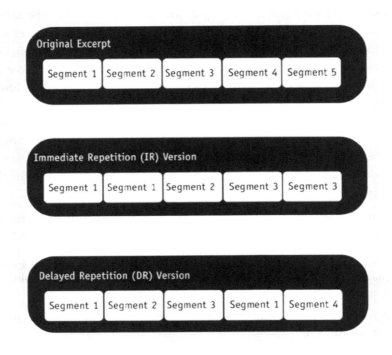

Figure 1.1
Graphic representations of the three types of stimuli used in Margulis's experiment:
original excerpts, excerpts with immediate repetitions inserted, and excerpts with
delayed repetitions inserted (Margulis 2013b, 16)

Margulis draws an important lesson from her study (2013b, 15):

> The simple introduction of repetition, independent of musical aims or princi-
> ples, *elevated people's enjoyment, interest, and judgments of artistry*. This suggests
> that repetition is a powerful and often underacknowledged aesthetic operative.
> (Italics mine)

In other words, Margulis sees repetition as a catalyst for pleasure.

An important takeaway from Margulis's experiment is that multiple
exposures played no role. An original piece of music and a doctored partner
were played side by side. Participants were asked to express a preference
then and there. They went for the version with repetition.

In Margulis's experiment the repeated segments were identical. This
being the case, one would expect artists to exploit that coupling of pleasure

and repetition by latching onto some poetic or musical form that involves repetition—say, rhyme in poetry or a motif in music—and, well, repeating it. Indeed, when it comes to rhyme, repetition is built into the very structure of the form. Rhyme is nothing if not repetition of a particular sort. We'll come to that in the next chapter.

The link between repetition and pleasure has been explored by researchers outside the realm of music. For example, Kahneman (2013, 66) describes the work of the psychologist Robert Zajonc who "dedicated much of his career to the study of the link between the repetition of an arbitrary stimulus and the mild affection that people eventually have for it. Zajonc called it the mere exposure effect."

Kahneman (2013, 67) goes on to say that Zajonc believed that this link between repetition and affection "is a profoundly important biological fact, and that it extends to all animals." In Zajonc's words cited in Kahneman (66–67):

> The consequences of repeated exposures benefit the organism in its relations to the immediate animate and inanimate environment. They allow the organism to distinguish objects and habitats that are safe from those that are not, and they are the most primitive basis of social attachments. Therefore, they form the basis for social organization and cohesion—the basic sources of psychological and social stability.

The position in this book is that this biological function of repetition was coopted by poets, composers, and painters precisely because repetition entailed pleasure.

First let's look at the mechanism at work in determining when something is an actual repetition. Endress, Nespor, and Mehler (2009, 348) propose a set of POMPs (perceptual or memory primitives) about which they write:

> [H]umans use a specialized primitive devoted to processing identity relations. Although this POMP responds much more strongly to repetitions of adjacent elements, it also seems to process repetition at a (short) distance (A. M. Kovács, PhD thesis, SISSA, Trieste, Italy, 2008). The POMP seems to be innate, and might be present in different modalities. Not only are human neonates sensitive to repetition structures [Gervain et al. 2008] but even bees are sensitive to visual and olfactory identity relations [Giurfa et al. 2001]. It thus seems that a repetition-processing primitive is available in different animals [Giurfa et al. 2001; . . . Murphy, Mondragón, and Murphy 2008], and in humans even at birth [Gervain et al. 2008].

Moira Yip (2014) surveys identity in human and nonhuman cognition and explores its use in natural language. She argues, like Endress, Nespor, and Mehler (2009), that the ability to make repetition judgments is not specific to humans and moreover that when it appears in language, it has been recruited from a more general cognitive function (2014, 323).

> Endress, [Nespor, and Mehler] (2009) postulate that humans are endowed with a perceptual or memory primitive (POMP) devoted to identity relations. This is neither specific to language, nor to humans, but it is recruited by language, where it has a range of effects. . . . The presence of this primitive ability means that both the presence and the absence of identity are potential carriers of information.

These studies corroborate an observation made over a century earlier by William James in his *Principles of Psychology*. James (1890, 528) calls attention to the human ability to perceive differences in like objects:

> The perception of likeness is practically very much bound up with that of difference. That is to say, the only differences we note *as* differences, and estimate quantitatively, and arrange along a scale, are those comparatively limited differences which we find between members of a common genus. . . . To be found *different*, things must as a rule have some commensurability, some aspect in common, which suggests the possibility of their being treated in the same way. (James's italics)

Recognition of this capacity in human beings did not begin with James. In his in-depth analysis of ornamentation in the arts, E. H. Gombrich (1979, 113) notes that the function of likeness can be traced all the way back to Plato:

> The question is as old as philosophy itself. It plays a decisive role in one of Plato's most moving dialogues, the *Phaedo*, where Socrates in his death cell tries to persuade his disciples not to grieve, because the soul is immortal. He introduces this particular argument by asking one of his pupils whether he knows what 'likeness' is. And yet, how can he know? Had he ever seen two things which were absolutely alike—for instance two pieces of chalk or of wood which could be so described? If not, his knowledge of the idea or the concept of likeness could not derive from sense experience. It must come from elsewhere. We must have seen or experienced mathematical equality before our soul ever entered into our bodies, and it is this memory that provides us with the standard by which we judge whether things in this world are more or less alike.
>
> I once had a student who cried when she read this poignant scene because she could not bear the thought of Socrates having grounded his hopes of immortality on a fallacy. It is true that as a proof of personal survival the argument will not hold water, but if we replace the notion of the individual's memories of a former

state by the more modern-sounding idea of our biological equipment Plato was surely right that we are endowed from birth with the capacity to judge our experiences by such prior categories as identity or difference, similarity or contrast.

If Gombrich is right—and I think he is—then for our brain to construct an internal order from what is the external chaos of the real world, the ability to distinguish between what is the same and what is different is crucial.

It was left to Margulis to make the crucial connection, crucial for the thesis of this book, that repetition—a phenomenon that requires the ability described by James and Plato—has an enhancing dimension. To her discovery I add the supposition that art forms throughout the ages have accommodated their constraints to this connection.

I first came across the passage from James in Peter Culicover and Ray Jackendoff's (2012) discussion of a relationship they term *same/except*. They argue that the ability to discern a *same/except* relationship between similar objects is a general cognitive capability found in vision, audition, and taste and that it surfaces in English in constructions like these:

(3) a. This vase is the same as that one except it is red.

　　b. This song is identical to that one only it is in the key of G.

　　c. My salad is just like yours except that it has anchovies instead of almonds.[3]

Culicover and Jackendoff describe two kinds of *same/except* repetition, which they term *elaboration* and *contrast*. To illustrate, they use a creature made famous by Jean Berko Gleason (1958) in a set of experiments testing the acquisition of plurals by children (see figures 1.2 and 1.3). Gleason

Figure 1.2
Elaboration (Culicover and Jackendoff 2012, 306)

Figure 1.3
Contrast (Culicover and Jackendoff 2012, 306)

called the figured animal a *wug*. In elaboration, the second wug is a repetition of the first but with a curlicue atop its head. In any discussion of decoration this would constitute ornamentation. In contrast, the second figure is the same as the first, except the curlicues are different. As we will see, the practice of rhyming in English poetry falls into the contrast category of repetition. Two words rhyme if everything to the right of the stressed vowel is the same, including the stressed vowel itself (the wug), and everything to the left is different (the curlicues).

To his great credit, Bernstein was sensitive to the *same/except* dimension of repetition (1976, 147–148):

> Roman Jakobson, the great linguistic thinker and one of Chomsky's most influential teachers . . . speaking of poetry, said (and I reduce this quote): "It is only . . . by the regular reiteration of equivalent units that poetry provides an experience of time . . . comparable to that of musical time." Now that would seem a gross oversimplification, especially if he is referring to the regular reiteration of metrical units. Da-dá, da-dá, da-dá, da-dá hardly produces poetry; it's more like doggerel. But the moment we apply to that mechanical regularity the processes of transformation and variation, we immediately see what he's getting at, and we can extend Jakobson's reiterative principle to include all facets of poetic diction, not only meter.
>
> For example, the repetition of elementary sounds—vowels, consonants, phonemes—which gives us the whole range of poetic assonance, from the simple alliteration of Shakespeare's "full fathom five" to the complex and mysterious resonances of Milton in *Paradise Lost*, "fragrant the fertile earth after soft showers"; or of Gerard Manley Hopkins' sonorous hymn of praise for "dappled things" "for skies of couple-colour as a brinded cow"; to say nothing of the fascinating auditory correlatives that resonate in the poetry of Dylan Thomas, "And green and golden I was huntsman and herdsman"; or the so-called prose of James Joyce, which is really poetry: "Beside the rivering waters of, hither and thithering waters of. Night!" . . . Not to mention Gertrude Stein, who made a whole career out of repetition.

Honoring Bernstein's intuitions and following Culicover and Jackendoff and Margulis, I would like to suggest that repetition as a general *same/except* cognitive capability is a major source of aesthetic impact in works of art. When two events are in a *same/except* relationship, discovering that to be the case is a pleasurable activity.[4] From this perspective, rhyme is the poster child for poetic pleasure. Let's see how that works.

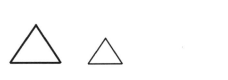

2 Rhyme in Poetry

In the history of English letters, the use of rhyme goes back as far as the *Beowulf* poet, circa 700 CE.[1] Every well-known English poet from the Gawain poet through Chaucer, Shakespeare, Milton, Dryden, Pope, Bryon, Shelley, Keats, and Tennyson made use of rhyme.[2] I am interested in by far the most common rhyme of all, the so-called perfect or end rhyme like *books* and *looks*. This is the kind of rhyme that appears at the end of not necessarily consecutive lines; see, for example, the opening quatrain of William Wordsworth's "The Tables Turned":

(1) Up! up! my Friend, and quit your books;

Or surely you'll grow double:

Up! up! my Friend, and clear your looks;

Why all this toil and trouble?

Here there are two end-rhyming pairs: *books/looks* and *trouble/double*. Let's see how this kind of rhyme works. We start by dividing syllables into two parts, an *onset* and a second part confusedly called a *rime*—confusedly because it forms an identical *rhyme* with *rhyme*. But let's stick with it. So, we say that a syllable consists of an onset and a rime and that a rime is divided up into a *vowel* and everything else, which is called a *coda*:

(2)

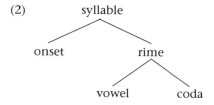

Let's review an argument for this kind of structure. Consider the secret language called *Pig Latin*. The rule for forming a Pig Latin word—say, *ooksbay*

for *books*—describes how to alter the normal shape of a word to disguise it—hence, make it secret. From our first example, it appears that the rule is "Move the first sound of a word to the end of the word and add *ay*." But that can't be right. The Pig Latin for *strum* is not **trumsay* or even **rumstay*. It is *umstray*. So we need a structure that will take more than just the first sound or the first and/or second sound of a word. The structure in (2) does the trick. If we treat syllables as being made up of an onset and everything else, then the Pig Latin rule is easy to state: "Take everything dangling from the onset, move it to the end, and add *ay*." That gives both *ooksbay* and *umstray*.[3]

(3)

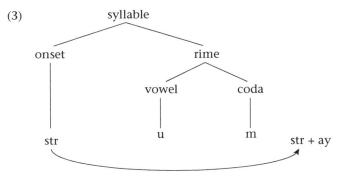

So, Pig Latin is a secret language whose rules work first to take any word and add an extra syllable at the end and then to transfer the contents of the original onset to the new onset, leaving the old onset empty.

(4)

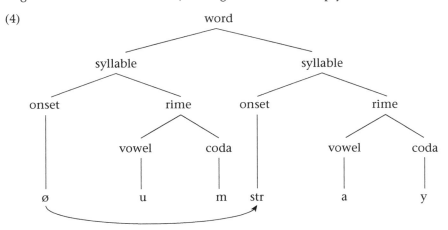

Now let's examine how rhyme works from the point of view of the structure of syllables containing onsets.

(5)

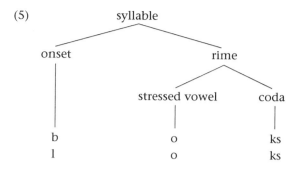

Given this structure, we determine whether two words constitute an end rhyme by subjecting the structure to a test.

(6) 1. Are all the sounds from the stressed vowel to the end of the word(s) the same?[4]

2. Are all the sounds under the stressed vowel's onset different?

3. If yes to (1) and (2), then the pair constitutes a perfect end rhyme.

It's as simple as that. Of course, words longer than monosyllabic words rhyme; for example, here are the representations for the rhyming pair *receives:leaves* that occurs in the last stanza of "The Tables Turned." (See appendix 1 for the entire poem.)

(7) a.

b.

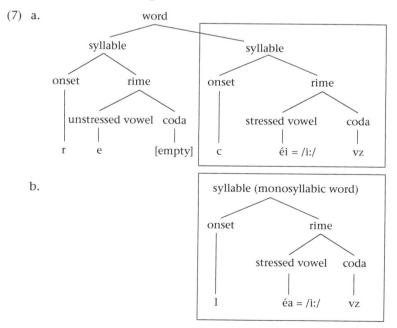

To make the end-rhyme determination, all you need to do is line up the stressed vowels in each structure and run through the test. (I have done that by enclosing the relevant portions of each tree in a box.) In (7a) the relevant stressed vowel sequence is [i:vz], that is, the phonetic representation of the orthographic representation -*eives* in *receives*. In (7b) the relevant stressed vowel sequence is [i:vz], that is, the phonetic representation of the orthographic representation -*eaves* in *leaves*. The associated onset in the former is [s] (spelled *c*). The associated onset in the latter is [l]. The stressed vowel sequences are the same. The onsets are different. Hence, *receives:leaves* constitutes a perfect end rhyme.[5]

Notice that the structure in (7) will also apply to *Supercalifragilisticexpialidócious,* the nonce word from the 1964 movie *Mary Poppins*. The primary stress is on the penultimate syllable. The rule in (6) is only concerned with the associated onset. Hence, like *re-* in (7) the sequence *Supercalifragilisticexpiali-* is invisible. Here is the relevant lyric:

(8) It's supercalifragilisticexpialidocious

 Even though the sound of it is something quite atrocious

 If you say it loud enough, you'll always sound precocious

 Supercalifragilisticexpialidocious

The rhyming sequence is -*docious:-trocious*. The relevant onsets that are *different* are /d/ and /tr/. The relevant *same* sequence is -*ócious*. That sequence consists of two syllables, and the rule (6) takes that into account with its use of the term *word(s)*. This usage, however, needs a bit of explaining.

Recall that note 4 points to the rhyme *linnet:in it* in "The Tables Turned," where one bisyllabic word, *linnet*, rhymes with two monosyllabic words, *in it*. Moreover, there are lines that end with trisyllabic words. Gilbert and Sullivan lyrics are a treasure trove of examples. Here is one from "I Am the Very Model of a Modern Major General" from *The Pirates of Penzance*:

(9) Then I can hum a fugue of which I've heard the music's din afore

 And whistle all the airs from that infernal nonsense *Pinafore*.

Here two words, *din* and *afore*, rhyme with one trisyllabic word, *Pinafore*. Notice that the sequence *afore* falls outside the meter. Metrical lines often end with syllables that follow the final foot of the line, hence are called *extrametrical*. But while they are outside the meter, they still must meet the constraints of rhyme. The lines in "Major General" are composed of seven

iambic (weak-strong) feet. They are typically fourteen syllables in length. But in (9) *afore* counts as syllables fifteen and sixteen. They are extrametrical, after the meter. The takeaway here is that for purposes of determining if there is a legitimate end rhyme, when you lay out the sequences beginning with the primary stressed vowel and ending when the line actually ends, pay no attention to where the meter says the line has ended or to the spaces between words. Just focus on the sounds of the word(s). That's what (6.1) means.

Notice that this *same* determination pays no attention to constituent construction. In this respect it is quite unlike the *except* determination, which requires that attention be paid to a constituent—namely, the onset of a syllable.[6]

Though end rhyme is not the only kind of rhyme to be found in poetry— there are eye rhymes (*cough:though*), assonance (*look:luck*), identical rhymes (*way:weigh:whey*), and more—far and away the most common is end rhyme. But even with nonperfect rhyme the *same/different* test applies. Knoop et al. (2021, 562) provide this extensive sampling:

> For German, two main corpus studies have tried to establish the types of phonological divergence in imperfect rhymes that are licensed in the literary canon. Berg (1990) identified three primary types of imperfect rhyme in the works of author Wilhelm Busch, with 5,700 rhymes as the basis of his study: rhyming pairs that differed in vowel roundedness (e.g., *Besenstiel* /'be:znʃti:l/—*Gefühl* /gə'fy:l/), which made up 97.5% of the imperfect rhymes in the corpus; in vowel quantity (i.e., length, as in *sucht* /zu:Xt/—*Flucht* /flʊXt/), which made up 2.0%; or in voicing (e.g., *befunden* /bə'fʊndn/—*unten* /'ʊntn/), which made up only 0.5%. A study by Primus (2002) drew on a corpus of poems by Goethe, Schiller, and Heine and found a similar pattern for these three types. In addition, the study identified two further groups of imperfect rhymes, which differed in the height of the e-phoneme (e.g., *Tränen* /trɛ:nən/—*dehnen* /'de:nən/) or in g-spirantization (e.g., *Aug'* /'aʊg/—*Strauch* /ʃtraʊX/).

In this German corpus, rhymes were deemed *same/except* for individual properties like vowel roundness, vowel length, vowel height, consonant voicing, or spirantization.[7] In other words, two words were said to rhyme if all their phonetic properties were the same except for vowel roundness, vowel length, or consonant voicing, and so on, with the vast preponderance of imperfect rhymes differing only in vowel rounding.[8] These so-called imperfect rhymes are steps away from perfect rhymes but they still involve meeting a test similar to (6), albeit with a slight modification to step 1:

(10) 1. Are all the sounds from the stressed vowel to the end of the word(s) the same except for [insert the relevant property here: roundness, voicing, length]?

2. Are all the sounds under the stressed vowel's onset different?

3. If yes to (1) and (2), then the pair constitutes an imperfect end rhyme.

This discussion of imperfect rhyme raises a question. Is end rhyme more pleasurable than imperfect rhyme? One would have to design some kind of experiment in which pleasure is measurable—maybe just by asking as Margulis did, "Which do you prefer?" But here is a suggestion.

Margulis's experiment involved repeated segments that were identical. Such segments are hard to come by in English. Recall (5) from the introduction.

(11) Monty Woolley was such a ham
That all he ever ate was ham.

And compare it with this end-rhyme counterpart ((9) from the introduction):

(12) Monty Woolley was such a ham
That all he ever ate was Spam.

The rhyme in (11) is built on the homonyms *ham:ham*. This rhyme is called an identical rhyme, like *two:too* or *way:weigh:whey*. Sometimes that term is used for what I am calling end rhymes, also called perfect rhymes in some of the literature. (I will continue to use the term *end rhyme* for the common type of rhyme.) The rhyme in (12) is an end rhyme. End rhymes are vastly more common than identical rhymes.[9] For the sake of discussion and in accordance with my own intuition, I will assume that (12) is a more satisfactory rhyme than (11) from the point of view of pleasure. If this were to turn out to be true, there would be a ready explanation in terms of the *same/except* model. (12) contains a sameness, /-am/, and a difference, /h-/ and /sp-/. (11) contains only a sameness. Two sources of pleasure versus one. I predict English-speaking readers will find (12) the more desirable.

Before we leave the subject of rhyme altogether, I should say something about a different kind of rhyme: alliteration. Alliteration was to Old English poetry what end rhyme was to Chaucer.[10] It requires that onsets associated with stressed vowels be filled with the same sounds and that everything to the right of the associated stressed vowel including the stressed vowel be

different.[11] Edgar Allan Poe was a master of alliteration (as well as rhyme), as the opening line from stanza 3 of "The Raven" illustrates:[12]

(13) And the silken, sad, uncertain rustling of each purple curtain[13]

The opening lines of the (probably) eighth-century poem *Beowulf* illustrate precisely the same phenomenon:

(14) Hwæt! Wé Gárdena in géardagum
 Listen! We—of the Spear Danes in the days of yore

 þéodcyninga þrym gefrúnon.
 of those clan-kings— their glory we have heard.

In other words, we see the same device used by the *Beowulf* poet (or poets) and Poe, separated in time by more than a thousand years.

Most remarkable of all is the tenth-century "Rhyming Poem" (or "Riming Poem") that survived in the *Exeter Book* (circa 960–990 CE), English's oldest known poetry anthology. "The Rhyming Poem" is the only example of its kind in the entire Anglo-Saxon corpus. If you don't read Old English, then read Poe's "The Raven," written in 1845 (see appendix 2). The patterns of internal rhyme and alliteration in "The Rhyming Poem" are so reminiscent of "The Raven" that Poe could easily be the reincarnation of the poet who wrote "The Rhyming Poem," mutatis mutandis, of course.

Any history of English versification has to make note of the shift in rhyming practice from alliteration to end rhyme that took place between roughly 700 and 1200 CE. McKie (1997, 821) describes the transition:

> Apart from the fourteenth-century alliterative revival, Middle English verse from the later thirteenth century onwards was regularly rhymed. With the exception of *The Owl and The Nightingale*, the rhyming was usually crude, and only by the time of Chaucer did rhyming approach the exactness of the early modern period. Hence any account of the origins of rhyme in English verse has to explain the sporadic but slowly increasing use of rhyme in Old English verse over three centuries, with a single poem, around the middle of that period, that used far more rhyme than any other English poem of that time; the period of about a hundred and fifty years, from about 1050–1200, in which verse had both alliteration and rhyme; the transition, completed by the early fourteenth century, to a Romance syllabic prosody, at first in the couplet and subsequently in stanzaic verse, in which end rhyme was obligatory.

I won't attempt an explanation for the shift from alliteration to end rhyme that began in Old English and was thoroughly complete by the time of Chaucer.[14] But the change can be represented in terms of what I have said so far. Recall the representation of monosyllabic *books* and *looks* in (5), repeated here:

(15)

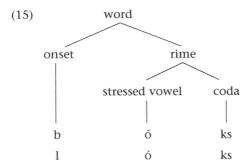

Associated with this structure was the test (6), also repeated here:

(16) 1. Are all the sounds from the stressed vowel to the end of the word(s) the same?

2. Are all the sounds under the stressed vowel's onset different?

3. If yes to (1) and (2), then the pair constitutes a perfect end rhyme.

To represent alliteration, all we need to do is alter (16.1) and (16.2) with two words: namely, *same* and *different*. In (16.1), change *same* to *different*. In (16.2), do the reverse. (16) now reads:

(17) 1. Are all the sounds from the stressed vowel to the end of the word(s) different?

2. Are all the sounds under the stressed vowel's onset the same?

3. If yes to (1) and (2), then the pair constitutes a perfect alliteration.

In plain English, the only difference between alliteration and end rhyme is what part of the word must be the same and what part must be different. So the grand shift from alliteration to end rhyme is not a shift in the *same/except* mechanism for aesthetic pleasure but merely a shift in the phonological material being assessed along the dimension of *same/except*.[15]

As McKie's comment above implies, English poetry achieved an "exactness" of end rhyme at the hands of Geoffrey Chaucer. Here is the opening sentence to the prologue of Chaucer's masterpiece, *The Canterbury Tales*. It

is twenty lines long. The meter is iambic pentameter. Let's focus on the line endings. Chaucer wrote in couplets, two-line pairs, each of which ended in a perfect end rhyme. This is no doubt a form carried over into English from French poets like Marie de France. The same form appeared in a sophisticated poem of the late eleventh–early twelfth century called "The Owl and the Nightingale." In this form each couplet is independent of each subsequent couplet. Consequently, there is no instance of three identical end rhymes in a row.

(18) Whan that Aprille with his shoures soote,

The droghte of March hath perced to the roote,

And bathed every veyne in swich licóur

Of which vertú engendred is the flour;

Whan Zephirus eek with his swete breeth

Inspired hath in every holt and heeth

The tendre croppes, and the yonge sonne

Hath in the Ram his halfe cours y-ronne,

And smale foweles maken melodye,

That slepen al the nyght with open ye,

So priketh hem Natúre in hir corages,

Thanne longen folk to goon on pilgrimages,

And palmeres for to seken straunge strondes,

To ferne halwes, kowthe in sondry londes;

And specially, from every shires ende

Of Engelond, to Caunterbury they wende,

The hooly blisful martir for to seke,

That hem hath holpen whan that they were seeke.

Compare this with the opening three stanzas of Poe's "The Raven":

(19) Once upon a midnight dreary, while I pondered, weak and weary,

Over many a quaint and curious volume of forgotten lore—

While I nodded, nearly napping, suddenly there came a tapping,

As of some one gently rapping, rapping at my chamber door.

"'Tis some visitor," I muttered, "tapping at my chamber door—

Only this and nothing more."

Ah, distinctly I remember it was in the bleak December;
And each separate dying ember wrought its ghost upon the floor
　　Eagerly I wished the morrow;—vainly I had sought to borrow
From my books surcease of sorrow—sorrow for the lost Lenore—
For the rare and radiant maiden whom the angels name Lenore—
　　　　Nameless *here* for evermore.

And the silken, sad, uncertain rustling of each purple curtain
Thrilled me—filled me with fantastic terrors never felt before;
　　So that now, to still the beating of my heart, I stood repeating
"'Tis some visitor entreating entrance at my chamber door—
Some late visitor entreating entrance at my chamber door;—
　　　　This it is and nothing more."

(19) is how the poem appeared in the February 1845 issue of the *American Review*. Looking at the rhyme scheme, we see that each stanza consists of five trochaic octameter lines and a trochaic tetrameter half-line tag. The five lines are distributed with respect to rhyme in this fashion: Lines 1 and 3 never end-rhyme, but they always exhibit internal rhyme. Lines 2 and 4 always end-rhyme. Line 4 always exhibits an internal rhyme with the pattern of line 3. Moreover, lines 4 and 5 always end-rhyme identically. Line 5 always end-rhymes—though not identically—with the half line 6. As noted earlier, identical rhyme is quite rare in English verse—and yet here it is in one of the poetic canon's best-known works, where it dominates the last two full lines of each stanza.

It should be noted that—except for stanzas 2 and 4 (and possibly 17)—line 5 always repeats some portion of line 4.[16] Therefore, I find it preferable to think of line 5 coupled with the tetrameter tag as a varying refrain. (The noun *refrain* derives from Old French *refraindre* meaning 'to repeat'.) So "The Raven" consists of eighteen trochaic tetrameter quatrains of the form x_a, a, x_b, a followed by a trochaic octameter and tetrameter refrain with the rhyme scheme a, a.[17]

Poe's refrain contrasts with the invariant refrain in Dylan Thomas's "Do Not Go Gentle into That Good Night": *Rage, rage against the dying of the light*. For Poe, sometimes the same phrase ends the couplet: for example, *at my chamber door* in stanza 1 and *entreating entrance at my chamber door* in stanza 3. And sometimes it is only the last word that is repeated: for example, *Lenore* in stanza 2.

This intricate rhyme scheme is indicated on the right of the opening two stanzas of the poem in (20), where the astonishing tour de force of linking identity and end-rhyming in the sequence a a a a (see note 17) is clear—astonishing because despite the rigidly repetitive rhyme on the syllable *-ore*, the poem's rhyming structure never flags into monotony. (See also appendix 2, where I have indicated the internal/end rhyme scheme of the poem with boldface type.)

The upshot of all this is that the poem exercises the *same/except* determination in two ways. In the refrain the *same* judgment and only the *same* judgment is made. Line 4 and line 5 always exhibit identity rhyme. The rest of the rhyming lines make use of *same/except* judgments. Making use of both types of repetition, identity and *same/except*, is a large part of the sense of rhyming richness that the poem conveys. And I have said nothing about its rampant alliteration.

(20)

	Rhyme scheme
Once upon a midnight dreary, while I pondered, weak and weary,	x_a
Over many a quaint and curious volume of forgotten lore—	a
While I nodded, nearly napping, suddenly there came a tapping,	x_b
As of some one gently rapping, rapping at my chamber door.	a
"'Tis some visitor," I muttered, "tapping at my chamber door—	a
Only this and nothing more."	a
Ah, distinctly I remember it was in the bleak December;	x_a
And each separate dying ember wrought its ghost upon the floor	a
Eagerly I wished the morrow;—vainly I had sought to borrow	x_b
From my books surcease of sorrow—sorrow for the lost Lenore—	a
For the rare and radiant maiden whom the angels name Lenore—	a
Nameless *here* for evermore.	a
And the silken, sad, uncertain rustling of each purple curtain	x_a
Thrilled me—filled me with fantastic terrors never felt before;	a
So that now, to still the beating of my heart, I stood repeating	x_b
"'Tis some visitor entreating entrance at my chamber door—	a
Some late visitor entreating entrance at my chamber door;—	a
This it is and nothing more."	a

There are, of course, other rhyme schemes. Here are a few, limited to the sonnet form:

(21) *Shakespearean sonnet* (Sonnet 30, William Shakespeare)

When to the sessions of sweet silent thought	a
I summon up remembrance of things past,	b
I sigh the lack of many a thing I sought,	a
And with old woes new wail my dear time's waste:	b
Then can I drown an eye, unus'd to flow,	c
For precious friends hid in death's dateless night,	d
And weep afresh love's long since cancell'd woe,	c
And moan th' expense of many a vanish'd sight;	d
Then can I grieve at grievances foregone,	e
And heavily from woe to woe tell o'er	f
The sad account of fore-bemoaned moan,	e
Which I new pay as if not paid before.	f
But if the while I think on thee, dear friend,	g
All losses are restor'd, and sorrows end.	g

(22) *Spenserian sonnet* ("Amoretti I," Edmund Spenser)

Happy ye leaves when as those lilly hands,	a
Which hold my life in their dead doing might	b
Shall handle you and hold in loves soft bands,	a
Lyke captives trembling at the victors sight.	b
And happy lines, on which with starry light,	b
Those lamping eyes will deigne sometimes to look	c
And reade the sorrowes of my dying spright,	b
Written with teares in harts close bleeding book.	c
And happy rymes bath'd in the sacred brooke,	b
Of *Helicon* whence she derived is,	c
When ye behold that Angels blessed looke,	b
My soules long lacked foode, my heavens blis.	c
Leaves, lines, and rymes, seeke her to please alone,	d
Whom if ye please, I care for other none.	d

(23) *Petrarchan sonnet* (No. 43, Elizabeth Barrett Browning)

How do I love thee? Let me count the ways.	a
I love thee to the depth and breadth and height	b
My soul can reach, when feeling out of sight	b
For the ends of being and ideal grace.	a
I love thee to the level of every day's	a
Most quiet need, by sun and candle-light.	b
I love thee freely, as men strive for right.	b
I love thee purely, as they turn from praise.	a
I love thee with the passion put to use	c
In my old griefs, and with my childhood's faith.	d
I love thee with a love I seemed to lose	c
With my lost saints. I love thee with the breath,	d
Smiles, tears, of all my life; and, if God choose,	c
I shall but love thee better after death.	d

(24) *Terza rima* ("Acquainted with the Night," Robert Frost)

I have been one acquainted with the night.	a
I have walked out in rain—and back in rain.	b
I have outwalked the furthest city light.	a
I have looked down the saddest city lane.	b
I have passed by the watchman on his beat	c
And dropped my eyes, unwilling to explain.	b
I have stood still and stopped the sound of feet	c
When far away an interrupted cry	d
Came over houses from another street,	c
But not to call me back or say good-bye;	d
And further still at an unearthly height,	e
One luminary clock against the sky	d
Proclaimed the time was neither wrong nor right.	a
I have been one acquainted with the night.	a

We saw earlier that the mechanism of rhyme is a perfect example of the operation of the *same/except* test on repetition. *Books* and *looks* are the same except for the onset. We have also seen that the notion of rhyme entails a rhyme scheme. Examining the rhyme schemes above yields a further generalization. The rhyming pairs from Chaucer's couplets through all the sonnet forms including Frost's terza rima never separate a rhyming pair by more than one line. We can call this property of rhyme schemes a *locality constraint*.

This constraint must surely be based on a short-term memory limitation: how much can we remember of what we have just read as we read further? For example, consider William Butler Yeats's "Broken Dreams":

(25) 1. THERE is grey in your hair. a

 2. Young men no longer suddenly catch their breath b

 3. When you are passing; c

 4. But maybe some old gaffer mutters a blessing c

 5. Because it was your prayer a

 6. Recovered him upon the bed of death. b

 7. For your sole sake—that all heart's ache have known, d

 8. And given to others all heart's ache, e

 9. From meagre girlhood's putting on d

 10. Burdensome beauty—for your sole sake e

 11. Heaven has put away the stroke of her doom, f

 12. So great her portion in that peace you make e

 13. By merely walking in a room. f

 14. Your beauty can but leave among us g

 15. Vague memories, nothing but memories. h

 16. A young man when the old men are done talking i

 17. Will say to an old man, "Tell me of that lady j

 18. The poet stubborn with his passion sang us g

 19. When age might well have chilled his blood." k

 20. Vague memories, nothing but memories, h

 21. But in the grave all, all, shall be renewed. l

 22. The certainty that I shall see that lady j

23. Leaning or standing or walking i

24. In the first loveliness of womanhood, m

25. And with the fervour of my youthful eyes, n

26. Has set me muttering like a fool. o

27. You are more beautiful than any one, p

28. And yet your body had a flaw: q

29. Your small hands were not beautiful, r

30. And I am afraid that you will run s

31. And paddle to the wrist t

32. In that mysterious, always brimming lake e

33. Where those that have obeyed the holy law q

34. paddle and are perfect. Leave unchanged u

35. The hands that I have kissed, t

36. For old sake's sake. e

37. The last stroke of midnight dies. n

38. All day in the one chair a

39. From dream to dream and rhyme to rhyme I have ranged w

40. In rambling talk with an image of air: a

41. Vague memories, nothing but memories. h

This poem has a rhyme scheme, although it is not metrical, thus demonstrating what is perhaps obvious: that meter and rhyme are independent artifices. Its rhyme scheme disintegrates as the poem goes along, a literary device intended to mirror the dissolution of thought and memory. The poem ends in "rambling talk." A tight rhyme scheme would counter that theme. As it is, there are echoes. Lines 1 and 5 rhyme. The same rhyme appears in lines 38 and 40. Are we to say that lines 1/5/38/40 constitute a component of the rhyme scheme? I think not. In poetry, for a pair of words to participate, each must be close to its partner, where "close" probably ranges over no more than three lines as in "The Raven."

It is this perceptual limitation that keeps rhymes within a few lines of one another. That way they can't be missed. Stretch the distance and you dilute the perception of repetition. This is certainly true in music as well as poetry. A tangential but suggestive experiment done by Nicholas Cook (1987, 197) indicates that

beginning and ending in the same key ("tonal closure") fails to evoke a greater sense of completion, coherence or pleasure for passages that are longer than roughly 2 minutes. . . . [T]he direct influence of tonal closure on listeners' responses is relatively weak and is restricted to fairly short time spans—much shorter than the duration of most tonal compositions.

While most rhymes occur within one or two lines, though three lines works well enough as in the beginning of Yeats's "Broken Dreams" (recall (22)), in music proximity seems to stretch over wider distances. Thus, in Mozart's *Six German Dances No. 1* (see figure 3.14) or his *Rondo alla Turca* (see figure 5.2) repetition works over a stretch of eight measures. Interestingly, this eight-measure constituent was given a name by Schoenberg, who called it a sentence and talked of its appearance in, for example, Beethoven's Sonata in F Minor, Op. 2/1. William Caplin (1998), beginning with a reference to the Schoenberg neologism, provides a meticulous description of the various types of what he calls "classical form" in his superb book of the same name. His work suggests that it would be worthwhile to compare the classical forms of music with those of metrical poetry to see if there are salient differences with respect to proximity between the forms of music (e.g., Schoenberg's "sentence" constructions) and poetic rhyme schemes (e.g., a Shakespearean sonnet).[18]

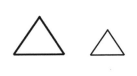

3 Rhyme in Music

In the previous chapter I discussed the nature of rhyme and the accompanying notion of rhyme scheme. In terms of the thesis of this book, repetition in poetry is one source of pleasure based on priming. Priming involves abstract tree perseverance, and I have described what those trees look like when it comes to end rhymes. I will show precisely how this perseverance works in chapter 14.

In this chapter I will show that, mutatis mutandis, music demonstrates a relationship between elements of a melody that is the exact analog of *same/ except* in poetic end rhyme. A good place to start is the jazz standard "Satin Doll," Duke Ellington's musical accolade to his longtime companion Bea "Evie" Ellis, written by Ellington and Billy Strayhorn with lyrics supplied later by Johnny Mercer. It was the last of their popular hits, reaching #27 on the *Billboard* pop charts in 1953, the year it was released.

That lowly position belies its place in the pantheon of classical jazz standards. No student of jazz can graduate without having mastered its relatively straightforward melody and harmony. It is a very simple tune, but a deservedly memorable one. Figure 3.1 is the "lead sheet," in musical parlance. It contains the clef sign (treble), the key signature (C; no sharps or flats), the time signature (4/4), the melody, and the chord changes indicated by the numbered letters above the staves.

Melodies like "Satin Doll" consist of small packages. Following Lerdahl and Jackendoff (1983a), I call them *groups*. Group boundaries are usually intuitively obvious, though there can be differences of opinion. In figure 3.2 I have indicated with brackets above the stave how I would group the melody of "Satin Doll." Melodic grouping is the key to lyric placement. The groups define the line lengths of the lyrics that attach to the tune.

Satin Doll

Composed by Duke Ellington and Billy Strayhorn
Lyrics by Johnny Mercer

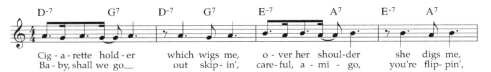

Cig - a - rette hold - er which wigs me, o - ver her shoul-der she digs me,
Ba - by, shall we go__ out skip- in', care- ful, a - mi - go, you're flip- pin',

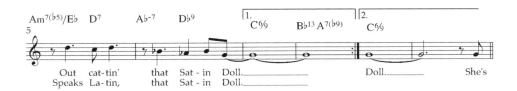

Out cat- tin' that Sat - in Doll._____ Doll._____ She's
Speaks La- tin, that Sat - in Doll._____

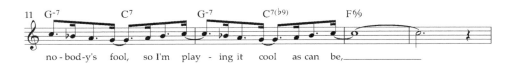

no - bod-y's fool, so I'm play - ing it cool as can be,_____

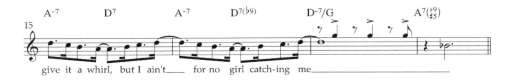

give it a whirl, but I ain't____ for no girl catch-ing me_____

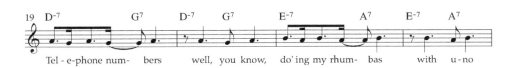

Tel - e-phone num- bers well, you know, do' ing my rhum- bas with u- no

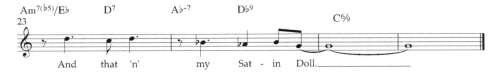

And that 'n' my Sat - in Doll._____

Figure 3.1
"Satin Doll" lead sheet

Satin Doll

Composed by Duke Ellington and Billy Strayhorn
Lyrics by Johnny Mercer

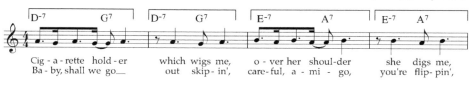

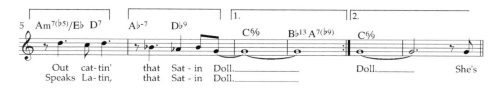

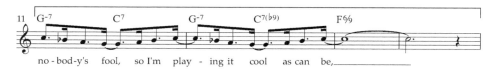

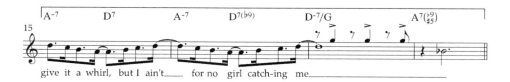

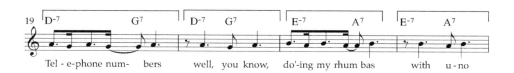

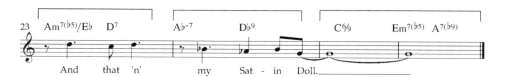

Figure 3.2
"Satin Doll" lead sheet with group brackets

Conversely, the groups can be reconstructed from the end rhymes of the lyrics. The two are completely codependent. As Stephen Sondheim (2010, xvii) notes, "Poetry doesn't need music. Lyrics do."

Musical notation has the admirable property of combining both the duration and the pitch of a note into a single system. For the purpose of this discussion, let's separate those dimensions. Figure 3.3 shows the rhythmic form of "Satin Doll" sans pitch.[1] This is the kind of musical score a drummer would read. It is obvious that measures 1 and 2 and measures 3 and 4 are rhythmically identical.

The same is true of measures 5 and 6, with a slight difference. Notice that measure 5 is identical to measures 2 and 4 rhythmically. One would therefore expect measure 6 to match measure 5, following the same pattern of measure 4 repeating 2. However, Ellington introduced a slight difference. He lengthened the third beat of measure 6 by adding an eighth note of duration. This automatically reduced the last beat to a quarter note that he divided into two eighth notes. Consequently, the rhythmic pattern of measure 6 is slightly different from that of measure 5.[2] Finally, measures 7 and 8 consist of one long note. Rhythmic identity doesn't apply.

Recall that I have described poetic rhyme as a form of repetition that fits Culicover and Jackendoff's (2012) category *contrast*. That is, two words rhyme if in each of them, the phonetic sequence from the stressed vowel rightward is the same and the onset of the word containing the stressed vowel is different. This is a clear *same/except* kind of repetition.

When we come to "Satin Doll," the identical *same/except* relationship is the foundation of the tune. Only the dimensions differ. Whereas in verse we are comparing the identity of speech sounds in onsets and rimes, in music we are comparing the identity of rhythms and pitches in measures. We have already seen what is the same in figure 3.3, namely, the rhythm. Thus, in the A sections (the first eight measures repeated and the last eight measures) the rhythm is virtually identical. In the bridge (the eight measures between the A sections) the first two measures, 17 and 18, are identical to measures 21 and 22. What is different? The pitch.

To see what's happening, let's lay out the first eight measures of the tune, not as they are usually displayed in a lead sheet like figure 3.1, but as if the melodic groupings were lines of a poem where groups are the equivalent of lines (see figure 3.4). Start by comparing group 1 and group 3. They are rhythmically identical. But group 3 differs from group 1 in that the pitch

Satin Doll
Rhythm Chart

Figure 3.3
"Satin Doll" lead sheet with pitch information omitted

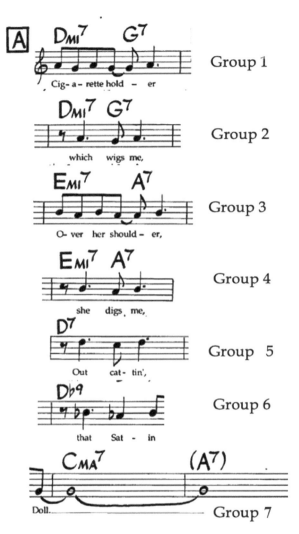

Figure 3.4
First eight measures of "Satin Doll" displayed as a rhyming poem

of each note is one step higher than that of its counterpart in group 1. We can say that group 3 is the same as group 1 except for pitch. In other words, group 1 and group 3 rhyme, where the dimensions are different from those of verse but where the relationships are identical. The same can be said of group 2 and group 4.

We've already noted that groups 5 and 6 are almost identical. The interval separating the groups is a third, group 6 being a third lower than group 5. But the rhythm is slightly different. Groups 5 and 6 each begin with an eighth rest and a dotted quarter note. Then they diverge. Group 6 has a quarter note on the third beat where measure 5 has an eighth note. And group 6 ends with two eighth notes beginning on the fourth beat, where group 5's final dotted quarter note is "off the beat." (The second eighth note can be seen at the beginning of the group 7 display.) Despite these differences, though, the two groups are rhythmically very similar. They both begin off the beat with a dotted quarter note because of the initial eighth-note rest. They both have a note that begins on the third beat. In this, the two groups resemble rhythmically what in verse is called assonance. That is, two words are thought to rhyme even though what follows the stressed vowel is not identical—for example, *reticence* rhymes with *penitence* assonantly. The words are close enough to be heard as rhyming. I treat groups 5 and 6 as rhythmically assonantal. Group 7 is unpaired. It consists of two measures, each with a whole note, the two tied over. Trivially, these are examples of identical rhyme, like *ham* and *ham* in the preceding chapter.

So parallel to the way *book* and *look* are in a *same/except* relationship phonologically, the notes of the groups in figure 3.4 can be said to rhyme musically. Johnny Mercer's lyrics capture that parallelism perfectly, as shown in (1). The rhyme scheme of the lyric is identical to the rhyme scheme of the melody. Just as (1.3) rhymes with (1.1), so too does group 3 rhyme with group 1, group 4 with group 2, and group 6 with group 5. (I have used matching typefaces to capture the melodic rhyme scheme.)

(1) Rhyme scheme for first eight measures in A₁

		Lyric	Melody
1.	Cigarette holder	a	*Group 1*
2.	Which wigs me	b	**Group 2**

3.	Over her shoulder	a	*Group 3*
4.	She digs me	b	**Group 4**
5.	Out cattin'	c	***Group 5***
6.	That Satin	c	***Group 6***
7.	Doll	d	Group 7

The pattern displayed in (1) is identical in all the A sections. Here are the remaining A schemes:

(2) a. Rhyme scheme for A_2

		Lyric	Melody
1.	Baby, shall we go	a	*Group 1*
2.	Out skippin'	b	**Group 2**
3.	Careful amigo	a	*Group 3*
4.	You're flippin'	b	**Group 4**
5.	Speaks Latin	c	***Group 5***
6.	That Satin	c	***Group 6***
7.	Doll	d	Group 7

 b. Rhyme scheme for A_3

		Lyric	Melody
1.	Telephone numbers	a	*Group 1*
2.	Well, you know	b	**Group 2**
3.	Do'-ing my rhumbas	a	*Group 3*
4.	With uno	b	**Group 4**
5.	And that 'n'	c	***Group 5***
6.	My Satin	c	***Group 6***
7.	Doll	d	Group 7

The musical group rhyme scheme and the lyric rhyme scheme are both of the form $x_a\ x_b\ x_a\ x_b\ x_c\ x_c$, a poetic rhyme scheme called a sextilla (a fourteenth-century Galacian-Portuguese form used by William Wordsworth in "I Wandered Lonely as a Cloud"; see appendix 1). The identity of the patterns in the two dimensions underscores Sondheim's observation about the connection between a lyric and its music.

Group 1

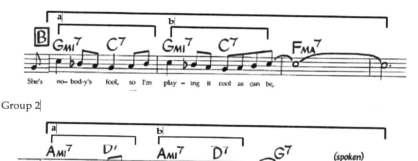

Group 2

Figure 3.5
Bridge of "Satin Doll" displayed as a rhyming couplet

Now let's turn to the "Satin Doll" bridge. Intuitively, the bridge consists of two groups, each four measures long. These are displayed in figure 3.5. Each group consists of two subgroups, also indicated in figure 3.5 as groups 1a and 1b and groups 2a and 2b. The first thing to notice is that these subgroups rhyme. They meet the *same/except* relationship. Their melodies are the same. Their rhythms are slightly different. In group 1a the first two beats of measures 1 and 2 are identical. But measure 1 of group 1a ends with a quarter note and two eighth notes while measure 2 ends with four eighth notes. In group 2 we have the same situation. Group 2a begins with six eighth notes and ends with a quarter note. Group 2b begins with six eighth notes and ends with two eighth notes.

Thus, not only does group 2 rhyme with group 1—it is a step higher—but within each group two measures rhyme with one another. Mercer acknowledges this by building internal rhyme into the lyric, as the boldfaced words in (3) illustrate:

(3) Rhyme scheme for bridge

 Lyric Melody

a. She's nobody's **fool** so I'm playing it a Group 1
 cool as can **be**.

b. I'll give it a **whirl** but I ain't for no a Group 2
 girl catching **me**.

In group 1 *fool* begins on the third beat of its measure. Its rhyming partner begins on the third beat of its measure. In group 2 *whirl* begins "on the back end" of the second beat just as *girl* does in its corresponding measure.

From this perspective, the bridge of "Satin Doll" and lines 22–23 of Poe's "The Raven" share a common pattern:

(4) a. And so faintly you came **tapping, tapping** at my chamber **door,**

 b. That I scarce was sure I **heard** you"—**here** I opened wide the **door;**—

Lines (4a) and (4b) illustrate two half lines alliterating: (4a) alliterates on /t/ and (4b) on /h/. Lines (3a) and (3b) show the same kind of repetitive pattern but with internal rhyme instead of alliteration:

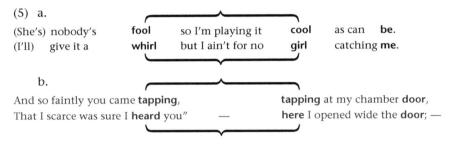

(5) a.

| (She's) nobody's | **fool** | so I'm playing it | **cool** | as can | **be.** |
| (I'll) give it a | **whirl** | but I ain't for no | **girl** | catching **me.** |

 b.

| And so faintly you came **tapping,** | | **tapping** at my chamber **door,** |
| That I scarce was sure I **heard** you" | — | **here** I opened wide the **door;** — |

Access to the original scores of jazz standards is not a straightforward matter. Over the years as different bands made recordings of "Satin Doll," variants crept in. The variants leave the melody unchanged; at least I have never found a "Satin Doll" lead sheet that changes the melody. However, rhythmic changes are more common. Even then, every lead sheet I have seen preserves the rhyming nature of the rhythm, with one exception—an exception that seems to prove the rule. Dick Hyman (1986) displays the bridge of his version of the lead sheet for "Satin Doll" as shown in figure 3.6. He presents two staves. The top stave he labels the "usual," meaning the way the melody and rhythm appear in contemporary performances of the tune. The bottom stave he labels "original." What is of interest is how the melody and rhythm of the original lead sheet differ from the "usual" variant. Measures 1 and 2 are identical rhymes, as are measures 5 and 6. However, the rhythm of measures 1 and 2 differs from the rhythm of measures 5 and 6. The pairs are close but not exact. One might say they rhyme assonantally. In particular, the initial quarter note in measures 1 and 2 is replaced by a dotted eighth and a sixteenth note in measures 5 and 6. It is a small change, but enough to break up the exact rhyming character of the relevant measures.

Satin Doll

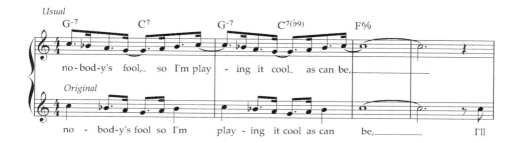

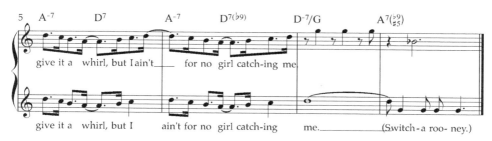

Figure 3.6

Dick Hyman's (1986) display of the two bridges for "Satin Doll," the usual and the original

But now look at the corresponding measures in the staves labeled "usual." Exact rhyme has been introduced in the variant where it did not exist in the original by changing the rhythms so they are exact copies. Apparently, over time the versions produced by a wide variety of bands drifted toward maximizing the rhythmical rhyme in the bridge. One might see this as increasing the pleasure quotient of the tune.[3]

"Satin Doll" teems with *same/except* repetition. Our inspection of the lyrical and musical rhyme schemes has, I hope, shown that the end-rhyme scheme of the Mercer lyric replicates the melodic rhyme scheme of the tune, that the rhyme scheme thus appears twice, and that this is no coincidence. Mercer knew what he was doing because he knew what Ellington was doing.

The overall form of "Satin Doll"—an eight-measure A section repeated, followed by an eight-measure bridge, followed by the A section again (i.e., AABA) replicates a vast number of Dixieland and swing standards. One of them is "Ain't She Sweet"—see the lead sheet in figure 3.7, the tune laid out like the lines of a poem in figure 3.8, and the bridge displayed as a rhyming couplet in figure 3.9. Here are the lyrics to each section along with the associated groups. As with "Satin Doll" the correspondence is one syllable per note:

(6) Rhyme scheme for A_1

		Lyric	Melody
1.	Ain't she sweet	a	Group 1
2.	See her coming down the street	a	Group 2
3.	Now I ask you very confidentially	b	**Group 3**
4.	Ain't she sweet	a	Group 4

Rhyme scheme for A_2

		Lyric	Melody
5.	Ain't she nice	a	Group 1
6.	Look her over once or twice	a	Group 2
7.	Now I ask you very confidentially	b	**Group 3**
8.	Ain't she nice	a	Group 4

Rhyme scheme for bridge

		Lyric	Melody
9.	Just cast an eye in her direction	c	*Group 5*
10.	Oh me oh my. Ain't that perfection	c	*Group 6*

Rhyme scheme for A_3

		Lyric	Melody
11.	I repeat	a	Group 7
12.	Don't you think that's kind of neat	a	Group 8
13.	And I ask you very confidentially	b	**Group 9**
14.	Ain't she sweet	a	Group 10

Ain't She Sweet

Music by Milton Ager
Words by Jack Yellen

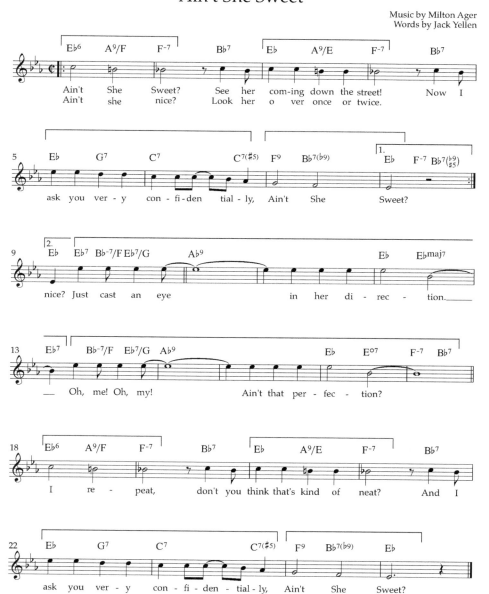

Figure 3.7
Lead sheet for "Ain't She Sweet" with brackets indicating melodic groups

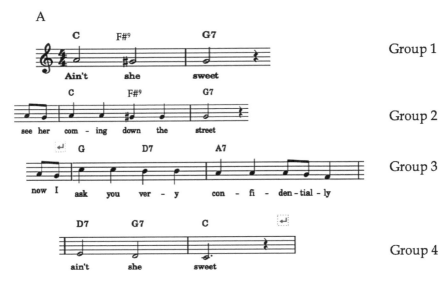

Figure 3.8
First eight measures of "Ain't She Sweet" displayed as a rhyming poem

Figure 3.9
Bridge of "Ain't She Sweet" displayed as a rhyming couplet

Now let's examine the melody. The A sections of "Satin Doll" display melodic lines that are rhythmically identical and differ only with respect to pitch. The bridge has melodic lines that differ slightly with respect to both rhythm and pitch. Melodic lines in which the pitch is constant but the rhythm changes—which don't occur in "Satin Doll"—would fill out all the possibilities. And this is what we find in comparing groups 1 and 2 in "Ain't She Sweet."

Group 1 consists of two measures of three half notes. Measure 1 starts with a half note A and drops down a half step to a half note G#. The second

Table 3.1
Same/Except pitch and rhythm changes in "Satin Doll" and "Ain't She Sweet"

	"Satin Doll" A section	"Satin Doll" B section	"Ain't She Sweet" Groups 1 & 2	"Ain't She Sweet" Group 3	"Ain't She Sweet" Group 4	"Ain't She Sweet" Bridge
Pitch	+	+	–	+	+	–
Rhythm	–	+	+	+	–	–

measure of Group 1 drops down another half step to a half note G. Group 2 matches the melody of Group 1 but changes the rhythm. Measure 3 starts with two quarter notes, each repeating the melody note A of the first measure. Then it drops down a half step to two quarter notes carrying the next melody note G# of measure 1. Measure 4 consists of a half note G followed by a rest and then a two-eighth-note pickup to Group 3. Group 3 introduces a new melody line, the first five notes of a descending C scale, C B A G F. Group 4 completes the scale with E D C, each a half note, repeating the rhythm of Group 1. I represent the possibilities of pitch and rhythm changes in table 3.1, where + indicates change and — indicates no change. As the table indicates, the bridge of "Ain't She Sweet," consisting of groups 5 and 6, shows neither a rhythm nor a pitch change.

Now let's look at the lyrics. The rhyme scheme of "Ain't She Sweet" perfectly matches the group rhyme scheme, as a glance at (6) (partially repeated here) shows:

(7) Rhyme scheme for A_1

		Lyric	Melody
1.	Ain't she sweet	a	Group 1
2.	See her walking down the street	a	Group 2
3.	Now I ask you very confidentially	b	**Group 3**
4.	Ain't she sweet	a	Group 4

Groups 1 and 2 rhyme melodically just as their associated lyrics rhyme phonologically (a a). Group 3 is melodically different and doesn't rhyme. Its lyric doesn't participate in rhyme. Group 4 rhymes rhythmically with Group 1. I take the shared property of pitch between groups 1 and 2 and

the shared property of rhythm between groups 1 and 4 to supply enough similarity to warrant treating groups 1, 2, and 4 as repetitions. That view is certainly supported by the lyrical rhyme scheme. Both are AABA. (I will have more to say about this in chapter 5.)

The tune and the lyrics of "Ain't She Sweet" are the epitome of simple repetition. For one thing, the phrase *Ain't she sweet* occurs three times. The phrase *Ain't she nice*, the same but different, occurs twice. *Now I ask you confidentially* occurs three times. In other words, out of fifteen lines eight are repetitions. When the last eight measures begin with the phrase *I repeat*, that is surely an example of sardonic self-reflection.

As I just mentioned, "Ain't She Sweet" is the epitome of simple repetition. The melody of the A section consists of a chromatic fall of three notes: A G# stated as half notes and repeated as quarter notes, and G. That's it. The next two measures, the remainder of the A section, is nothing but the C scale going down from C on the staff to C below the staff, with the last three notes repeating the rhythm of the opening measure.[4]

The bridge is even leaner. It consists of eight measures of four beats each for a total of thirty-two beats. Those thirty-two beats are divided between just two notes, the tonic C and the fourth below, the G. The notes are relegated to the beats so that twenty-three are given over to middle C, eight to its fourth below, and one to a rest. In other words, the entire tune is made up of three chromatically down-stepped notes, a C scale, and an essentially one-note bridge interrupted just twice by the fourth below.

It is hard to imagine a simpler tune. It was written in 1927 by Milton Ager with lyrics by Jack Yellen. It was covered by the Beatles in 1961, evidence of its staying power. And it remains a standard in Dixieland bands and at Dixieland jazz festivals everywhere. What makes this hundred-year-old tune so appealing? That is the same question as, Why is Mozart a better tunesmith than Haydn? I am certain the answer lies somewhere in the phenomenon of repetition and how it works in the brain. But, alas, while I may know something about the former, I am not alone in having no clue about the latter.

If "Ain't She Sweet" and "Satin Doll" are relatively simple tunes on the *same/except* spectrum, "My Funny Valentine"—a famous jazz standard by Richard Rodgers and Lorenz Hart—is a much more complicated tune. As with "Satin Doll" and "Ain't She Sweet," the form is AABA (see the lead sheet in figure 3.10).

My Funny Valentine

Figure 3.10
Lead sheet for "My Funny Valentine"

A section (16 measures, the first 8 repeated)

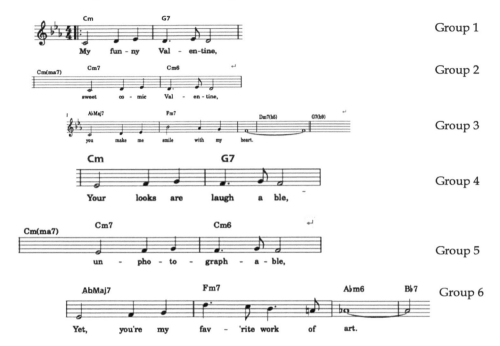

Figure 3.11
First sixteen measures of "My Funny Valentine" displayed as a rhyming poem

As before, in figure 3.11 the tune is laid out as a series of rhyming melody lines analogous to the way a poem appears on the page. Each melody line corresponds to a musical group. Figure 3.12 shows the bridge displayed as a rhyming poem, and figure 3.13 the last twelve measures (eight measures plus four-measure coda) also displayed as a rhyming poem.

The lyrical and group rhyme schemes are displayed in (8). The groups that rhyme are shown in matching fonts. In addition, the groups have been themselves grouped into "supergroups." We will see why shortly. Finally, the song is thirty-two measures long with a four-measure tag added on.

Bridge (8 measures)

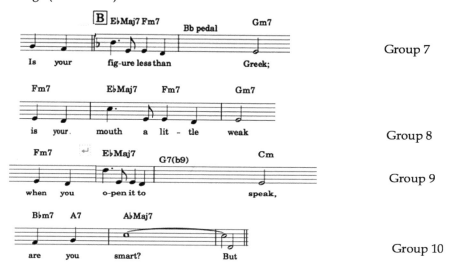

Figure 3.12
Bridge of "My Funny Valentine" displayed as a rhyming poem

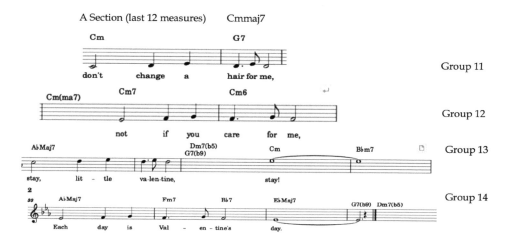

Figure 3.13
Last twelve measures of "My Funny Valentine" (eight measures plus four-measure coda) displayed as a rhyming poem

(8) Rhyme scheme for A_1

	Lyric	Melody
1. My funny valentine	a	Group 1
2. Sweet comic valentine	a	Group 2
3. You make me smile with my heart	b	**Group 3**

(Groups 1, 2, 3 braced as A)

Rhyme scheme for A_2

	Lyric	Melody
4. Your looks are laughable	c	*Group 4*
5. Unphotographable	c	*Group 5*
6. Yet you're my favorite work of art	b	**Group 6**

(Groups 4, 5, 6 braced as B)

Rhyme scheme for bridge

	Lyric	Melody
7. Is your figure less than Greek	d	*Group 7*
8. Is your mouth a little weak	d	*Group 8*
9. When you open it to speak	d	*Group 9*
10. Are you smart	b	**Group 10**

(Groups 7, 8, 9 braced as C)

Rhyme scheme for A_3

	Lyric	Melody
11. But don't change a hair for me	e	*Group 11*
12. Not if you care for me	e	*Group 12*
13. Stay little valentine stay	f	GROUP 13
14. Each day is Valentine's day	f	GROUP 14

(Groups 11, 12 braced as D; Groups 13, 14 braced as E)

The song begins with a lyric couplet ending in an identical rhyme: *Valentine:Valentine*. The corresponding groups 1 and 2 are also identical. The rhyme schemes of the lyric and of the associated groups are alike; identity repetition, no differences.

 Group 3 introduces a variation on the initial melody. Its first measure matches the first measures of groups 1 and 2, but then it diverges, jumping up to a B♭ and descending diatonically to F for two measures to end the A

section. This variation appears two more times. It has a special motivation to which I will return.

The second A section begins with a more typical end-rhyming couplet, a clever if unflattering one: *laughable:unphotographable*.[5] This section echoes the first A section: groups 4, 5, and 6 are identical to groups 1, 2, and 3, only a major (or minor) third higher. In terms of the higher grouping indicated in (8), we can say that supergroups A and B rhyme.

Stepping back a bit, we see that "My Funny Valentine" exhibits an unusual symmetry. In "Satin Doll" and "Ain't She Sweet," the second A is an automatic repeat of the first A. No divergence. In "My Funny Valentine," using a repeat sign at the end of eight measures won't work. The second eight measures are indeed the same as the first eight measures, but they are repeated a minor third above them. In other words, not only do we have *same/except* repetition within the first eight measures—we can describe the first and second eight-measure sequences as the *same/except* as well. The two sections musically rhyme.

There is, however, another process at work. In the first eight measures, notice that the melody line in measures 1 and 2 is repeated in measures 3 and 4. But measures 5 and 6 show an interesting departure. Measure 5 repeats measures 1 and 3. But measure 6 is not identical to measures 2 and 4. If measure 6 were to repeat 2 and 4, we would have three occurrences of the same melodic line, one right after the other: measures 1 and 2, measures 3 and 4, measures 5 and 6. We will see in chapter 5 that this would violate Music's Rule of Three.

Precisely the same pattern occurs in the next eight measures, only a minor third higher. Thus, measures 11 and 12 repeat measures 9 and 10, but measure 13 only repeats measures 9 and 11 before it rises up just as measure 6 did to avoid a perfect repetition of the preceding four measures. The purpose of this shift is also to avoid violating Music's Rule of Three.

The *same/except* relation governs the bridge as well. The first three groups, 7–9, are rhythmically identical. They are also identical with respect to pitch, with one exception. The first note of the first full measure of each group ascends the E♭ scale. Starting in group 7 on B♭, the fifth note of the $E\flat_{maj}$ scale, this first note moves to C in group 8 and then to D in group 9.

Group 10 consists of two pickup notes and one long note. Like its counterparts in groups 3 and 6, the long note brings its supergroup to a close. The long notes are connected by the lyrical rhyme scheme—*heart:art:smart*.

The A₃ section, the final eight measures, shows a group rhyme scheme all its own. As (8) shows, I have divided the last four groups into two supergroups, D and E. The reason is this. To my way of thinking, the A₃ section is a tour de force of recapitulation and, hence, repetition. Its first two measures (group 11) repeat the first four measures of the song, groups 1 and 2. The next two measures (group 12) repeat the first four measures of the A₂ section, groups 3 and 4. The next group, group 13, is four measures long. The first two measures repeat the first two measures of group 11, which themselves repeat the first two measures of group 1—only they do so *an octave higher*! In so doing, they set up the next two measures, which are unique to the entire song. They are made up of the highest note in the song. The final two measures of group 13 are the song's Mount Everest. They are what the entire melodic structure has been leading up to, a single high E♭ held for eight beats and sung to the word *Stay*.

Group 14 brings the song to its quiet conclusion, a repetition of Mount Everest an octave lower, the foothills as it were. This is accomplished with a four-measure tag. It begins by repeating the first two measures of group 12. This is the melodically right move to make since it begins on a pitch that is identical to that of the preceding two measures, the high point of the song, but an octave lower. It ends by repeating the last two measures of group 13, only an octave lower. Thus, the song ends on the high E♭ of measure 32. But it can't end on that high point. It needs to relax that tension. It accomplishes this by beginning group 14 with that high E♭ an octave lower, repeating group 12 and then ending on the E♭ again, only an octave lower. (Group 14 begins and ends with the same note, the high point of the song only an octave lower.) The effect of the relaxation of the tag is enhanced by the harmony. The song is in the key of Cm, the relative minor of E♭. It is in that key when it reaches the high E♭, the third of the Cm scale. But then it modulates to the relative major, E♭. So the same note has a double function. At the high point of the song it functions as the third of Cm, the song's original key signature, while at the very end it functions as the root of Cm's relative major, E♭, only an octave lower.

Underlying the entire design is an upward movement toward that climaxing high E♭. Starting with the original A₁ section, moving a third higher in A₂, and then ascending the E♭ scale in the bridge, the melody gradually moves higher and higher until it reaches its E♭ peak.

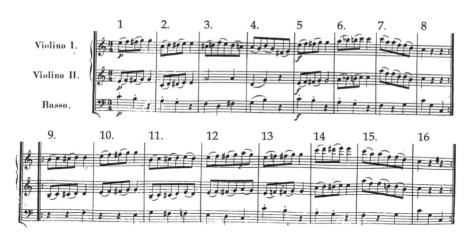

Figure 3.14
Thirty-two-measure excerpt from Mozart's *Six German Dances No. 1* (Mozart, part of K. 600, 1791)

This kind of tactic is not new by any means. Consider the excerpt in figure 3.14 from Mozart's *Six German Dances No. 1* (part of K. 600, 1791).[6] The first motif occurs in the very first measure. It is immediately repeated rhythmically but starting a third lower. Two cadential measures follow. In measure 5 the motif occurs for the second time and is again immediately repeated rhythmically, this time reversing the direction of the pitch change and again followed by two cadential measures. The motif next appears in measure 10, set up by the preceding measure. Measures 11 and 12 replicate measures 9 and 10 with a change in rhythm: the quarter notes that end measures 9 and 10 are replaced with eighth-note couplets, a *same/except* shift. Measure 13, the fourth repetition of the motif, is immediately followed by the motif repeated an octave higher.

In summary, the trajectory of this piece has *same/except* repetitions from measure 5 on, gradually shifting the motif higher until it reaches a peak in measure 14, the highest note in this segment of the dance. The strategy is identical to that in "My Funny Valentine": a series of *same/except* repetitions moving higher and higher until a peak is reached, followed by a descending tension-releasing resolution.

Before we leave "My Funny Valentine," there is one more device worth examining. The word *Valentine* is three syllables long, with stress on the

first syllable. This trisyllabic property of *Valentine* is repeated in every measure in the first AA structure. Each measure contains three notes paired with three syllables stretched out to accommodate the 4/4 time signature. Only measure 14 departs from that pattern: *fav'rite work of art.*

Each measure begins with a long note, either a half note as in measure 1 or a dotted quarter note as in measure 2. This device echoes the stress pattern of *Valentine*: because the first syllable is stressed, it is the most prominent syllable, just as the first note of each measure is the most prominent note.

In fact, the melodic counterpart of the name's syllable count dominates the song. Of its thirty-six measures in a four-beats-to-the-measure song, twenty-three measures (63%) echo *Valentine*. You can gauge the achievement of an artist the same way you can gauge the achievement of a juggler. The greater the number of balls in the air, the greater the juggler.

"My Funny Valentine" has created a marriage of melody and lyric that matches the repetitive complexity of a fine Persian rug. I will have more to say about that later when I discuss Immanuel Kant's notion of music as "wallpaper." There is no denying the popularity and the complexity of the tune. Its Wikipedia entry reflects its excellence:

> The song became a popular jazz standard, appearing on over 1300 albums performed by over 600 artists. One of them was Chet Baker, for whom it became his signature song. In 2015 the Gerry Mulligan quartet's 1953 version of the song (featuring Chet Baker) was inducted into the Library of Congress's National Recording Registry for its "cultural, artistic and/or historical significance to American society and the nation's audio legacy."

I suspect that ranking "Ain't She Sweet," "Satin Doll," and "My Funny Valentine" in that order would match most listeners' ranking of the tunes from simple to complex. More generally, to the extent that listeners have intuitions about the complexity of songs, I suspect that that ranking corresponds to the number of ways in which a melody and its lyric avails itself of *same/except* mechanisms.

Since I am claiming that repetition is a source of pleasure and that priming is its engine, I need to establish the abstract representation that takes part in priming with respect to music. I have already done so, I hope, with respect to end rhyme and alliteration. I will wait a bit before doing the same for music. First, I want to examine the role of repetition in tricolons and fairy tales.

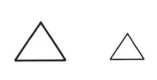

4 *Same/Except* and the Ubiquitous Rule of Three

Hidden in the structure of tunes like "Satin Doll," "My Funny Valentine," and "Ain't She Sweet" is an interesting constraint. It involves the number three. In this chapter I discuss the number three as it pertains to tricolons, jokes, cartoons, and fairy tales. In the next chapter I will look at this phenomenon in music. We will see that it is not quite the same in the two arts. Yet in both cases we are looking at conventions that guarantee repetition and hence pleasure.

There is something alluring about the number three. You find it everywhere. The use of threes is so ubiquitous, in fact, that it has come to be codified as the *Rule of Three*. Here is its definition in Wikipedia:

> The rule of three is a writing principle which suggests that a trio of entities such as events or characters is more humorous, satisfying, or effective than other numbers. The audience of this form of text is also thereby more likely to remember the information conveyed because having three entities combines both brevity and rhythm with having the smallest amount of information to create a pattern.

Note how threes overrun the *Zippy* cartoon in figure 4.1 (from the *Boston Globe*, July 17, 2022). The first panel establishes the context, three diners in a row in Rockford, Michigan. (The locale is real.) Zippy asks a question. The second panel focuses on a single diner, the famous Rosie's that closed in 2011. This time the theme of three is picked up twice. First, Zippy asks himself, "Who's inside?" and answers with three guesses, each of which refers to a triplet. In the final panel, three different people answer Zippy's question: Moe, Larry, and Curly. Although it isn't explicit, I think the reader is meant to suppose that the real Three Stooges are on the action end of the cartoon bubbles. If you look closely, you will see that *Rosie's Diner* is repeated in each panel. The entire cartoon consists of three panels. And, finally, there are three vehicles parked out front.

Figure 4.1
Zippy the Pinhead, July 17, 2022. © 2022 Bill Griffith. Distributed by King Features Syndicate, Inc.

Threes show up in every art form. Think of *The Mikado*'s "Three Little Maids from School Are We," or "The Three Little Pigs." This is what Bruno Bettelheim (1976, 219) says about threes:

> Three is a mystical and often a holy number, and was so long before the Christian doctrine of the Holy Trinity. It is the threesome of snake, Eve, and Adam which, according to the Bible, makes for carnal knowledge. In the unconscious, the number three stands for sex, because each sex has three visible sex characteristics: penis and the two testes in the male; vagina and the two breasts in the female.
>
> The number three stands in the unconscious for sex also in a quite different way, as it symbolizes the oedipal situation with its deep involvement of three persons with one another.

Well, maybe that's pushing it a bit. But our predilection for the number three is hard to deny. Three is a familiar figure of speech, the so-called *tricolon*. Bettelheim alludes to one example, *Father, Son, and Holy Ghost*, to which we might add these:

(1) Ready, aim, fire

On your mark, get set, go

Red, yellow, green (traffic lights)

Life, liberty, and the pursuit of happiness

Freedom, equality, fraternity

Of the people, by the people, for the people

Friends, Romans, countrymen

Blood, sweat, and tears

Red, white, and blue

Faith, hope, and charity

Mind, body, spirit

Stop, look, and listen

Lock, stock, and barrel

Hook, line, and sinker

The good, the bad, and the ugly

The good, the bad, and the beautiful

Tall, dark, and handsome

The long, the short, and the tall

Bacon, lettuce, and tomato (BLT)

Sex, Lies, and Videotape

Veni, vidi, vici

Manny, Moe, and Jack (the Pep Boys)

Larry, Curly, and Moe (the Three Stooges)

Hop, skip, and jump

Shake, rattle, and roll

Cry God for Harry, England, and St. George.

Peace, order, and good government (Canadian constitution)

Oyez, oyez, oyez (opening of Supreme Court and other court sessions)

Location, location, location

Tomorrow, and tomorrow, and tomorrow

And then there are the "three" jokes. Three men or clergymen or some combination of (clergy) man and beast walk into a bar. Here is an example. A priest, a minister, and a rabbit walk into a bar. The rabbit says, "I must be a typo." This is a joke at face value. But it can also acquire another layer of meaning—namely, as a self-referential joke—if the listener is aware of the more familiar setup: "A priest, a minister, and a rabbi walk into a bar." Then it becomes a joke about a joke. Thus, the same trio walks into a blood bank and the rabbit says, "I must be a Typo-O." Adding pun to punchline, it is a joke about a joke about a joke. Shades of Oulipo.

Often, the format is reversed. For example:

(2) A duck walks into a bar.

 "Got any grapes?" asks the duck.

 "This is a bar. Not a fruit store," says the irritated bartender.

 The duck leaves only to return a few minutes later.

 "Got any grapes?" asks the duck.

 "I said this is a bar. Not a fruit store," snaps the now angry bartender.

 "Come in here again and I'll nail your web feet to the floor."

 The duck leaves only to come back again.

 "Got any nails?" asks the duck.

 "No!" yells the infuriated bartender.

 "Got any grapes?"

Only one individual, a duck, walks into the bar, but the duck does it three times. Narrative theorists will doubtless have an account for why this joke works. But the fact that the duck returns three times must be part of it. I would conjecture that the first repetition is an identity repetition; that is, the repeated question is the *same: Got any grapes?* The second repetition, unlike the first, fulfills the *same/except* relationship. *Got any* is the same; *nails* and *grapes* are the *except* part. So structurally the joke moves from a *same* repetition, *Got any grapes?* to a *same/except* repetition. It is narrative rhyme on a small scale.

The number three plays an important role in fairy tales as well: "The Three Little Pigs," "The Three Billy Goats Gruff," "The Tinderbox," "The Emperor's New Clothes," "Rumpelstiltskin," and, of course, "Goldilocks and the Three Bears," to name a few.[1] All of these stories have some version of the three motif.[2]

So, what is the significance of all this with respect to the thesis that repetition in the arts is of the *same/except* variety? Beginning with the tricolon, the repetitions in (2) are consistent with the thesis. These examples repeat parts of speech or phrases; for example, nouns as in *blood, sweat, and tears* or *friends, Romans, countrymen*; adjectives as in *red, yellow, green*; verbs as in *ready, aim, fire*; and prepositional phrases as in *of the people, by the people, for the people*. Each one is the *same* in terms of syntactic category. The *except* part is the meaning. *Bacon, listen, and blue* is not a well-formed tricolon, although it is a perfectly well-formed constituent in the sentence (3):

(3) *Bacon, listen,* and *blue* are words you will find in English tricolons.

**Bacon, listen, and blue* fails the *same/except* criterion because while the nouns are different semantically, they are not the same in any readily perceived category other than the most general one of being English words.[3]

At the other end of the spectrum, what is one to say about a tricolon in which each word is identical syntactically and semantically, such as *Oyez, oyez, oyez?* Well, one could say that it is not a tricolon. Although it has three elements, it functions as a command, like a drill sergeant crying, "Attention!" It has only one highly dedicated use, to call a court session to order. Indeed, sometimes a sergeant at arms will lop off one *oyez.*[4] *Oyez, oyez* is sufficient. You can't lop off one of the terms in a bona fide tricolon.

But there are at least two tricolons that need explanation:

(4) Location, location, location

 Tomorrow, and tomorrow, and tomorrow

Location, location, location repeats the same word three times. It is not a *same/except* exemplar. Its metafunction via repetition is to underscore the importance of location. Repetition here functions as an intensifier. But first and foremost, the phrase is a joke, its humor deriving from its resemblance to a tricolon. The listener anticipates a difference among all that sameness. When it doesn't materialize, the listener is forced to look for something else. That twist is both amusing and instructive.

On the other hand, Shakespeare's *Tomorrow, and tomorrow, and tomorrow,* from act 5, scene 5 of *Macbeth,* is not amusing. Macbeth, on learning that Lady Macbeth is dead, delivers this speech:[5]

(5) Tomorrow, and tomorrow, and tomorrow,

 Creeps in this petty pace from day to day,

 To the last syllable of recorded time;

 And all our yesterdays have lighted fools

 The way to dusty death. Out, out, brief candle!

 Life's but a walking shadow, a poor player,

 That struts and frets his hour upon the stage,

 And then is heard no more. It is a tale

 Told by an idiot, full of sound and fury,

 Signifying nothing.

The repetition of *tomorrow* needs to be read very slowly, as does Patrick Stewart in his portrayal of Macbeth. But that, I think, is Shakespeare's point. The repetition creates "this petty pace" of which the next line speaks; that is, the first line exemplifies the second. Under this reading *this* of *this petty pace* refers precisely to the monotonic tinge induced by the repetition of the word *tomorrow*. Again, this phrase departs from the usual tricolon pattern for a specific reason.

In his presidential address to the Linguistic Society of America, Laurence Horn (2022, 837) offers a fascinating account of a special subset of the tricolon called the *tricolon crescens*:[6]

> While a tricolon is any series of three items, the tricolon crescens, or ascending tricolon, is a classical figure of speech comprising three parts that 'rise and grow in force' à la Quintilian, increasing from first to last in size, magnitude, or intensity. . . . In some cases, the third member of a series of three adds a mirative flavor: it represents material that is surprising or unexpected given the first two, or material harder to accommodate to the common ground. The contrast may be explicit or implicit, with the third item set off against the first two for rhetorical, comic, or mirative effect. A memorable instance is Dorothy Parker's aphorism, 'I require only three things in a man: he must be handsome, ruthless and stupid'. . . . Caesar's asyndetic report—*Veni, vidi, vici*—constitutes a *tricolon crescens,* since it presents the three events not only in the temporal order befitting narration, as observed by Jakobson (1965) . . . but also as a sequence in which the general's final accomplishment marks the essential, definitional event.

The point of the *tricolon crescens*, then, is that there is a crescendo of examples that "grow and rise in force" along some dimension. Horn (2022, 837) offers the following short list, to which I have added the number of syllables or phonological segments in each part, which I discuss below:

(6) Life, liberty, and the pursuit of happiness (1, 3, 7 syllables)

Sex, drugs, and rock 'n' roll (4, 5, 7 phonological segments)

Lies, damned lies, and statistics (1, 2, 3 syllables)

Jam yesterday, jam tomorrow, but never jam today (4, 4, 5 syllables)

It's a bird—it's a plane—it's Superman! (3, 3, 4 syllables)

It isn't clear to me what the rising and growing force might be in some of these examples, as opposed to *Veni, vidi, vici* where conquering does seem more powerful than the preceding pair of touristy actions, coming and seeing. I suppose one might plausibly say that *Lies, damned lies, and statistics* works because of the imputation that *statistics* is the worst kind of lie, a

kind of mirative force. *Sex, drugs, and rock 'n' roll* doesn't work for me as a *tricolon crescens*, though I could live with the reverse order*: rock 'n' roll, drugs, and sex*. But there is something off about *rock 'n' roll, drugs, and sex*. It just doesn't work. I think it is a formal thing like meter. Notice that each tricolon in (7) increases in terms of a phonological property: the number of syllables or, in the case of *sex, drugs, and rock 'n' roll*, phonological segments (four segments in *sex,* five in *drugs,* and seven in *rock 'n' roll*). The important thing is that the final item be the longest along some dimension.[7] That *sex, drugs, and rock 'n' roll* is readily scannable as an iambic trimeter line doesn't hurt to settle on this order. For that matter, it is notable that ordinary tricolons like those in (2) never end in a word whose syllable count is less than that of its preceding partners. The final word either matches the syllable count of its predecessors (*red, white, and blue*) or is longer (*friends, Romans, countrymen*).

What about jokes? I won't do an extensive analysis of jokes here. But having already analyzed the duck joke in (3), I think it is worth noting that while the duck's dialogue runs along a *same/except* spectrum (see (8) in chapter 5), the bartender's reaction is a *tricolon crescens*. Each duck visit raises the needle on the bartender's anger meter. The first visit reaches "irritated"; the second, "angry"; the third, "infuriated." The tension and release of the joke's narrative takes place in that third and last element.[8] It is particularly potent because two separate dimensions culminate in the final *Got any grapes?*[9]

The potency of the final element in a tricolon crescens is transparent in fairy tales, as we have seen. We can find them in literature as well. There are three caskets in *The Merchant of Venice.* Mentioned by Horn (2022) in connection with classic tricolons, these three can be seen to exemplify tricolon crescens along the dimension of true worth as opposed to apparent worth. And, of course, there are the three ghosts in Dickens's *A Christmas Carol,* again a crescens example—in my view, contrasting the direst of futures in the third vision, Christmas Yet to Come, with the greatest joy should Scrooge mend his ways, a twofer if ever there was one.

What I would like to suggest is that these examples are part of a larger pleasure-producing trajectory designed to create tension and release. I am thinking of "My Funny Valentine" and Mozart's *Six German Dances No. 1.* In both, the trajectory of the melody is, mutatis mutandis, the same trajectory as in a *tricolon crescens,* jokes, and stories. It exhibits a growing force,

higher and higher melodically, culminating in a peak followed by a sudden release. In "My Funny Valentine" the peak is the high E♭ in measures 31–32 followed by its immediate release in measure 33 to an E♭ an octave below, itself a foreshadowing of the low E♭ that is the sole occupant of measures 35–36.

In the case of music and literature the tension and release trajectory takes place in time. These are temporal art forms. You won't find that trajectory in art forms that demand global perception, like painting, sculpture, or architecture. It might occur in ballet or modern dance, which unfold in time. In landscape architecture, the temporal element is relevant because the garden unfolds in time as the viewer strolls through it. For example, when visiting the Peterhof Palace in St. Petersburg, a walk from the point where the garden opens onto the Gulf of Finland up to the palace's gold-statue-bedecked terrace can easily be seen as a trajectory rising and growing in force as the walk ends on a hill atop which rests the palace itself.[10]

In the epigraph to this book I quoted Italo Calvino's insightful comment about repetitions that ends *Just as rhymes help mark the rhythm of poems and songs, events can rhyme in prose narratives.* Perhaps the most famous example of Calvino's comment, one where the *same/except* relationship shines, is "Goldilocks and the Three Bears." It is also one of the most beloved of fairy tales, much to the chagrin of Bruno Bettelheim, whose view of fairy tales qua developmental aids for children came a cropper in "Goldilocks." A child would find no help in hacking her way into maturity here, although apparently, given the tale's popularity, she would find a great deal of pleasure. Nor does it instantiate a *tricolon crescens* since it doesn't "grow and rise in force." Bettelheim was right. "Goldilocks" is different.

In 1837 Robert Southey (1774–1843), one of the British Lake District poets, wrote a fairy tale entitled "The Story of the Three Bears," a precursor to "Goldilocks and the Three Bears" (Southey 1848).[11] Like so many fairy tales, it has a long oral prehistory. Southey is credited with being the first to write it down. In his version, the protagonist is not a pretty little girl with golden locks but an old woman, and not a very nice one at that. Here is a taste (pun intended) from Southey's tale:[12]

> So first she tasted the porridge of the Great, Huge Bear, and that was too hot for her; and she said a bad word about that. And then she tasted the porridge of the Middle Bear, and that was too cold for her; and she said a bad word about that, too. And then she went to the porridge of the Little, Small, Wee Bear, and tasted

that, and that was neither too hot, nor too cold, but just right; and she liked it so well that she ate it all up; but the naughty old woman said a bad word about the little porridge-pot, because it did not hold enough for her.

Over the years the tale was modified in ways designed to make it more palatable (pun still intended). With Southey's approval, Joseph Cundall (1850) transformed the old woman into a pretty little girl called Silver-hair. The trio of bears remained bachelors. According to Tatar (2002), the three bears became a family around 1852 and Silver-hair became Goldilocks in Flora Annie Steel's *English Fairy Tales* (1918). But for quite a long time beneath all those golden locks, Goldilocks retained the character of a nasty old woman.

The story turns out to be grist for a great many mills. Christopher Booker (2004) sees it in terms of his theory that there are only seven basic plots in all of storyland. For him, "Goldilocks" is an example of plot type 1, Overcoming the Monster, as in *Beowulf, Jaws*, or "Jack and the Beanstalk."

This latter categorization surely cannot be right. If there is a monster in "Goldilocks," it is Goldilocks herself and not the three bears. After all, in Southey's and Cundall's versions and others, Goldilocks is described as not being well brought up. She is an intruder, an uninvited guest. She is careless. She leaves the spoons in the bowl. She dislodges the pillow and the bolster and doesn't put them back. She isn't sorry that Baby Bear's chair bottom broke through. She's angry. She's put out—"ill-tempered." She's also described as "impudent," "rude," "naughty," and "truant." In other words, she's a thoroughly "bad girl."

What a contrast to the trio of bears, who are harmless and hospitable. They live in a snug little cottage in the middle of a forest, comfortably, good-naturedly, innocently. There is no hint that they are monsters. The worst Southey can muster is, "[F]or they were good Bears—a little rough or so, as the manner of Bears is." Goldilocks, on the other hand, is an out-and-out villain. Not to put too fine a point on it, she is a burglar. She breaks into a home; she steals food; she destroys property. In "Goldilocks," typical roles are reversed. A little girl with golden hair is normally expected to be made of sugar and spice and everything nice. Bears, on the other hand, belong in the class of wild animals up to no good. The wolves in "Little Red Riding Hood" and "The Three Little Pigs" are true to character. Not so the bears in Southey's and Cundall's Goldilocks tales.

Here is Booker's Goldilocks (2004, 89):

Similarly, little Goldilocks ventures out from home into the forbidden world of the great forest, where she eventually comes to the mysterious house belonging to the three bears. Again the initial excitement of exploring the empty house, with its steaming porridge bowls and inviting beds, gives way to a sense of growing menace as the bears return. As they begin to suspect her presence, the sense of threat comes nearer and nearer until finally they discover the little heroine asleep upstairs: at which moment Goldilocks wakes up, makes a 'thrilling escape' by jumping out of the window, and runs back to the safety of her mother and home.

This is a far cry from Southey's old woman and Cundall's little girl who jumps out the window and either breaks her neck, gets lost in the forest, or makes her way home to be spanked by her parents, leaving it to the reader's vengefulness to select one.

Booker has succumbed to reinventing "Goldilocks," along with other modern versions that have bent over backward to rewrite history. In one YouTube cartoon,[13] Goldilocks is a charming if mischievous little girl who goes into the forest against her mother's wishes. She gets lost, stumbles upon the bears' cabin, and makes herself at home. When the bears return and find her sleeping in Baby Bear's bed, they wake her up. She runs out the front door and into the forest, still lost. But her parents have come looking for her. She runs to them and after hugs all around, she promises never to disobey her mother again. That is the tale at its most anodyne.

Bruno Bettelheim is much less satisfied. He sees "Goldilocks" as a cautionary tale modified over time into an unsatisfactory fairy-tale-like story, one about a child's struggle to overcome Oedipal issues. In *The Uses of Enchantment* (1976, 224) he concludes his discussion of Goldilocks this way:

> This is the solution with which we are left in "Goldilocks." The bears seemed unmoved by her appearance in and sudden disappearance from their lives. They act as if nothing had happened but an interlude without consequences; all is solved by her jumping out of the window. As far as Goldilocks is concerned, her running away suggests that no solution of the oedipal predicaments or of sibling rivalry is necessary. Contrary to what happens in traditional fairy tales, the impression is that Goldilocks' experience in the bears' house made as little change in her life as it did in that of the bear family; we hear nothing more about it. Despite her serious exploration of where she fits in—by implication, of who she is—we are not told that it leads to any higher selfhood for Goldilocks.

I think Bettelheim is right to think of "Goldilocks" as having first been a cautionary tale. Consciously or otherwise, Cundall transmogrified the story into an English version of the German Struwwelpeter stories by Heinrich

Hoffmann (1844), published six years before Cundall's 1850 version of the Southey tale. Even the name is redolent of hair, as *Struwwelpeter* means something like "Shock-headed Peter" or "Shaggy-haired Peter." Unlike in "Goldilocks," however, there is no wishy-washy-ness in the Hoffmann tales. A naughty child behaves badly and is in no uncertain terms punished. By way of example, here is an English translation of "The Story of Little Suck-a-Thumb":[14]

(7) One day, Mamma said, "Conrad dear,
 I must go out and leave you here.
 But mind now, Conrad, what I say,
 Don't suck your thumb while I'm away.
 The great tall tailor always comes
 To little boys who suck their thumbs.
 And ere they dream what he's about
 He takes his great sharp scissors [out],
 And cuts their thumbs clean off—and then
 You know, they never grow again."

 Mamma had scarcely turn'd her back,
 The thumb was in, alack! alack!

 The door flew open, in he ran,
 The great, long, red-legged scissorman.
 Oh! children, see! the tailor's come
 And caught our little Suck-a-Thumb.

 Snip! Snap! Snip! the scissors go;
 And Conrad cries out—Oh! Oh! Oh!
 Snip! Snap! Snip! They go so fast,
 That both his thumbs are off at last.

 Mamma comes home: there Conrad stands,
 And looks quite sad, and shows his hands;
 "Ah!" said Mamma, "I knew he'd come
 To naughty little Suck-a-Thumb."

Bettelheim's unhappiness with Goldilocks and her bears borders on irrita-
tion. In a review of *The Uses of Enchantment*, John Updike (1976) captures
the dissatisfaction:

> Bettelheim discusses, in a rather grumpy tone, one fairy story which refuses to fit
> his pattern: "at its end there is neither recovery nor consolation; there is no reso-
> lution of conflict, and thus no happy ending." Yet the story's popularity, rising
> through the 19th century, forces it upon his attention.

Updike prompts an interesting question. Why should a flawed fairy tale be
so popular? Even Bettelheim (1976, 224) felt compelled to offer an explana-
tion for the anomaly:

> Even more important in this respect is the story's greatest appeal, which at the
> same time is its greatest weakness. Not only in modern times, but all through the
> ages, running away from a problem—which in the unconscious means denying
> or repressing it—seems the easiest way out when confronted with what seems to
> be too difficult or unsolvable a predicament.

Bettelheim is saying that "not only in modern times, but all through the
ages," the originators of the tale, be they the oral author(s) or Southey and
his literary descendants, were catering to the tendency to take the easy way
out. If this were true, one would expect to find similar plain vanilla endings
in other tales. But one doesn't. Certainly, in Bettelheim's own collection it
is sui generis. As Updike implies, Bettelheim is forced to pay attention to it
because it is popular despite its singularity of form.

I would like to explain the popularity of "Goldilocks and the Three Bears"
in terms of Calvino's suggestion of rhyming narratives, leaving Oedipal
predicaments on the doorstep. Going back to the experiment by Elizabeth
Margulis (2013b), recall that she introduced repetition into music where
it never was. Using compositions by the atonal masters Luciano Berio and
Elliott Carter, she copied a segment from early in a piece and pasted it in
later on, sometimes immediately after, sometimes several segments after.
Then she asked ordinary music listeners and PhDs in music theory to tell
her which version they liked best. They preferred the doctored version.
Margulis (2013b, 16) drew an inescapable conclusion:

> The simple introduction of repetition, independent of musical aims or prin-
> ciples, elevated people's enjoyment, interest, and judgments of artistry. This
> suggests that repetition is a powerful and often underacknowledged aesthetic
> operative.

And here, I think, lies the secret of the tale's success. Booker (2004, 229) observes, "Few childhood tales are built more conspicuously round the number three than Goldilocks and the Three Bears." Although Booker focuses on the central porridge/chair/bed trio, "Goldilocks" is chock-full of repetitions of three. As Bettelheim (1976) notes, outside the cottage Goldilocks looks in at the window, peeps in through the keyhole, and lifts the latch. This threesome is echoed in the original Southey version by the choice of three possible endings: "Out the little old Woman jumped; and whether she broke her neck in the fall; or ran into the wood and was lost there; or found her way out of the wood, and was taken up by the constable and sent to the House of Correction for a vagrant as she was, I cannot tell."[15] And then, of course, there are the three bears themselves.

Once inside the cottage, Goldilocks embarks upon three separate forays, the first with porridge, the second with chairs, the third with beds. This is a *same/except* relationship, one central to the Goldilocks tale and, I suspect, uniquely so. Thus, each of the porridge/chair/bed encounters is the same as its predecessor except for a difference. How are they the same? They are all tests beginning with two failures and ending with one success. Moreover, the tests all proceed in the same way. The first two define extremes. The last defines the golden mean between the extremes.

That's the *same* part. How are they different? The bed episode is just like the porridge and chair episodes, except we're talking about beds. The chair episode is just like the porridge episode except we're talking about chairs, not bowls of porridge or beds. In other words, they are the same except that the objects and hence the qualities they entail (temperature, comfort, size) are different.

But crucially, the *same/except* relationship goes further than that. Within each episode there are three objects; three bowls, three chairs, and three beds. Each object shares a special relationship with its siblings. The big bear's bowl is the same as the other bowls except it is bigger. The middle bear's bowl is the same as the others except it is bigger than one and smaller than the other. The little bear's bowl is the same as the others except it is smaller than both. Thus, the *same/except* relationship is true not only of the episodes but also of the things they are about. It is recursive, a form of repetition.[16]

That is why Goldilocks is such a poor story and yet such a popular one. Like Dr. Seuss's, its rhymes are clever. In fact, it is almost as if Italo Calvino

(2002, 41) had "Goldilocks and the Three Bears" in mind when he wrote the passage I've used as the epigraph to this volume, which I repeat here because it is so apt:

> The craft of oral storytelling in the popular tradition is shaped by functional concerns; it omits pointless details and insists on repetition, as when, for example, a fable consists of obstacles that must be overcome. Part of a child's pleasure in listening to stories is in the anticipation of certain kinds of repetition: situations, expressions, stock phrases. Just as rhymes help mark the rhythm of poems and songs, events can rhyme in prose narratives.

I might summarize the discussion so far this way:

(8) a. Repetition fosters aesthetic pleasure, especially when its elements are of the *same/except* variety, like end rhyme in poetry and melody in music.

 b. "Goldilocks and the Three Bears" is made up of a hitherto unrecognized form of *same/except* rhyme, where the rhymes are made not from the sounds of words but from the properties of objects as well as the structure of events. So we find *same/except*-derived pleasure in narrative as well.

In chapter 14 I will investigate why *same/except* is so prominent in the genres we have visited.

5 Music's Rule of Three

We have seen that the Rule of Three appears to be ubiquitous in the realms of the tricolon, cartoons, jokes, and fairy tales. Therefore, it is not surprising to find it in the realm of music where, according to some (e.g., Leonard Bernstein; see chapter 1), repetition, like ripeness, is all. What is surprising is that while there are no restrictions on its instantiations in the world of words, the musical version of the Rule of Three has a built-in constraint.

Recently Everett Longstreth—a friend, a professional musician, and author of a book on arrangement writing for "big bands" (Longstreth 1985)—told me about his use of the Rule of Three in music. He said, "If you have a good idea, you can repeat it once. If you repeat it again, make sure you vary it or else interest morphs into monotony." We can formalize his guideline like this:

(1) *Music's Rule of Three*

Any musical idea can be repeated once. To repeat it twice, insert a different musical idea before the second repetition.

Thus, if you have a musical idea, A, and you repeat it, AA, you can repeat it again, providing you insert a different idea first—for example, AABA. AAA is forbidden.

Is there a visual counterpart? In discussing Andy Warhol's *Marilyn Monroe* (Diptych 1962), a 5×5 silkscreen grid of Monroe's face repeated twenty-five times, E. H. Gombrich (1979, 151–152) comments on the homogenizing effect of too much repetition:

> Put a portrait of Marilyn Monroe in a series and what should have been an individual becomes a mere stereotype or counter. Individual after all means indivisible, but the repeat invites us to disregard this very characteristic. Instead of making us concentrate on the unique image by scrutinizing the features of the

portrait, it tempts us to single out any element, be it the eye, the mouth, or a mere shadow, which fuses into a new pattern. . . . A row of repeated eyes are no longer anybody's particular eyes.

And a few lines later:

Order and meaning appear to exert contrary pulls and their interaction constitutes the warp and woof of the decorative arts. For the designer no less than the beholder must experience the degree to which repetition devalues the motif while isolation enhances its potential meaning.

Gombrich is talking about the visual arts, but the same applies in music as well. In fact, we have already seen (1) in action. Recall the discussion of "Satin Doll," "Ain't She Sweet," and "My Funny Valentine" in chapter 3. In all three tunes we saw that the form is AABA. The first eight measures, A, are repeated once: AA. Why not AAA? Music's Rule of Three (1) provides an answer. Something must intervene before you can hear A again. That something is the bridge of the tune. It consists of eight measures, like the A section, but the melodic line is different. After the bridge has had its say, the way is clear to repeat A—hence, AABA.[1] The intervention of B avoids the degradation of A à la Warhol's Marilyn Monroe.

As two examples, consider the lead sheet for "Satin Doll" and the musical score for Mozart's *Rondo alla Turca* (figures 5.1 and 5.2, respectively, with the A and B sections alongside). As you can see in figure 5.2, an initial eight-measure A section is repeated (AA). The eight measures are returned to but not before a new seven measures with two eighth-note pickups (the B section) intervene. The overall pattern is [A A] [B A B A]. The same is true of "Satin Doll." The A section and its repeat cannot be reintroduced until a different melodic group intervenes. These musical examples obey Music's Rule of Three. New material intervenes before the melody returns to the material of the first repetition.

The AABA pattern of jazz standards is quite common. A breakdown of the tunes in an *iRealPro* corpus examined by Daniel Shanahan and Yuri Broze (2019) revealed these forms: AABA, AB, ABAC, AABA, AA, ABCD, ABA, ABC, AABC, ABAC. Indeed, 424 out of the 1,021 tunes, or 41.15%, display the AABA form[2]—and absolutely none the form AAA.

There is something else worth noting. If there is a repeated segment in the overall form, it will always involve A. This is tantamount to saying that repetition comes early. This might be construed as a matter of convention,

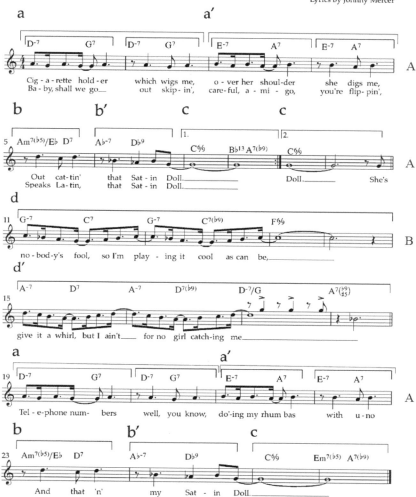

Figure 5.1

"Satin Doll" lead sheet with groups indicated by brackets above the staff

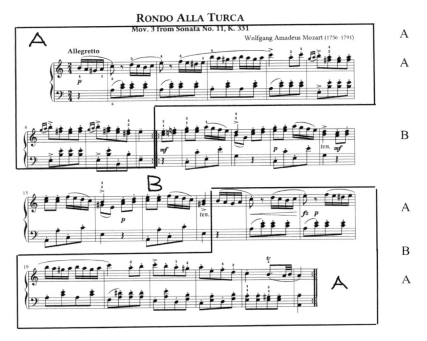

Figure 5.2
Rondo alla Turca score showing AABA(BA) form

but it turns out there is reason to think otherwise. Thus, Joy Ollen and David Huron (2004) conducted an experiment which suggested that listeners prefer early repetition to late repetition in a musical composition.[3] As they state in the abstract to their paper:

The purpose of this study was to determine listeners' preferences for patterns of successive repetition in musical form. Twenty-nine musically sophisticated and naïve participants performed a two-alternative forced-choice task in which they selected the "most musical" composition from pairs of stimuli that differed only with respect to form-related repetition.

Compositions were comprised of two or three randomly-selected discrete musical passages specifically composed for the experiment. For each of the 44 trials, compositions of the same length and using the same musical passages were paired together. Paired compositions differed only in that one exhibited patterns of successive repetition that decreased over the course of the work and the other exhibited patterns that increased. Results from a preliminary analysis indicate that listeners prefer "early repetition" forms over "late repetition" forms. These

results are consistent with Huron and Ollen (2004) who found evidence of early repetition in a cross-cultural sample of 50 musical works.

Ollen and Huron write (p. 405):

> Huron and Ollen tested two hypotheses and found significant results for both. Of special interest to the present study was their finding that longer sequences of repetition are more likely to occur in the first half of a work than in the second half. Using their analysis protocol, a musical work is more likely to exhibit a structure like A-A-A-B-B-A-C-B-A than A-B-C-B-B-B-A-A-A. Huron and Ollen dubbed this phenomenon "early repetition."

They continue with this conjecture (p. 405):

> If musical works from many cultures and time periods exhibit this early repetition, it is possible that, on some level, listeners may expect musical works to be structured in this way.

In their experiment they presented participants with artificially composed structures containing sequences like AAA and BBB. However, as we have seen, in a real environment (the *iReal Pro* corpus) such sequences never occur. Music's Rule of Three accounts for this distribution. Moreover, Margulis's experiment that associates pleasure with repetition accounts for early repetition. It's kind of a "spoonful of sugar helps the medicine go down" principle. If you're aiming to give pleasure, start with repetition.

We now have two rules, the literary Rule of Three and Music's Rule of Three. This raises an interesting question: Are there any crossover genres? The answer seems to be yes.

According to Merriam-Webster, the limerick is "a light or humorous verse form of five chiefly anapestic verses of which lines 1, 2, and 5 are of three feet and lines 3 and 4 are of two feet with a rhyme scheme of *aabba*." Here is an example, shown in the usual five-line format:

(2) There once was an old man from Esser	a
Whose knowledge grew lesser and lesser.	a
It at last grew so small,	b
He knew nothing at all	b
And now he's a college professor.[4]	a

However, lines 3 and 4 can just as easily be collapsed into a single line with internal rhyme (like the first line of "The Raven": *Once upon a midnight dreary while I pondered weak and weary*). For our purposes, let's do that:

(3) There once was an old man from Esser a

 Whose knowledge grew lesser and lesser. a

 It at last grew so small, he knew nothing at all b

 And now he's a college professor. a

In this form it is obvious from the rhyme scheme that limericks obey
Music's Rule of Three.

A version that flaunts it loses some of its punch:

(4) There once was an old man from Esser a

 Whose knowledge grew lesser and lesser. a

 He had to confess, sir—you never would guess, sir— a

 That he worked as a college professor. a

In fact, the parallel between the limerick's rhyme scheme and "Satin Doll"
is even more striking since line 3 of the compressed limerick form contains
an internal rhyme composed of two identical half lines just as the bridge
of "Satin Doll" consists of two four-measure groups that match in a type of
musical internal rhyme (see figure 5.3). This kind of bridge is by no means
rare in jazz standards.

Figure 5.3
Bridge of "Satin Doll" with arrows showing melodic internal rhyme

It is probably not an accident that limericks conform to Music's Rule of Three rather than to literature's Rule of Three. The origin of the form is unknown. One suggestion is that it derives from an eighteenth-century song called "Will You Come Up to Limerick?" Here is part of the etymological citation from the *Oxford English Dictionary*:

> 1879 *Sporting Times* 22 Feb. 1/2 Doesn't it seem to you that your acquaintance with nursery rhymes of an erotic character is very great? You had better bring over all your staff (except Miss Cobbe) here some fine Friday, and we will have a won't you come up, come up, oh, won't you come up to Limerick . . . of a high order.

Of course, if the limerick form is derived from a song, it would hardly be a surprise that it exemplifies Music's Rule of Three. But, frankly, that seems a bit of a stretch. For one thing, it doesn't take into account children's verse, which also adheres to Music's Rule of Three.

(5) a. Hickory, dickory, dock. a

 The mouse ran up the clock. a

 The clock struck one, the mouse ran down, b

 Hickory, dickory, dock. a

 b. The farmer in the dell a

 The farmer in the dell a

 Hi-ho, the derry-o . . . b

 The farmer in the dell a

 c. Hot-cross buns! a

 Hot-cross buns! a

 One a penny, two a penny, b

 Hot-cross buns! a

 If you have no daughters, c

 Give them to your sons; a

 One a penny, two a penny, b

 Hot-cross buns! a

 d. Little Jack Horner a

 Sat in the corner, a

 Eating a Christmas pie; b

He put in his thumb,	c
And pulled out a plum,	c
And said, "What a good boy am I!"	b

e.	Little Miss Muffet	a
	Sat on a tuffet,	a
	Eating her curds and whey;	b
	Along came a spider,	c
	Who sat down beside her,	c
	And frightened Miss Muffet away.	b

However, there is also this rhyme:

(6)	Polly, put the kettle on,	a
	Polly, put the kettle on,	a
	Polly, put the kettle on,	a
	We'll all have tea.	b
	Sukey, take it off again,	a
	Sukey, take it off again,	a
	Sukey, take it off again,	a
	They've all gone away.	c

Although it is often included in collections of Mother Goose rhymes, "Polly, Put the Kettle On" is a lyric set to a seventeenth-century tune. The Music's Rule of Three violation is only apparent. When you listen to the tune, the violation disappears because the melody changes.[5]

Earlier I mentioned that the duck joke in (2) of chapter 4 has a property that I wanted to defer until after I introduced Music's Rule of Three. Now is the time. I repeat the joke here for convenience.

(7) A duck walks into a bar.

 "Got any grapes?" asks the duck.

 "This is a bar. Not a fruit store," says the irritated bartender.

 The duck leaves only to return a few minutes later.

 "Got any grapes?" asks the duck.

 "I said this is a bar. Not a fruit store," snaps the now angry bartender.

"Come in here again and I'll nail your web feet to the floor."

The duck leaves only to come back again.

"Got any nails?" asks the duck.

"No!" yells the infuriated bartender.

"Got any grapes?"

Notice that this joke also obeys Music's Rule of Three. Consider the repeated pattern of the duck's questions:

(8) Got any grapes? Got any grapes? Got any nails? Got any grapes?

 A A B A

So far we have applied Music's Rule of Three to music (AABA, etc.), to poetry (i.e., the limerick's a a b a rhyme scheme and children's poetry), and to jokes (*Got any grapes?*). There is another dimension worth looking at: melodic development in music. We have already seen a version of Music's Rule of Three operating within a single melody line. Recall the opening eight measures of "Ain't She Sweet" (figure 5.4). The first two groups and the last group all share properties: group 1 shares pitches with group 2 but not rhythm, and group 4 shares rhythm with group 1 but not pitches. If this

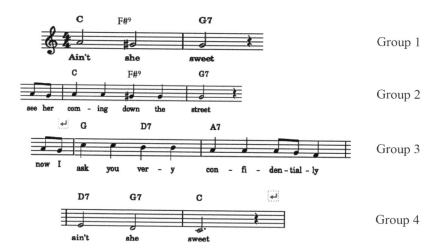

Figure 5.4
"Ain't She Sweet" lead sheet showing first eight measures with groups indicated by brackets above the staff

A section (16 measures, the first 8 repeated)

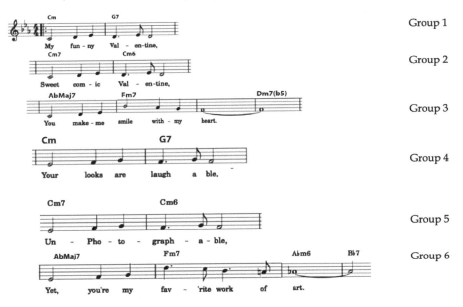

Figure 5.5
First sixteen measures of "My Funny Valentine" broken up according to groups and arranged to show the unusual melodic rhyme scheme

pattern of shared properties is sufficient to mark them as a repetition, AAA, then group 3 constitutes a complete departure, as it consists of a descending C scale (C B A G F). We can then represent the grouping sequence of the first eight measures as AABA. (This pattern is repeated in measures 9–16 and 25–32.)

In essence this kind of analysis reveals that melodies have rhyme schemes, just as rhyming verse does. To continue this investigation for a bit, let's return to "My Funny Valentine" from the point of view of Music's Rule of Three. The first sixteen measures of the tune, repeated in figure 5.5 for convenience, are a good place to start. Notice that the pitch and rhythm in group 1 and group 2 are identical. Group 3 appears to be on track to repeat groups 1 and 2, thereby violating Music's Rule of Three. But at the last minute it veers away from identity. Measure 6 introduces a new pitch (but not rhythmic) contour and the rule remains unbroken. One might argue that just looking at the first measure of each group in

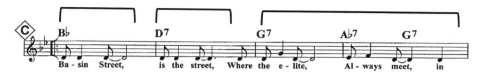

Figure 5.6
Grouping structure of opening bars of "Basin Street Blues"

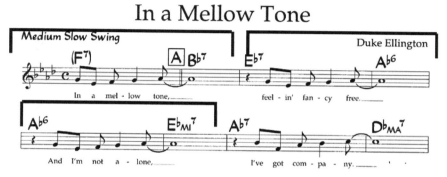

Figure 5.7
Grouping structure of opening bars of "In a Mellow Tone"

the first sixteen measures reveals a violation of Music's Rule of Three since groups 1–3 begin with the same three-note melody, as do groups 4–6 albeit a minor third higher. But notice that this objection disappears if we compare across groups rather than across measures within a group. I take this to be a principle of musical rhyme determination: comparison begins at the group level but not below it.

Of course, it is possible to have a group that extends over a single measure or less. I think the opening two measures of the C section of "Basin Street Blues" show this (figure 5.6). Duke Ellington's "In a Mellow Tone" is problematic. On first glance it clearly violates Music's Rule of Three (figure 5.7). I have bracketed the first three natural groups. The thirty-two-measure tune is of the form AA. There is no mistaking it. The first three groups have the same melody. They are, in fact, identical. And since the groups occur one after the other, the violation of Music's Rule of Three is apparent. But I use the word *apparent* advisedly. Even though the rhythm and the pitch are identical, there is a third dimension, harmonization. The chords associated

with each group change. The progression—F7, B♭7, E♭7, A♭6—is a common harmonic sequence: VI, II, V, I. It occurs in any number of compositions ranging from "I Got Rhythm" to Mozart's Symphony no. 40.

This raises an interesting question. Music has many dimensions. If you ask seasoned jazz musicians what the most important ones are, they are most likely to respond: melody, rhythm, and harmonization, usually ranked in that order. That list isn't exhaustive, though. For example, dynamics in a score indicate how loudly or softly a passage should be played.[6] But no one ever uses dynamics as a way of obeying Music's Rule of Three. The examples examined so far have dodged the rule's bullet by varying rhythm ("Ain't She Sweet"), melody ("Satin Doll"), or harmonization ("In a Mellow Tone"). I have not found a single example that uses dynamics the same way. It wouldn't be that difficult. "In a Mellow Tone" could easily be played with these dynamic markings: group 1 *p*, group 2 *mf*, and group 3 *f*.

So rhythm, melody, and harmonization appear to be the aspects of music that jazz composers turn to, to avoid violating Music's Rule of Three. In classical composition, the elephant in the room is Ravel's *Bolero*. It is one colossal violation of the rule if one limits oneself to the immutable triad. It won't do to take refuge in Ravel's often-reported comment that his most popular composition isn't music. He has a right to be ironic. However, the familiar and repeated theme exhibits a remarkable progression as the composition moves on. The lead voice changes from flute to clarinet to bassoon to hautbois d'amour and so on. That shift in timbre of the solo voice playing the same melody makes all the difference. It is the musical counterpart of a director asking an actor to read Lear's tragic lament *Never, never, never, never, never* ten different ways. So at least for *Bolero* one would have to include instrumentation as a change agent.

There are other dimensions. One, of course, is tempo. How slow is largo? How fast is allegro? Another is attack. This is very important in everything from classical symphony to big band jazz. How is a note to be played: with a soft legato attack, with a quick staccato attack, with neither? Still another is articulation: whether to use a soft onset or a hard onset when initiating a note. I have not found a single example where these are used to break a Music's Rule of Three chain.

We can divide musical notation into two parts: the mutable and the less so. That is to say, what part of a composition does a conductor or a performer feel free to interpret and what part is sacrosanct? Rhythm, melody,

and harmony are sacrosanct in classical music. In jazz they can be tampered with but only so much. Rhythm, melody, and harmony are always there like a musical *éminence grise*. Big band arrangers will reharmonize an original progression but the reharmonization will not be very far from the original. For example, in 1952 one of the greatest big band arrangers of them all, Billy May, recorded an arrangement of "You're Driving Me Crazy" in which the second half of the third measure and the fourth measure of the A section repeat are filled with May's big band conception of "crazy." It's a wonderful moment of ordered disorder wonderfully executed by a superb band, but you can still hear the harmony underneath.

Such a move would be impossible in classical music, where the canonical form of a manuscript is sacrosanct.[7] Instrumentation is a different matter; see, for example, Debussy's reorchestration of Erik Satie's *Gymnopédies nos. 1* and *3* and Ravel's brilliant reorchestration of Modest Mussorgsky's piano piece *Pictures at an Exhibition*. Even so, while reorchestration changes the timbre radically, the sacrosanct three remain unchanged. But tempo, dynamics, attack are up for grabs in the classics and in jazz. These are the dimensions that make a performance distinct. Think of Glenn Gould's recording of Bach's *Goldberg Variations*, which took 38 minutes in 1955 and 51 minutes in 1981.

I began this chapter with the observation that the Rule of Three in English tricolons, jokes, and so on, and Music's Rule of Three differ in a surprising way. The former is a straight-ahead repetition; the latter requires a break to continue. To put it in terms of musical form, the linguistic Rule of Three favors AAA, while Music's Rule of Three requires a break in the pattern, AABA. Why should this be so? I think the answer probably lies in the fact that the linguistic Rule of Three never threatens monotony because the meaning always changes from one member to the next, and when it doesn't—*location, location, location*—something special is going on (see discussion surrounding (4) in chapter 4). Music, on the other hand, does not have meaning to stave off monotony—hence the need for a break.

6 Is Music Wallpaper?

Let's now turn to music from a philosophical point of view, in particular Immanuel Kant's comments on music at the end of the eighteenth century. A good place to start is Peter Kivy's book *The Fine Art of Repetition* (1993). Chapter 18 begins with this epigraph:

> Our understanding of musical technique would have advanced much further if only someone had asked: Where, when, and how did music first develop its most striking and distinctive characteristic—repetition?
>
> <div align="right">Heinrich Schenker</div>

Kivy chooses this epigraph because of the peculiar place repetition occupied in post-Kantian music criticism. The *primum movens* of the furore was Kant's comment (1911, 229):

> Flowers are free beauties of nature. Hardly anyone but a botanist knows the true nature of a flower, and even he, while recognizing in the flower the reproductive organ of the plant, pays no attention to this natural end when using his taste to judge of its beauty. Hence no perfection of any kind—no internal finality, as something to which the arrangement of the manifold is related—underlies this judgement. Many birds (the parrot, the humming-bird, the bird of paradise), and a number of crustacea, are self-subsisting beauties which are not appurtenant to any object defined with respect to its end, but please freely and on their own account. *So designs à la grecque, foliage for framework or on wall-papers, etc., have no intrinsic meaning; they represent nothing—no object under a definite concept—and are free beauties. We may also rank in the same class what in music are called fantasias (without a theme), and, indeed, all music that is not set to words.* (Italics mine)

And elsewhere (1911, 243) Kant contrasts the freedom of "natural beauties" with the constraints of rule-based art forms, expressing his distaste for precisely the thing that Schenker says is the heart of music: repetition:

Even a bird's song, which we can reduce to no musical rule, seems to have more freedom in it, and thus to be richer for taste, than the human voice singing in accordance with all the rules that the art of music prescribes; for we grow tired much sooner of frequent and lengthy repetitions of the latter.

As Kivy (1993, 345) remarks:

Kant was apparently quite untroubled by the implication for the status of absolute music that placing it among the minor decorative arts of wallpaper and designs à la grecque carried with it. For music ranked very low in his estimation and as §54 of the *Critique of Judgement* amply testifies, he saw absolute music as a bodily rather than a mental pleasure—indeed, nothing more than a sonic *digestif*, if we are to take his remarks seriously.

For the Kant of these passages, then, music was simply an agreeable art (1911, 305–306):

Agreeable arts are those which have mere enjoyment for their object. Such are all the charms that can gratify a dinner party: entertaining narrative, the art of starting the whole table in unrestrained and sprightly conversation, or with jest and laughter inducing a certain air of gaiety. . . . (Of the same sort is also the art of arranging the table for enjoyment, or, at large banquets, the music of the orchestra—a quaint idea intended to act on the mind merely as an agreeable noise fostering a genial spirit, which, without anyone paying the smallest attention to the composition, promotes the free flow of conversation between guest and guest.) In addition must be included play of every kind which is attended with no further interest than that of making the time pass by unheeded.

Fine art, on the other hand, is a mode of representation which is intrinsically final, and which, although devoid of an end, has the effect of advancing the culture of the mental powers in the interests of social communication.

So for Kant music was "an agreeable noise fostering a genial spirit," a glass of port after a chateaubriand.

Kant was not only interested in categorizing the arts; he also wanted to rank them (1911, 326):

Among all the arts poetry holds the highest rank. (It owes its origin almost entirely to genius and is least open to guidance by precept or examples.) It expands the mind: for it sets the imagination free, and offers us, from among the unlimited variety of possible forms that harmonize with a given concept, though within that concept's limits, that form which links the exhibition of the concept with a wealth of thought to which no linguistic expression is completely adequate, and so poetry rises aesthetically to ideas.

Compare this with his view of music (1911, 328):

After poetry, if we take charm and mental stimulation into account, I would give the next place to that art which comes nearer to it than to any other art of speech, and admits of very natural union with it, namely the art of tone. For though it speaks by means of mere sensations without concepts, and so does not, like poetry, leave behind it any food for reflection, still it moves the mind more diversely, and, although with transient, still with intenser effect. It is certainly, however, more a matter of enjoyment than of culture—the play of thought incidentally excited by it being merely the effect of a more or less mechanical association—and it possesses less worth in the eyes of reason than any other of the fine arts. Hence, like all enjoyment, it calls for constant change, and does not stand frequent repetition without inducing weariness.

And a bit later on (1911, 328–329):

Music, then, since it plays merely with sensations, has the lowest place among the fine arts—just as it has perhaps the highest among those valued at the same time for their agreeableness. Looked at in this light, it is far excelled by the formative arts. . . . The two kinds of art pursue completely different courses. Music advances from sensations to indefinite ideas: formative art from definite ideas to sensations. The latter gives a lasting impression, the former one that is only fleeting. The former sensations imagination can recall and agreeably entertain itself with, while the latter either vanish entirely, or else, if involuntarily repeated by the imagination, are more annoying to us than agreeable. Over and above all this, music has a certain lack of urbanity about it. For owing chiefly to the character of its instruments, it scatters its influence abroad to an uncalled-for extent (through the neighbourhood), and thus, as it were, becomes obtrusive and deprives others, outside the musical circle, of their freedom. This is a thing that the arts that address themselves to the eye do not do, for if one is not disposed to give admittance to their impressions, one has only to look the other way. The case is almost on a par with the practice of regaling oneself with a perfume that exhales its odours far and wide. The man who pulls his perfumed handkerchief from his pocket gives a treat to all around whether they like it or not, and compels them, if they want to breathe at all, to be parties to the enjoyment, and so the habit has gone out of fashion.

I find this passage odd. In it Kant is dissing music because it can be heard by others whether they like it or not. Having been sitting in my car waiting for the light to change when a boom box with an engine pulls alongside blasting the Rolling Stones at full volume, I can sympathize with Kant's "whether they like it or not" qualification, but if the ambient music is from Joshua Bell playing Bach in a subway, well, that's a stone of a different color.

Views like this have troubled philosophers. One is Samantha Matherne (2014, 129):

Several prominent philosophers of art have worried about whether Kant has a coherent theory of music on account of two perceived tensions in his view. First, there appears to be a conflict between his formalist and expressive commitments. Second (and even worse), Kant defends seemingly contradictory claims about music being beautiful and merely agreeable, that is, not beautiful.

There are other Kant-instigated debates among philosophers—for example, to what extent music is the purest of art forms because it is the freest from the influence of Nature. None of these issues are relevant here. I am concerned with the cognitive mechanisms that cater to art and that art caters to—that is, how repetition in music works to give the listener pleasure. As far as I am concerned, music can be agreeable, autonomous, and beautiful separately or all at once. The question remains: why does musical repetition work?

Kant's distaste for the repetitious aspect of music and his view of it as merely ornamental—as opposed to poetry, which he deems the highest of the fine arts—is also curious. Kant ranks poetry over music because the former has semantic content whereas the latter does not. Poetry makes you think. Music "speaks through nothing but sensations." And to add insult to injury, he claims that being a mere "enjoyment," rather than food for thought, music becomes boring after its omnipresent repetitions.

But if, as Schenker and Bernstein assert, repetition is at the heart of music, then one wonders if Kant really liked music. After all, he thinks music is especially prone to "omnipresent repetitions" that induce "weariness." But being bored by repetition isn't unique to music. Certainly discourse can be soporific. The important point is that repetition serves an artistic purpose in music, while in common discourse it is a stumbling block. Indeed, I would go so far as to say that music is a fine art precisely because it is the optimal art form to accommodate endless repetition without irritation, a form of repetition that is inherently pleasurable. Kant seems to find this central aspect of music wearisome. Ah, well. Chacun à son goût.

Writing in 1801, August Wilhelm Schlegel agrees with Kant in ranking poetry at the top of the pantheon of the arts. But Schlegel makes to my mind a more interesting case. For him poetry is the premier art form because its medium, language, is the outward manifestation of the creative capacity of the mind. Through the medium of poetry—that is, language— the artist can command the paint onto the canvas.[1] But paint cannot on its own command poetry.[2]

Several critics have taken umbrage at Kant's relegating music to the world of wallpaper design *à la greque*. Looking back on these discussions from today's vantage point, one wonders why ranking of the arts should ever have been an issue in the first place. It seems a pointless activity. Better to study each art form on its own turf, then step back to see where the generalizations might lie.

Today one might reasonably want to compare genres along the lines of investigating the brain's ability to parse music beside its ability to parse speech, for example. That is a very lively and interesting topic. It raises several questions. Do the language and music capabilities overlap? For example, is there a shared mental computation that assigns primary stress to words in English and to the strong beat in a measure of music? But none of this motivated the discussions around music and poetry in the eighteenth and nineteenth centuries. So, what did?

The period of absolute music's greatness—instrumental music unattached to a vocal narrative as in Gregorian chant or opera—can be circumscribed between 1685, the year of J. S. Bach's birth, and 1827, the year of Beethoven's death. Six years after Bach died in 1750, Mozart was born. Joseph Haydn was by then 18 years old. When Mozart died in 1791, Haydn was 59, Beethoven, 21. In the 118-year period between Bach's first composition (1708) and Beethoven's last (1826) some of the greatest absolute music ever written came into being. This was music without meaning, pure music if you will. It was also the art form that Kant likened to wallpaper.

Kivy (1993, 259) mocks Kant's attitude toward music as making

> no more of our enjoyment of the expressive in music than an aid to digestion: the sonic counterpart of Tums for the tummy . . . [w]hile audiences in Vienna, Mannheim, Prague, Paris, and London were sitting in rapt attention at performances of the mature instrumental works of Haydn and Mozart, with Beethoven on the verge of making his stormy entrance onto the Viennese musical scene!

And to twist the knife a bit more, Kivy recalls for us that Kant had once described a person of taste as someone who might spend part of a mealtime listening to music.

To retrieve music from the depths to which it had been relegated, aestheticians developed elevating theories, which Kivy (1993, 327–357) explores. There are three of them: the literary, the organic, and wallpaper. As we will see, in the end he comes down on the side of wallpaper, but as he might say, "What divine wallpaper!"

Here is what he has to say about the first theory (Kivy 1993, 330–331):

The literary model seems to have been by far the most rigorously pursued in the 18th century, and understandably so. To begin with it had the obvious virtue of being a temporal model. For a piece of music, like a play, narrative, or discourse, is experienced as a series of ordered events.

Second, the literary model seems to give to music alone a dimension that assures something like the high status that its enthusiasts and practitioners ascribe to it. That dimension is the dimension of meaning or content that linguistic models are bound to carry with them, albeit in this case in the highly suspect form of the conceptually inexpressible. As Carl Dalhaus put the point in his brief history, *The Idea of Absolute Music,*

> Instrumental music's claim to be taken seriously as a manifestation of "pure art," rather than being dismissed as empty sound, was nourished by literary models that grounded a new musical consensus to its formulations. . . . The metaphysical prestige of absolute music came about via a transfer of the poetic idea of unspeakability.

What has all this to do with repetition? Quite a bit, as it turns out. If you are committed to a literary model, then repetition literally forces itself upon you. It becomes an unwanted stylistic side effect. The reasoning goes like this. Music is a literary event. Repetition in a literary event such as a discourse makes no sense. Why would one go to the theater to watch a three-act play where act I is repeated after act II and before act III? Therefore, repetition in music is to be avoided. Here is the eighteenth-century critic André-Ernest-Modeste Grétry on the topic (quoted from Broyles 1980, 343):

A sonata is a discourse. What would one think of a man who, after cutting his discourse in two, would repeat each half? (For example) "I went to your home this morning; yes, I went to your home this morning, in order to discuss some business with you; in order to discuss some business with you." That is just about the effect that repeats in music have on me.

Grétry never had the pleasure of listening to Robert Johnson singing his 1934 composition "They're Red Hot" (see (2) in chapter 1) or his 1937 composition "Stones in My Passway":

(1) I got stones in my passway

And all my roads seem dark at night

I got stones in my passway

And all my roads seem dark at night

I have pains in my heart

They have taken my appetite

I have a bird to whistle

I have a bird to sing

Have a bird to whistle

And I have a bird to sing

I have a woman that I'm loving

Boy, but she don't mean a thing

Indeed, it wouldn't be that hard to turn Grétry's example into the blues:

(2) I went home this morning to discuss some business with you.

Yes, I went home this morning to discuss some business with you.

You slammed the door shut, saying you and me, we were through.

Of course, Grétry can't be faulted for not knowing the blues.[3] But thinking about Grétry's comment in that context raises an interesting question. Why should repetition of a line like *I went home this morning to discuss some business with you* work in a blues format, but not in a conversation? We will come back to this question in a moment. But first we need to look at Kivy's critique of the models of music that he identifies.

Kivy disposes in short order of the literary and organic models, and I encourage you to see what he has to say. For present purposes, it is sufficient to note that both models come a cropper of repetition. We have already seen Grétry's conclusion that because a sonata is a discourse and repetition makes no sense in discourse, repeats need to be excluded. This is a remarkable example of the tail wagging the dog. The heart of the sonata form is repetition. So, identifying music with literary form leads to a reductio ad absurdum, the elimination of a central characteristic of a sonata.

The organic model holds that music unfolds the way an organism unfolds. Once again repetition is a stumbling block (Kivy 1993, 343–344):

If a musical composition is to be illuminatingly described as an organism, we must, I would think, show how, in its musical particulars, it exhibits the character of an organism. And as a musical composition proceeds temporally from a beginning to an end, it is the growth, the goal-directed development of the organism, particularly an embryo, that provides the over-arching metaphor, as we have seen. But that metaphor is simply contradicted by the musical repeat, even with the understanding that the successor and predecessor relations are changed the second time around. An embryo that repeated the first third of its development

all over again before continuing to term would be seen as doing something biologically absurd, at least as biological organisms have developed on planet earth, even if it were pointed out that the second coming of the first stage bore relations to what came before and after it different from those of the initial first stage. The whole thing is biological nonsense. But it is not musical nonsense. And one can only conclude from that that the biological metaphor, like the literary one, fails to be revelatory of the character of musical experience and for much the same reason. As attractive as these metaphors have been, it is time at last to admit their bankruptcy and seek for another. The wallpaper model awaits us.

Not surprisingly, Kivy begins by noting that whereas repeat signs are a problem for the other two models, the wallpaper model welcomes repeats with open arms. He agrees that music is fundamentally wallpaper, but wallpaper on steroids. Here is a list of his reasons for opting for Kant's conception, but from the perspective of a highly complicated variety of wallpaper (Kivy 1993, 354–357):

1. Music is a multidimensional pattern. This follows from its polyphonic nature.
2. Music is a quasi-syntactic pattern. Its structure is grammatical.
3. Absolute music is, in most of its traditional manifestations in the last two hundred years, a highly expressive pattern of sound. It possesses emotive properties as part of its perceived structure.
4. Absolute music is deeply moving. It provides a profoundly emotional experience to its devotees.

There are two observations worth making about this list. The first is that, following Lerdahl and Jackendoff (1983a), items 1 and 2 can be collapsed. Music's polyphonic nature is part of its grammatical structure.[4] That leaves items 3 and 4. They are intended to distance music from wallpaper. Presumably no one looks at wallpaper and sheds a tear or jumps for joy.

Let me try to move the discussion in a different direction by picking up on the promissory note of my earlier question: why should repetition of a line like *I went home this morning to discuss some business with you* work when you sing it in a blues format, but not in a conversation?

I think the answer is quite straightforward. Repeating *I went home this morning to discuss some business with you* when attended to as music is pleasurable. When attended to as discourse, it is a nuisance: "You've already said that. Get on with it."[5]

There is evidence for this view. Diana Deutsch, Trevor Henthorn, and Rachel Lapidis (2011) conducted two experiments with an interesting result. They discovered a new "transformation effect, in which a spoken phrase comes to be heard as sung rather than spoken, simply as a result of repetition" (2011, 2252). Here they discuss the results of one of their experiments (2011, 2247):

> It was found that for a group of subjects who were naïve concerning the purpose of the experiment and who had been selected only on the basis of having had at least 5 yr of musical training, the repeated presentation of a spoken phrase caused it to be heard as sung rather than spoken. However, this perceptual transformation did not occur when, during the intervening presentations, the phrase was transposed slightly or the syllables were presented in jumbled orderings. The illusion could not, therefore, have been due to repetition of the pitch contour of the phrase or even repetition of the exact melodic intervals, since these were preserved under transposition. Further, since the perceptual transformation did not occur when the intervening patterns were transposed leaving the timing of the signal unaltered, it could not have been due to the repetition of the exact timing of the phrase. In addition, since the perceptual transformation did not occur when the syllables were presented in jumbled orderings, it could not have been due to the exact repetition of the unordered set of syllables. The illusion therefore appears to require repetition of the untransposed set of syllables, presented in the same ordering.

While further experimentation is obviously called for, it isn't too hard to imagine what's happening here. There is a familiar phenomenon called, among other things, semantic satiation. It refers to the impression one gets after repeating a word over and over. As the repetitions pile up, the sound sequence morphs from a word to a nonsense syllable.

Why would that happen? Here is a scenario. Let's hypothesize that the brain is constantly paying attention to sensory input. Consequently, it is always shunting incoming stimuli to one dedicated area or another—visual, auditory, tactile, whatever might be needed to process the data. When the brain detects a sequence of phonemes, it assumes that the language faculty needs to do the processing. But when the same sequence comes in again and again and again, it begins to wonder, probably represented by a fatiguing of the relevant neural sensing circuitry. By the tenth time, the circuitry rejects the stimulus as linguistic and looks around for a better cognitive fit. That's when the music faculty comes in. The brain discovers that it can treat the stimulus as if it were a bit of a song. The brain accepts it as words

set to music. The stimulus hasn't changed. All that has changed is what function of the brain is attending to it.

And that, I think, is the heart of the matter. As Margulis has shown, there is every reason to believe that repetition is pleasurable. Music is the ideal medium to exploit this property. I say *ideal* because what Kant perceives as music's greatest weakness is in fact its greatest strength—namely, a lack of content that enables it to exploit the pleasurable aspect of repetition untrammeled by meaning. And this aspect of music does not appear to be true only of Western music. Huron (2007, 228–229) writes:

> My collaborator Joy Ollen and I measured the amount of repetition in a cross-cultural sample of fifty musical works. Our sample included the most varied potpourri we could assemble. We studied Calypso, Inuit throat singing, Japanese New Age, Estonian bagpipe music, Punjabi pop, fifteenth-century Chinese *guqin*, Norwegian polka, a Navaho war dance, bluegrass, Macedonian singing, Ghanaian drumming, Spanish flamenco, Kalimantan ritual music, Hawaiian slack key guitar, Gypsy music, and thirty-five other works from similarly varied cultural sources. On average, we found that 94% of all musical passages longer than a few seconds in duration are repeated at some point in the work.[6]

Huron adds that 94% "probably underestimates the amount of repetition. Repetition need not be verbatim in order to convey useful predictive patterns." He then references the repetition inherent in the time signature, in the harmony, and in stable instrumentation. All of this is a remarkable testament to the ubiquity of repetition in music.

One can push this line of argument a bit farther and ask why there should have been a drive to link end rhyme and meter in poetry for so many centuries. The answer is that poets fit content into the Procrustean bed of rhyme and/or meter to capture some of the essence that renders music pleasurable. These techniques endow discourse with some of the pleasure that comes so naturally to music. Rhyme and meter are quintessentially repetitious. That is the point.

By contrast, this excerpt from "A Last World," a poem by John Ashbery, shows what poetry became when pleasure by repetition was abandoned with the advent of modernism:

(3) These wonderful things

 Were planted on the surface of a round mind

 that was to become our present time.

The mark of things belongs to someone

But if that somebody was wise

Then the whole of things might be different

From what it was thought to be in the beginning,

 before an angel bandaged the field glasses.

The point of this fragment, from a poet widely considered to be one of the best of the twentieth century, is to show that if poetry in previous times was content-fettered by the pleasures of repetition, then much subsequent poetry was, for better or for worse, content-free of the pleasure that repetition brings.

Marjorie Perloff (1993) calls this kind of poetry the poetry of "indeterminacy." As I've written elsewhere (Keyser 2020, 122):

> This is a kind of carrot-and-stick theory. The stick is the poem. The carrot is the promise of a "disclosure"—in my terms, a private format.

Later Perloff says (1993, 18):

> For what happens in Pound's *Cantos*, as in Stein's *Tender Buttons* or Williams' *Spring and All* or Beckett's *How It Is* or John Cage's *Silence*, is that the symbolic evocations generated by words on the page are no longer grounded in a coherent discourse, so that it becomes impossible to decide which of these associations are relevant and which are not. This is the "undecidability" of the text I spoke of earlier.

Assuming that Perloff is right—and I do—what appears to have happened is that modernism abandoned the kind of automatic pleasure produced by perceived repetition for an intellectual search for a narrative. That this search is associated with the same kind of pleasure is certainly not the case. But it might well be a pleasurable activity of a different sort. I know of no experiment such as Margulis's that sheds light on this. I can only surmise that poetry that requires the reader to build a narrative bridge that goes from *the surface of a round mind* to *our present time* seems like a bridge too far.

When I look back on the comments by Kant, Grétry, and Kivy, I am struck by the absence of any consideration of pleasure associated with repetition. The word appears nowhere in Kivy's four-point program, although he is as strong a proponent of repetition in music as one might ask for (1993, 359):

The importance of the repeat, both external and internal, in the music of this [Western tonal classical] tradition cannot be overestimated, and has been not merely underestimated, but almost totally ignored by those who have tried to write "philosophically" about such music. Indeed, I would put it this strongly: The music which I have been discussing does not merely contain repetition as an important feature, but as a defining feature.

Thus, Kivy brings us back to the epigram with which he started:

Our understanding of musical technique would have advanced much further if only someone had asked: Where, when, and how did music first develop its most striking and distinctive characteristic—repetition?

Heinrich Schenker

I mentioned in note 3 of chapter 5 that history constructed its own experiment that supports Joy Ollen and David Huron's (2004) experimental results. In his article exploring binary repeats in music, Michael Broyles (1980, 340–341) notes:

A general survey of movements in binary structure composed between 1760 and 1810 indicates a fairly simple and straightforward trend. Before 1780, both halves of a binary structure were almost always repeated. It was possible to repeat only the first, but this was done so seldom as to be insignificant in determining stylistic norms. In the 1780s, the pattern began a steady trend toward eliminating the repeat of the development and recapitulation throughout the latter two decades of the eighteenth century until by 1800 the use of the second half repeat sign appeared archaic. It might still be found, but as the exception rather than the rule.

Broyles includes an exhaustive analysis of the compositions surveyed.[7] As the Grétry quotation above suggests, seeing music as a discourse required eliminating repetition because, as he points out, it is absurd to repeat oneself in ordinary discourse.

What Broyles shows is that between 1760 and 1810 composers succumbed to the pressure to reduce repetition, and the repeats that were in jeopardy were not, in Ollen and Huron's terms, the early repeats but the later ones. Thus, Ollen and Huron's study dotted the *i*'s and crossed the *t*'s on an experiment that had naturally unfolded two hundred years earlier.

I mention discourse theory here because it is a remarkable example of how a philosophical debate about an art form can have a dramatic impact on how works of art in the relevant genre are presented. It doesn't usually work that way. Thus, cubism and free verse produced their defenders, not

the other way around. Apparently, music theory in the eighteenth century was to composers what economic theory is to policy makers. It was meant to drive behavior.

In that same century there was a shift away from the view of music as a form of dramatic art, a form of discourse à la Grétry. As Meyer Abrams (1953, 59) puts it:

> In place of painting, music becomes the art frequently pointed to as having a profound affinity with poetry. For if a picture seems the nearest thing to a mirror-image of the external world, music, of all the arts, is the most remote: except in the trivial echoism of programmatic passages, it does not duplicate aspects of sensible nature, nor can it be said, in any obvious sense, to refer to any state of affairs outside itself. As a result music was the first of the arts to be generally regarded as non-mimetic in nature; and in the theory of German writers of the 1790's, music came to be the art most immediately expressive of spirit and emotion, constituting the very pulse and quiddity of passion made public.

One wonders if this shift away from viewing music as a mimetic art form toward viewing it as the most remote (i.e., abstract) of genres created a gravitational force that pulled painters like Édouard Manet and Claude Monet away from the mimetic and poets like Ezra Pound away from meter and rhyme. As interesting as these questions are, they fall well outside the purview of this study, which is devoted to the role repetition plays in making music pleasurable.

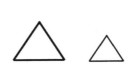

7 Meter and Repetition

Meter is found in poetries all over the world. In English, practically every poem in the literary canon is syllabo-tonically metrical up until the advent of modernism, when free verse began to dominate. Since meter is by its very nature repetitive and since what is repetitive is pleasurable, we need to understand how meter works. First and foremost, it must involve the arrangement of the words of a poem in such a way that the metrical pattern recurs in every line of the poem. But what exactly is recurring? As we will see, it certainly isn't the most obvious property of English words, primary stress.

Let's unpack what that means.

In English every polysyllabic word has one syllable that stands out more than the others. In the word *táffeta*, for example, that syllable is the third from the end, the antepenultimate syllable. In the word *Agénda*, that syllable is the second from the end, the penultimate. In the word *voluntéer*, that syllable is the final syllable.

Of course, monosyllabic words get stressed by default since there are no other syllables competing for attention. This is true of so-called major lexical category words: verbs like *hit* and *miss*, nouns like *ham* and *eggs*, adjectives like *tall* and *short*, and adverbs like *hard* and *fast*. Function words like prepositions (*to, at, for,* etc.) can often lose the stress on their vowels and replace them with the unstressed vowel called "schwa" (i.e., the vowel in the final syllable of *sofa*). Auxiliary verbs (*have, are*) can often undergo severe truncation, severe enough to lose the vowel altogether and attach what's left to the preceding word (*you have → you've, you are → you're*). (The process is called cliticization.) Major lexical category words (nouns, verbs, adjectives, adverbs) never cliticize. The rule is that major lexical categories never lose their stress. Function words can. Some words like conjunctions

(*and*, *or*, and *but*), pronouns (*I*, *me*, *you*, *he*, etc.), and interrogatives (*when*, *where*, *what*, *who*, etc.) are variable. Sometimes they have primary stress, sometimes not. Think of *Come 'n get it* (*Come and get it*), *win'r lose* (*win or lose*), *gonna* (*going to*), *wanna* (*want to*), *gotcha* (*got you*), *whaddya* (*what do you*), and the like.

With this as background, let us ask again: if meter is repetitive, what is it that is recurring? Look at line 4 of Shakespeare's Sonnet 30 (I represent primary stresses in each line with slash marks (/) and assign a dash (–) to all other syllables):

(1) – – / / / / – / / /
 And with old woes new wail my dear time's waste:

It consists of ten monosyllabic words, only seven of which contain primary stress. There is no patterned repetition in this line as there is, for example, in lines 3 and 8:

(2) a. – / – / – / – / – /
 I sigh the lack of many a thing I sought,[1]

 b. – / – / – / – / – /
 And moan th' expense of many a vanish'd sight;

In fact, these are the only lines that exhibit the same repetitive pattern. So what exactly is being repeated in metrical poetry? Unfortunately, the answer is complicated.

To start with, let's look at the whole of Shakespeare's Sonnet 30. The sonnet rhyme scheme is shown in (3):

(3) Rhyme scheme

When to the sessions of sweet silent thought a

I summon up remembrance of things past, b

I sigh the lack of many a thing I sought, a

And with old woes new wail my dear time's waste: b

Then can I drown an eye, unus'd to flow, c

For precious friends hid in death's dateless night, d

And weep afresh love's long since cancell'd woe, c

And moan th' expense of many a vanish'd sight; d

Then can I grieve at grievances foregone, e

And heavily from woe to woe tell o'er f

The sad account of fore-bemoaned moan, e

Which I new pay as if not paid before. f

But if the while I think on thee, dear friend, g

All losses are restor'd, and sorrows end. g

Margulis's suggestion that "repetition is a powerful and often underacknowledged aesthetic operative" offers a reasonable account of how pleasure is derived from the rhyme scheme. Discerning rhymes is a form of contrast (see chapter 2). Contrast is a form of *same/except* repetition, and repetition, as Margulis shows, can introduce pleasure.

But what about meter? In so-called "sophisticated" verse like Sonnet 30, repetition is not worn on the poetry's sleeve the way rhyme and alliteration are. Linguistic stress certainly has much to do with repetition in premodernist English verse. But it isn't easy to see at first glance what is repeating. Consider the primary and other stresses in Sonnet 30:

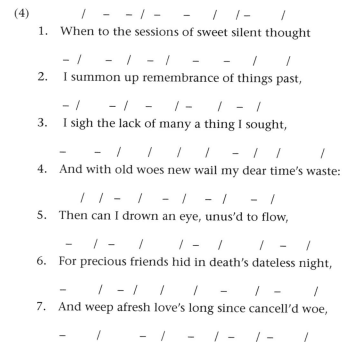

(4) / – – / – – / / – /
1. When to the sessions of sweet silent thought

 – / – / – / – – / /
2. I summon up remembrance of things past,

 – / – / – / – / – /
3. I sigh the lack of many a thing I sought,

 – – / / / / – / / /
4. And with old woes new wail my dear time's waste:

 / / – / – / – / – /
5. Then can I drown an eye, unus'd to flow,

 – / – / / – / / – /
6. For precious friends hid in death's dateless night,

 – / – / / / – / – /
7. And weep afresh love's long since cancell'd woe,

 – / – / – / – / – /
8. And moan th' expense of many a vanish'd sight;

/ / – / – / – – – /
9. Then can I grieve at grievances foregone,

– / – – – / – / / /
10. And heavily from woe to woe tell o'er

– / – / – – – / – /
11. The sad account of fore-bemoaned moan,

– – / / – – / / – /
12. Which I new pay as if not paid before.

– – – / – / – / / /
13. But if the while I think on thee, dear friend,

/ / – – – / – / – /
14. All losses are restor'd, and sorrows end.

Table 7.1 summarizes the number of primary stresses in each line of the sonnet and shows each line's place in the rhyme scheme.

Table 7.1
Primary stresses in relationship to the rhyme scheme in Sonnet 30

Line	Number of primary stresses	Rhyme scheme
1.	5	a
2.	5	b
3.	5	a
4.	7	b
5.	6	c
6.	6	d
7.	6	c
8.	5	d
9.	5	e
10.	5	f
11.	4	e
12.	5	f
13.	5	g
14.	5	g

As (4) and table 7.1 show, there is no obvious correlation between the rhyme scheme and the number of primary stresses and their distribution in the line. Only two of the fourteen lines have identical stress patterns, namely, lines 3 and 8. All the other lines differ in number and/or placement of the primary stresses.

The metrical pattern that the poem is meant to conform to is a sequence of two metrical elements, traditionally referred to as W for weak and S for strong. So, we have a binary metrical unit WS. Repetition of [WS] five times gives the meter its name, *iambic* (Weak Strong) *pentameter* (repeated five times).[2]

(5) W S W S W S W S W S

How can we tell that the lines of Sonnet 30 conform to some unobvious pattern? ((4) and (5) show just how unobvious it is.) Well, modern metrists have answered that question by asking another one: how can we distinguish between a metrical and an unmetrical line?[3] Perhaps it is not surprising that this question was first asked by linguists, since the fundamental question a linguist asks is how it is possible for a speaker of a language to distinguish between grammatical and ungrammatical sentences (see Halle and Keyser 1972). The linguist answers by saying it is because the speaker has command of a systematic body of knowledge called a grammar. The linguist's task is to tease out the rules that make up that grammar, a body of knowledge that is largely unconscious. The same thing is true of meter. So here is one pass at such a grammar. I have vastly simplified the discussion, but the idea should still be clear.[4]

Our first step is to align every syllable of a candidate metrical line with an element of the metrical pattern in (5), as in (6).

(6) W S W S W S W SW S
 | | | | | | | || |
 When to the sessions of sweet silent thought

We now have two separate levels of representation to consider. One is the line itself. The second is the metrical pattern. On the reasonable assumption that what is being manipulated is the stress in English words, the question is, How do the stresses in each line relate to the metrical pattern? Consequently, the next step is to divide the line into primary stressed syllables (/) and all the rest (–) and to align them with the metrical pattern:

(7)
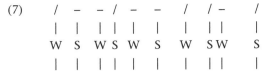

When to the sessions of sweet sil ent thought

So now we have three levels of representation: the line itself, the metrical pattern, and the primary stresses in the line, all aligned as in (7). Where do we go from here? We postulate what is called a *correspondence rule*.

A correspondence rule (or rules) is the theoretical device that tells us whether the alignments are legitimate. That is, is it okay to have a stressed or unstressed vowel in the position it occupies in the line? For example, in (7) is it okay to have a stressed vowel in the seventh (W) position or an unstressed vowel in the sixth (S) position? Think of it as a kind of quality control check. Given the representation in (7), the correspondence rule checks to see if there is a certain property that holds throughout the line with respect to the alignment of the three levels: stress, syllables, and elements of the metrical pattern.

And there's the rub.

The metrist must come up with a precise definition of that "certain property." It is in reality a theoretical construct. It claims that this is the property that determines whether the three levels of representation in (7) are aligned properly. Here is a proposed rule:

(8) *Correspondence rule*[5]

No W position can be occupied by the stressed syllable of a polysyllabic word unless that syllable is adjacent to a phrase boundary, where *phrase boundary* is defined by the syntactic tree associated with the relevant word.

Let's see what rule (8) hypothesizes as the "certain property." First off, it is only concerned with polysyllabic words (words with more than one syllable). The implication is that monosyllabic words can go anywhere. This is illustrated in (1), where stressed monosyllables occur in both W and S positions. In (7) there are only two polysyllabic words, *sessions* and *silent*. In each one the unstressed syllable is the final syllable, and both are associated with a W position. Since (8) throws up no red flags, the line in (7) is metrical.

Now let's look at a line that would fail the rule (8) test:[6]

(9)

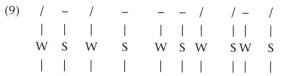

```
    /   –   /    –    –  –  /   / –   /
    |   |   |    |    |  |  |   | |   |
    W   S   W    S    W  S  W   S W   S
    |   |   |    |    |  |  |   | |   |
```
Pluck immense teeth from enraged tigers' jaws

This line contains three polysyllabic words: *immense, enraged,* and *tigers'*. Only the first two are relevant since the stressed syllable in *tiger's* falls uncontroversially on an S position. The stressed syllables of the remaining two words are in a W position but, crucially, *neither is adjacent to a phrase boundary.* This is the important part of (8). If there is a line with a stressed syllable in a polysyllabic word corresponding to a W position, then that W position must be next to a phrase boundary. In the case of (9) both *immense* and *enraged* modify the nouns that follow them, so as (10) shows they are both inside a noun phrase but their stressed syllables are not adjacent to one:

(10) a. b.

The stressed syllables in *immense* and *enraged* are aligned with a W position. In order for that to be metrically acceptable, however, there must be a phrase boundary abutting the W position. The syntactic trees corresponding to the noun phrases in which those adjectives occur do not meet this criterion. Therefore, the line is unacceptable metrically. And sure enough, lines like that don't occur in Shakespeare's sonnets, although they do in his early plays (see Kiparsky 1975). Rule (8) also explains why compounds like *all-eating, love-lacking,* and *deep-sunken* only occur in WSW stretches of the meter; and again, this explains what *doesn't* occur.

Since the corpus is finite, 154 sonnets or 2,156 lines, it may well be that these are accidental gaps. Or it may be that they were simply stylistic

"avoid" notes for Shakespeare. But let's assume that they are real metrical no-no's for the Shakespeare of the sonnets. In that case it is obvious that while (8) rules out these specific kinds of matches between stresses and metrical positions, it allows a great many others. That is no doubt a big part of the reason why so-called "sophisticated" poetry like Shakespeare's sonnets is thought to resemble natural speech. Poets like Robert Browning ("My Last Duchess") and Robert Frost ("Mending Wall") are especially good at writing poetry that sounds like someone's conversation.

So, let's return to the question we started with: what exactly is repetitive in metrical poetry? The answer must be the metrical pattern. Think of the correspondence rule (8) as the doorman of a literary nightclub whose potential patrons are lines purporting to be iambic pentameter. A line presents itself to the doorman. The doorman checks to see that all its stressed W positions are monosyllabic or adjacent to a phrase boundary. If they are, the doorman lets the line in. The point of this playlet is that the doorman enjoys his work. When you are reading an iambic pentameter poem, think of yourself as the doorman.

And in terms of our *same/except* metric, what is different is the distribution of stressed syllables from one line to the next. The function of a correspondence rule like (8) is to license the stress placements that occur and by so doing reveal the underlying repetitive sameness of WSWSWSWSWS.

In this regard it might be helpful to compare Sonnet 30 with children's poetry:

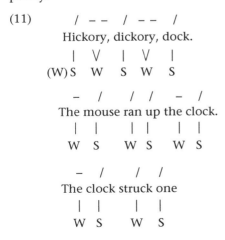

(11)

```
        –   /   /   /
    The mouse ran down
        |   |   |   |
        W   S   W   S

      /  – –  /  – –  /
    Hickory, dickory, dock.
        |  V  |  V  |
    (W) S  W  S  W  S
```

(12)
```
      /  – –     /  –
    Little Jack Horner
      |  V     |  |
      S  W     S  W

      /  –   –  /  –
    Sat in the corner,
      |  \/   |  |
      S  W    S  W

      /  –   –    /  –  /
    Eating a Christmas pie;
      |  V     |  |  |
      S  W     S  W  S

      –  / –   –    /
    He put in his thumb,
      |  |  \/    |
      W  S  W     S

      –   /    –  –  /
    And pulled out a plum,
      |   |    \/  |
      W   S    W   S

      –    –      /  –  /   /  –  /
    And said, "What a good boy am I!"
      \/         |  V  |  |  |
      W          S  W  S  W  S
```

(13)

The meter of these three poems is what Robert Frost called "loose iambic" (see Halle and Keyser 1999), where a W position can be occupied by one or two syllables. The V-shaped lines indicate which W positions are occupied by two syllables instead of one. The difference in style between these poems and Sonnet 30 is this. In Sonnet 30 there are many S positions that are not occupied by a stressed syllable, ten to be exact. In the poems in (11) every S position has a stressed vowel. This property is what gives these verses their distinctive rhythmic lilt. It would be easy to accompany oneself on a drum while reciting them. Try reading them aloud while slapping your hand to their rhythm on a tabletop or armrest.

Now try maintaining a rhythmic beat by thumping the tabletop every time you encounter a stressed syllable in Sonnet 30. That's a horse of a different color. As a historical side note, in the eighteenth century, roughly from 1720 to 1790, the standard practice for reading poetry out loud was to read everything as if it were like "Little Miss Muffet." Paul Fussell (1966, 64) describes the practice like this:

> In 1762, Thomas Sheridan complains of the wide-spread practice of stressing naturally unaccented syllables in declamation; this affection, he says, is particularly prevalent in the reading of the church service. Sheridan makes the same observation over twenty years later and supplies the information that this habit of laying a stress on every alternate syllable is generally acquired in the elementary schools (many of them taught, of course, by the very grammarians whose hack textbooks helped perpetuate Bysshian syllabism[7] and stress regularity), from which institutions it is carried abroad to corrupt the whole world of readers.

A bit further on, Fussell (1966, 64) calls attention to the sensible comments of John Rice, another eighteenth-century prosodist:

> John Rice in 1765 terms artificial elocution a "vicious Custom," and says that it is the "common Method" of reading aloud. Most readers, Rice asserts, would read the line
>
> > Tow'rds four fair Nymphs, ran four tall men full speed
>
> as if it consisted of five iambic feet, when it should be read with precisely equal stress on each word. Rice calls the fashionable elocution "artificial Modulation," and says that it "breaks in upon that natural Modulation [i.e., sense elocution] which is essential to Expression."

One gets the impression that the eighteenth century was a hotbed of debate about how lines ought to be recited. Had metrical commentators had more of an appreciation of the rule-based approach described here, the hotbed might have cooled a bit.

8 Repetition and Framing

I have often wondered, "Why meter in the first place?" I would like to attempt an explanation. At first, I thought meter was a kind of framing. I had in mind the kind of frame one finds in poetry—the *Odyssey*, for example. In book I Athena urges Telemachus to leave Ithaca and seek word of his father. He visits Pylos and Sparta. In book XV she urges him to leave Sparta and return to Ithaca. In between Telemachus's journey (one intended to limn his growth from boyhood to manhood), Odysseus's adventures take place. In Chaucer's *Book of the Duchess* a knight who has lost his lady is deep in sorrow. He falls asleep and in a dream explores his loss. At the end he wakes up and decides to set his dream in verse. Indeed, the multitude of tales that begin *Once upon a time* and end *And they all lived happily ever after* are frame stories. I conjectured that meter serves as a kind of frame for the poetry that it embodies. But thinking it through, I am led to conclude that that can't be right. Still, it might be useful to go through the reasoning that led me to look elsewhere for meter's *raison d'être*.

I began by asking what Raphael's *Madonna della Sedia* has in common with Wallace Stevens's "Anecdote of the Jar." I thought of this pair because "Anecdote of the Jar" is to my mind an especially good example of framing in a metrical poem. Perhaps, I thought, Stevens's exercise of framing matched that of the painting.

Figure 8.1 shows the painting as it appears in its Wikipedia entry, and figure 8.2 shows it as it appears hanging in the Pitti Palace in Florence, where it is displayed in the Room of Saturn. The obvious difference between the two images, of course, is the frame, which was added in the seventeenth century. This over-the-top frame is a favorite topic in E. H. Gombrich's *Sense of Order* (1979, 156–157):

Figure 8.1
Unframed image of Raphael's *Madonna della Sedia* (Pitti Gallery, Florence, Italy)
(https://en.wikipedia.org/wiki/Madonna_della_Seggiola)

> We here come back again to the strange object we considered at the outset of
> this investigation—the ornate and sumptuous frame of Raphael's *Madonna della
> Sedia*. . . . Without a frame there can be no centre. The richer the elements of the
> frame, the more the centre will gain in dignity. We are not meant to examine
> them individually, only to sense them marginally, and once more "marginally"
> here oscillates between a mere metaphor and a literal description.

Recall Gombrich's view that ornamentation differs radically from mimetic
or figurative art because, however complicated, it is never meaningful in
the way a mimetic image is. That doesn't mean that ornamentation is anti-
thetical to imagery. Quite the contrary; as figure 8.2 illustrates, ornamenta-
tion in the form of a frame enhances an image because it makes the image
the center of attention. Comparing the frameless *Madonna* in figure 8.1
with the image in figure 8.2 tells the story. When you look at the latter
image, your attention is not on the frame. Rather, the frame directs your

The scansions are identical.[2] But, if "emotional disturbance" is meant to be imparted to (1a) because of its metrical form, why doesn't that happen in (1b) and (1c)? If (1a) evokes emotional disturbance, why not leave it at that without any help from the metrical forms that, as lines (1b) and (1c) illustrate, sit just as nicely on lines whose content is not in the slightest tinged with emotional disturbance?

If you were to separate the stress from the words, using the syllable *te* for less stress and *tum* for more stress, then representation of the stresses in the lines in (1) would be *te-tum te-tum tum te te tum te tum*. Now ask an English speaker what *heaven* means and that speaker will easily provide a definition. Ask that same speaker what *te-tum te-tum tum te te tum te tum* means and the answer is likely to be a puzzled expression. My conclusion is that stress in and of itself is not meaningful, and the similarity of the metrical patterns in (1) suggests that the idea that metrical stress contributes meaning to a line of verse is dubious.

If metrical stress has no meaning, then it may well be a candidate for ornamentation, like the frame around the *Madonna della Sedia*. But what sort of ornamentation?

Viewing meter as an ornament like rhyme suggests that it is the poetic counterpart of the frame of a painting. Both types of frame deliver pleasure. Neither delivers meaning. To borrow Gombrich's phrase, meter centers the content of its line the way a frame centers its image. But this is where the parallel falters. Meter participates in the form and shape of a poem in a way that the frame of a painting does not and, indeed, should not.

To see this, let's pause for a moment and consider the notion of framing in poetry—in particular, in the Wallace Stevens poem mentioned earlier called "Anecdote of the Jar":

(2) I placed a jar in Tennessee,

 And round it was, upon a hill.

 It made the slovenly wilderness

 Surround that hill.

 The wilderness rose up to it,

 And sprawled around, no longer wild.

 The jar was round upon the ground

 And tall and of a port in air.

It took dominion everywhere.

The jar was gray and bare.

It did not give of bird or bush,

Like nothing else in Tennessee.

The poem is divided into two separated topics; what the jar was and what the jar did:

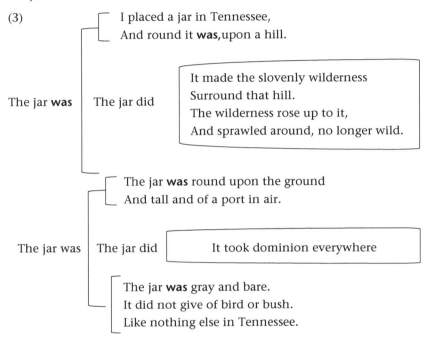

What the jar was surrounds what the jar did. One might think of the poem as the poetic version of a diptych, whereby two frames (what the jar is) encompass two images (what the jar does to what it frames).

Line 7 is the pivot of the poem, the axis around which it turns. The couplet that the line initiates forms the edge of two frames. Stevens calls our attention to line 7 by making it the only line that rhymes internally.

Displaying the poem as in (3) reveals a fundamental difference between the *Madonna* frame and the literary frame employed by Stevens. The *Madonna* frame simply encircles its image. Stevens's literary frame transforms the image. Here is how that transformation works:

(4) The jar was *round*

 It made the slovenly wilderness sur + *round* the hill

 the wilderness rose up to it and sprawled a + *round*

 The jar was *round*

 upon the g + *round*

The roundness of the jar imposes itself on the wilderness and changes it. The adjective *round* reflects this in its occurrence in the verb *surround* and the adverb *around*. Thus, the frame in "Anecdote" couldn't be more different from the frame around the *Madonna*. The latter focuses; the former distorts. It is as if the jar were a lens that creates the appearance of an order that doesn't exist. It is not too much of a leap, I think, to see the jar as a metaphor for the work of a poet. By way of contrast, the frame around the *Madonna* has no such impact on the image that it frames.

And this is where meter comes in. "Anecdote" is written in iambic tetrameter, except for line 4, which is iambic dimeter, and line 10, which is iambic trimeter. The rules of metrical behavior predetermine the poet's choices of and placement of words, phrases, sentences—all the constituents of language. Like its jar, the poem's metrical rules "take dominion everywhere," but unlike the jar, "everywhere" is limited to the domain of primary-stressed and lesser-stressed syllables. Thus, Stevens has chosen fifty-eight monosyllabic and thirteen polysyllabic words: *Tennessee* (twice), *dominion, slovenly, wilderness* (twice), *surround, around, upon* (twice), *longer, everywhere, nothing*. The line is made up of WSWSWSWS units for ten of the lines, WSWSWS once and WSWS once. The monosyllabic words are free to go anywhere. But for all thirteen polysyllabic words, Stevens has chosen to place their main stress on an S position. This choice doesn't add to the content of the line. Rather, it makes the line march to a predetermined metrical drumbeat (iambic). But beyond that, the stress patterns of the lines have no relationship at all to the literary frame at work in the poem.

When modern poetry abandoned meter and rhyme, it was abandoning the only way a listener could determine where the minimal poetic unit, the line, ended. Without a meter to determine where a metrical line ends, poetry devolves into prose, which is tantamount to saying that modern poetry sans meter and rhyme became a visual art form—because to retain its character as poetry, it is necessary to have something repeated. All that

was left to repeat was the line. However, without meter or rhyme, one could no longer hear where the line ended. Sight was all that was left. One could certainly *see* where it ended.[3]

Regarding this shift H. T. Kirby-Smith (1998, 211) writes:

> As we approach the end of the twentieth century, the truth is that for much published poetry its appearance on the page does matter—that in fact visual arrangement may be more important than any recurrent patterns that appeal to the ear.

And as Kirby-Smith (1998, 45) exclaims with respect to the poetry of William Carlos Williams and H.D.:

> The patterning also says to us: "Do not listen for regular rhythms! Suspend your requirements for aural equivalence! Use your eyes! See what I'm talking about!"

He might well have added e. e. cummings to the list. So why, then, do critics compare metrical poetry to music (see, for example, the passage from Bernstein 1976 early in chapter 1)? The point must be clear by now: that it is repetition, modified in one way or another, that gives poetry its musical qualities, because repetition is so essential to music itself.

When Bernstein says that it is repetition that gives poetry its musical qualities, I believe what lies behind that intuition is the fact that meter validates the notion of a repetitive line and therefore emulates what Bernstein considers so essential to music, namely, repetition. In the metrical analysis of Sonnet 30 in chapter 7, we saw a wildly varying distribution of weaker and stronger stresses from one line to another. But we also saw a repeating pattern of W and S units. These units defined the length of the line. They were the repetitive element in metrical poetry. But it didn't stop there. These units were mapped onto syllables in a one-to-one fashion, leaving some units to correspond to primary-stressed syllables and the remainder to correspond to lesser-stressed syllables. However, not all possible correspondences were allowed. It was the business of correspondence rule (8) to separate the wheat from the chaff. This operation is what turned metrical poetry into a *same/except* phenomenon just like end rhyme or rhyming melodies. The same line length is like the same rime. The differing stress distributions are like the different onsets in end rhyme. The parallel is not exact, of course. Onsets must be different. Stress distributions need not be, though they usually are. But the underlying point is the same. Both require *same/except* judgments. Metrical lines are the same except for certain prescribed distributions of stressed syllables. From this

perspective end rhyme has a double function. It enhances the *same/except* function of the correspondence rule but it also punctuates the end of a metrical line.

Recall that Milton wrote *Paradise Lost* without rhyme but not without meter. Its first sentence consists of sixteen metrically identical lines.

(5) Of Mans First Disobedience, and the Fruit

Of that Forbidden Tree, whose mortal tast

Brought Death into the World, and all our woe,

With loss of *Eden*, till one greater Man

Restore us, and regain the blissful Seat,

Sing Heav'nly Muse, that on the secret top

Of *Oreb*, or of *Sinai*, didst inspire

That Shepherd, who first taught the chosen Seed,

In the Beginning how the Heav'ns and Earth

Rose out of *Chaos*: or if *Sion* Hill

Delight thee more, and *Siloa's* brook that flow'd

Fast by the Oracle of God; I thence

Invoke thy aid to my adventrous Song,

That with no middle flight intends to soar

Above th' *Aonian* Mount, while it pursues

Things unattempted yet in Prose or Rhime.

His justification for abandoning rhyme appears in this passage ahead of the poem entitled "Paradise Lost: The Verse" (1658–1663):

> The measure is English heroic verse without rime, as that of Homer in Greek, and of Virgil in Latin—rime being no necessary or true ornament of poem or good verse, on longer works especially, but the invention of a barbarous age, to set off wretched matter and lame metre.

Presumably he kept meter to keep the repetitive line. And whether he did it for traditional reasons or not, the effect was to retain the only other major source of repetition in the poem once rhyme was gone.

I propose, then, that meter's primary function is to define the poetic line and, as a consequence, to infuse the poem with the pleasure that readers experience in discovering identical line after identical line. Correspondence rules make that identification more of a challenge and hence more

pleasurable as readers make their way through the thicket of wildly varying patterns of stress placement.[4]

This suggests an important parallel between metrical poetry and music. Let us consider how music and metrical poetry introduce repetition. We know that the latter does it through meter and rhyme. Music does it in several ways: for example, melodic rhyme as in "Satin Doll" or repeat signs after several measures of music as in the AABA pattern of "Satin Doll." But the most fundamental device of all is the time signature. This specifies the number of beats that each measure written in that time signature must have. If a piece of music is written in 3/4 time, then every measure will conform to the constraint of three beats in a measure (the 3 of the time signature 3/4) with a quarter note getting one beat (the 4). The number of variations that this formula introduces is surprisingly large. One can have three quarter-note beats and the time signature is fulfilled. But one can also have one half note and one quarter note, or one dotted half note, or one dotted quarter note and three eighth notes, or one quarter note and four eighth notes, or six eighth notes or . . . well, you get the idea. A whole note and a quarter note would not be possible in a 3/4 time measure since they would exceed three quarter notes in duration.

So, in 3/4 time to yield all possible rhythms, you start with a whole note that is three beats long, and the set of all possible rhythms is derived by dividing the whole note into halves and continuing the halving operation as often as you like. The limitation is a practical one, the ability of the musician to play the rhythm. The counterpart of a correspondence rule in poetry would be the constraint that the total of the note values in a measure must never exceed three in a 3/4 time signature, four in a 4/4 time signature, and so forth.

And just as a musical measure can be fulfilled with a variety of rhythmic patterns, so too in poetry a variety of different stress patterns can be substituted for the basic $(WS)^n$ pattern so long as they conform to the rules. So the fundamental idea is that the measure is to music what the line is to a metrical poem. Both the measure and the line are a source of the pleasure that derives from repetition.[5] It is the time signature in music and the metrical rules in poetry that define them.

Some implications of this equivalency are worth mentioning. Most of the speech we hear during a typical day is ourselves talking silently to ourselves. Silent speech, the speech that we hear inside our head when we are

thinking, is what we use when we read a poem without vocalizing. It is this inner ear that lets us hear the alliteration in *And the silken sad uncertain rustling of each purple curtain* even though we are not exercising our speech apparatus. Because natural language does not vocalize line endings, the experience of coming to the end of a free verse line is strictly visual. If your eyes are closed as you listen to Pound's *Canto 81*, the one in which he wrote *To break the pentameter, that was the first heave*, you have no idea where one line ends and the next begins. But Pound has obviously gone to great trouble to adjust line length. If you want to enjoy that, open your eyes. Indeed, the best way to experience free verse is to read it to yourself, either aloud or silently. Whatever you do, don't recite it from memory, unless your memory is eidetic. So long as you can see the text while you are reading it, line endings and unusual spacing on the page won't be lost. This visual aspect is not necessary when listening to music or metrical verse.

From this perspective, the change in poetry that overshadowed metrical and rhyming verse at the turn of the twentieth century was the abandonment of repetition and hence of a source of pleasure. What it gained was grammatical freedom. Poets could put *dominion everywhere* wherever they pleased. And, as noted, a corollary of this freedom was that poetry became a visual art form as opposed to an aural one, leaving the variable line as the last vestige of poetic form. Poetry was now almost exclusively in the realm of meaning. And that meant, among other things, an enhanced role for syntactic structure[6] in the making of a poem.[7]

9 Repetition and Formulas

It is rare in the annals of literary criticism to find an article that effects a sea change in its field. In the case of Ancient Greek that article was Milman Parry's "Studies in the Epic Technique of Oral Verse-Making: I. Homer and Homeric Style," published in 1930. Part II, "Studies in the Epic Technique of Oral Verse-Making: II. The Homeric Language as the Language of an Oral Poetry," appeared in 1932. Parry's major insight was the discovery of an all-pervasive use of what he called *formulas* and the conclusion that he drew from that discovery. In the words of Adam Kirsch (2021, 73), in a review of Robert Kanigal's biography of Parry:

> We may not know when Homer was born, but we can say for certain that he ceased to exist in the early nineteen-thirties, when a young Harvard professor named Milman Parry published two papers, in the journal *Harvard Studies in Classical Philology*, with the seemingly innocuous title "Studies in the Epic Technique of Oral Verse-Making." Parry's thesis was simple but momentous: "It is my own view, as those who have read my studies on Homeric style know, that the nature of Homeric poetry can be grasped only when one has seen that it is composed in a diction which is oral, and so formulaic, and so traditional." In other words, the Iliad and the Odyssey weren't written by Homer, because they weren't written at all. They were products of an oral tradition, performed by generations of anonymous Greek bards who gradually shaped them into the epics we know today. Earlier scholars had advanced this as a hypothesis, but it was Parry who demonstrated it beyond a reasonable doubt.

In what follows I will try to show a similarity between the oral-formulaic technique proposed by Parry and Margulis's experiment. Think of her cut-and-pasted segments as the counterpart of formulas in the oral-formulaic tradition. Mutatis mutandis, the repetition of the formulas is a formula (repetition intended) for injecting pleasure into the narrative. Thus, the

use of formulas in oral poetry, doubtless a useful mnemonic device for the singers as they improvised their songs, had the unexpected side effect of enhancing aesthetic appeal, just as Margulis's cut-and-pasted segments did for the Berio and Carter compositions.

The discovery of formulas led to three fundamental questions:

1. What are they?
2. How are they used?
3. Where did they come from?

Let's deal with each of these separately.

What Are They?

Parry (1930, 80) defines the formula in the Homeric poems as

> a group of words which is regularly employed under the same metrical conditions to express a given essential idea.

One important characteristic of the formula is that it consists of a group of words whose syllable structure corresponds to a specific meter, namely, dactylic hexameter.[1] As Parry illustrates (1930, 81):

> Homer uses θεὰ γλαυκῶπις Ἀθήνη [divine, wide-eyed Athena] fifty times to express in the last half of the verse, after the trochaic caesura of the third foot, the idea 'Athena'.

A second characteristic is that formulas frequently reoccur. Parry notes (1930, 122):

> The expressions in the first twenty-five lines of the *Iliad* which are solidly under-lined[2] as being found unchanged elsewhere in Homer count up to 29, those in the passage from the *Odyssey* to 34. More than one out of every four of these is found again in eight or more places, whereas in all Euripides there was only one phrase which went so far as to appear seven times.

He (1928, 39) provides a table that maps the number of occurrences of noun + epithet formulas of the sort normally translated as 'white-armed Hera', 'divine Odysseus', 'wine-dark sea', 'wide-eyed Athena', and so on (see figure 9.1). These are cross-referenced with the metrical role the formula plays in the hexameter line. For example, δῖος Ὀδυσσεύς 'divine Odysseus' occurs sixty times between the bucolic diaeresis[3] and the end of the line.

TABLE I—NOUN–EPITHET FORMULAE OF GODS AND HEROES IN THE NOMINATIVE CASE; PRINCIPAL TYPES

(An asterisk * indicates that the metre of a name makes a noun-epithet formula impossible in the metre in question)

	Between the bucolic diaeresis and the end of the line ⏑––⏑––⏑		Between the hepthemimeral caesura and the end of the line ⏑⏑–⏑⏑––		Between the feminine caesura and the end of the line ⏑–⏑⏑–⏑⏑–⏑		Between the beginning of the line and the penthemimeral caesura –⏑⏑–⏑⏑–		Noun-epithet formulae of different types	Different types of formulae
Ὀδυσσεύς	δῖος Ὀδυσσεύς	60	πολύμητις Ὀδυσσεύς	81	πολύτλας δῖος Ὀδυσσεύς	38	διογενὴς Ὀδυσσεύς	4	12	8
	ἐσθλὸς Ὀδυσσεύς	3	πτολίπορθος Ὀδυσσεύς	4						
Ἀθήνη	Παλλὰς Ἀθήνη	39	γλαυκῶπις Ἀθήνη	26	θεὰ γλαυκῶπις Ἀθήνη	51	Παλλὰς Ἀθηναίη	8	11	6
	[ὀβριμοπάτρη]	2			ἠλακομενηὶς Ἀθήνη	2				
Ἀπόλλων	Φοῖβος Ἀπόλλων	33	Διὸς υἱὸς Ἀπόλλων	2	ἄναξ Διὸς υἱὸς Ἀπόλλων	5	[Φοῖβος ἀκερσεκόμης]	1	15	5
			ἑκάεργος Ἀπόλλων	6	ἄναξ ἑκάεργος Ἀπόλλων	3				
			κλυτότοξος Ἀπόλλων	1						
Ἀχιλλεύς	δῖος Ἀχιλλεύς	34	πόδας ὠκὺς Ἀχιλλεύς	31	ποδάρκης δῖος Ἀχιλλεύς	21			10	7
	υἱὸς Ἀχιλλεύς	5	μεγάθυμος Ἀχιλλεύς	1						
Ζεύς	μητίετα Ζεύς	18	νεφεληγερέτα Ζεύς	30	[πατὴρ ἀνδρῶν τε θεῶν τε]	15	Ζεὺς ὑψιβρεμέτης	5	39	24
	εὐρύοπα Ζεύς	14	Ζεὺς τερπικέραυνος	4	Ὀλύμπιος εὐρύοπα Ζεύς	1				
			στεροπηγερέτα Ζεύς	1						
Ἥρη	πότνια Ἥρη	11	λευκώλενος Ἥρη	3	βοῶπις πότνια Ἥρη	11			3	3
					θεὰ λευκώλενος Ἥρη	19				
Ἕκτωρ	φαίδιμος Ἕκτωρ	29	κορυθαίολος Ἕκτωρ	25	μέγας κορυθαίολος Ἕκτωρ	12	Ἕκτωρ Πριαμίδης	6	11	7
	ὄβριμος Ἕκτωρ	4								
Νέστωρ	ἱππότα Νέστωρ	1			Γερήνιος ἱππότα Νέστωρ	31			7	4
Ἄρης	χάλκεος Ἄρης	5	χρυσήνιος Ἄρης	1	βροτολοιγὸς ὄβριμος Ἄρης	1			12	10
	ὄβριμος Ἄρης	5			Ἄρης ἆτος πολέμοιο	3				
Διομήδης	[Τυδέος υἱός]	8	κρατερὸς Διομήδης	12	βοὴν ἀγαθὸς Διομήδης	21			7	5
			ἀγαθὸς Διομήδης	1						
Ἀγαμέμνων	*		κρείων Ἀγαμέμνων	26	ἄναξ ἀνδρῶν Ἀγαμέμνων	37	[ἥρως Ἀτρείδης]	3	15	6
				1						

Figure 9.1

Table indicating frequency of noun epithets in nominative case in the *Odyssey* from Parry 1928, 39

That is, sixty different lines in the *Odyssey* end with the expression δῖος Οδυσσεύς, whose syllable structure corresponds to the metrical sequence long, short, short, long, long: in English, "shave and a haircut." The formula begins after the fourth foot (the bucolic diaeresis):

(1) F₁ F₂ F₃ F₄ F₅ F₆

 [δῖ ος Οδ] [υσσ εύς]

 [dii os # od [us seus]

 | | | | |

 – u u – –

As the numbers in figure 9.1 to the right of the noun + epithet expressions indicate, there is quite a bit of repetition. For example, θεὰ γλαυκῶπις Ἀθήνη 'divine wide-eyed Athena' occurs fifty-one times between a feminine caesura and the end of the line. Elsewhere Parry provides a similar list of formulaic finite verbs of which the following are four examples:

(2)

αὐτὰρ ἐπεί⁴+ {

κατέπαυσα(δ 583)
'I brought it to a halt'

ὤπτησε(Ι 215)
'he/she roasted' (meat)

ἐτέλεσσε (λ 246)
'he/she brought to completion'

ἐνέηκε(δ 233
'he/she ordered'

Now we are in a position to create a well-formed dactylic hexameter line out of formulas. It is a bit like ordering from a Chinese menu, one item from list A, one item from list B. In this case, let us select from figure 9.1, the noun + epithet list, the second item from the third column: θεὰ γλαυκῶπις Ἀθήνη 'divine wide-eyed Athena'. From (2) we select the first item, taking pains to change the verbal ending to agree with a third person singular subject. Putting the two together, we get:

(3) αὐτὰρ ἐπεὶ κατέπαυσε θεὰ γλαυκῶπις Ἀθήνη

 autar epei katepause theaa glaukoopis Atheenee

 'When divine wide-eyed Athena brought it to a halt.'

The entire line is made up of formulas.[5]

How Are They Used?

This is what Parry (1932, 6) says about the way formulas are used:

> [The oral poet] makes his verses by choosing from a vast number of fixed phrases which he has heard in the poems of other poets. Each one of these phrases does this: it expresses a given idea in words which fit into a given length of the verse. Each one of these fixed phrases, or formulas, is an extraordinary creation in itself. It gives the words which are best suited for the expression of the idea, and is made up of just those parts of speech which, in the place which it is to fill in the verse, will accord with the formulas which go before and after to make the sentence and the verse. Each formula is thus made in view of the other formulas with which it is to be joined; and the formulas taken all together make up a diction which is the material for a completely unified technique of verse-making.

Parry describes the process as, at bottom, finite. He doesn't tell us that the number of phrases is infinite, even though the grammar of the oral poet's native language has the capability, like the grammar of any natural language, to generate an infinite number of formulas (as well as sentences). Rather, he says that the oral poet has access from memory—this is an art form that predates writing—to a vast number of "fixed phrases."[6] The model that he describes seems to work like this:

(4) 1. There is a vast number of fixed phrases that the poet has access to.

2. There is a fixed phrase for every occasion, one that embodies the "right" idea in the right grammatical shape corresponding to a specific metrical pattern.

3. The oral poet puts together a poem/song/epic by making fortuitous selections from the store of "fixed phrases" that he has heard and committed to memory.

Where Did They Come From?

However, this account is at bottom static. The system is finite. Parry seems aware of this when he writes (1932, 7):

> When one singer (for such is the name these oral poets most often give themselves) has hit upon a phrase which is pleasing and easily used, other singers will hear it, and then, when faced at the same point in the line with the need of expressing the same idea, they will recall it and use it.

Everything hangs on what he means by "When one singer . . . has hit upon a phrase which is pleasing and easily used." On the face of it, this contradicts his earlier reference to "a vast number of fixed phrases." But the discrepancy is easily reconciled if we suppose that Parry allows for two dialects. The first is the poetic language that has come down from predecessors whose formulas, having passed the test of time and usage, have become part of a fixed poetic language. The second is that of the singer who makes up a candidate for a new formula using his native language and his knowledge of meter and then, as they say, runs it up the flagpole to see who will salute it.

Indeed, as the continuation of Parry's article suggests (1932, 7), he seems to view the creation of formulas as a kind of Darwinian survival of the fittest:

> If the phrase is so good poetically and so useful metrically that it becomes in time the one best way to express a certain idea in a given length of the verse, and as such is passed on from one generation of poets to another, it has won a place for itself in the oral diction as a formula.

There is an important perspective on the nature of the special dialect of the Homeric epics that is worth noting before we move on. Regarding the origin of the dialect in question, Leonard Muellner (personal communication) writes:

> Ancient Greek society (which covered the west coast of Turkey, the islands and the mainland part of what is now the Greek nation state, and many colonies in Italy as well as around the Mediterranean for example in what is now Libya) was a society of city-states with a variety of different ways of organizing themselves. These city-states were by default at war (and that does not always mean literally acting violently to each other, though sometimes there was ritualized violence); the main thing is that until you had imperialistic city-states like Athens and Sparta and Macedonia in the 5th and 4th centuries BCE, no citizen had any rights in someone else's city-state except if they were an appointed ambassador or had the status of a resident alien. These city-states had their own customary law codes, their own religious festivals and calendar, their own divinities as well; along with differentiating dialects of Greek. So what did they have in common? The crown games—the Nemean, Pythian, Isthmian, and Olympic Games—where a general truce was declared so that people could travel to them and compete with each other in "sports" that were actually training for warriors, like throwing a javelin at a target, or running and jumping off or onto a chariot. That was one of the things that all "Hellenes" shared in, and another was Homeric poetry, which had currency across city-states. So the dialectal mélange is not just an accident but a consequence of this sort of "trans-national" investment in something overarching

that gave all these diverse and uncooperating city-states some common identity, and it enabled them to cooperate when they were menaced as a whole by external powers like the Persian Empire.

Formulas and Repetition

Assuming something like the above picture to be correct, two observations can be made. First, Parry's reconstruction of how oral poetry is fashioned provides a ready-made account of how singers, in a nonwriting environment, remember long stretches of their songs. Formulas are a valuable mnemonic device that enables singers to more easily construct their songs.

But, second, this process has an unexpected and desirable side effect. Notice that our made-up line, repeated in (5), contains a noun + epithet hemistich, θεὰ γλαυκῶπις Ἀθήνη, which, according to Parry, occurs fifty-one times in the *Odyssey* (see figure 9.1):

(5) αὐτὰρ ἐπεὶ κατέπαυσε θεὰ γλαυκῶπις Ἀθήνη

'When divine wide-eyed Athena brought it to a halt.'

Here we can connect with Elizabeth Margulis's (2013b, 15) observation quoted in chapter 1:

> The simple introduction of repetition, independent of musical aims or principles, elevated people's enjoyment, interest, and judgments of artistry. This suggests that repetition is a powerful and often underacknowledged aesthetic operative.

That is to say, the process of oral formulaic composition is at its very core repetitious, and repetition, as Margulis argues, is inherently associated with aesthetic pleasure.

In a paper entitled "Poetics of Repetition in Homer" (2022, 1), Gregory Nagy proposes that

> repetition in Homeric poetry is a matter of performance, not only composition. I argue that this observation applies to the Homeric phenomenon of "repeated utterances."

Later he adds (2022, 1):

> Essential for my argument is the idea that Homeric composition comes to life in performance. In oral poetry, performance is essential to composition: the composition of oral poetry is a matter of recomposition-in-performance. If it is true that the Homeric text derives from oral poetry, then the phenomenon of repeated utterances is itself a matter of performance, not only composition.

He illustrates what he means by repetition using two passages from the *Iliad*. Here is the first:

(6) A *Iliad* 6.87–101

Ἕκτορ ἀτὰρ σὺ πόλιν δὲ μετέρχεο, εἰπὲ δ' ἔπειτα

As for you, Hector, go back to the citadel and, once you get there, say'

μητέρι σῇ καὶ ἐμῇ· ἣ δὲ ξυνάγουσα γεραιὰς

'to that mother of mine and of yours that she should assemble the venerable women'

νηὸν Ἀθηναίης γλαυκώπιδος ἐν πόλει ἄκρῃ

'at the temple of Athena, [goddess] with the looks of an owl— [assemble them] on the heights of the citadel'

οἴξασα κληῖδι θύρας ἱεροῖο δόμοιο

'—and that she should open with the key the doors of the sacred edifice'

90 πέπλον, ὅς οἱ δοκέει χαριέστατος ἠδὲ μέγιστος

'and get a peplos, whichever one she thinks has the most pleasurable-beauty [*kharis*] and size'

εἶναι ἐνὶ μεγάρῳ καί οἱ πολὺ φίλτατος αὐτῇ,

'[of all the *peploi*] in the palace—the one [*peplos*] that is by far the most near-and-dear to her—'

θεῖναι Ἀθηναίης ἐπὶ γούνασιν ἠϋκόμοιο,

'and place it on the knees of Athena, [goddess] with the beautiful head of hair,'

καί οἱ ὑποσχέσθαι δυοκαίδεκα βοῦς ἐνὶ νηῷ

'while promising to her, in the temple, that she [= our mother] will take twelve cows'

ἤνις ἠκέστας ἱερευσέμεν, αἴ κ' ἐλεήσῃ

'that are yearlings, not yet touched by the goad, and that she will sacrifice them, in hopes that she [= Athena] will take pity'

95 ἄστυ τε καὶ Τρώων ἀλόχους καὶ νήπια τέκνα,

'on the city and on the wives of the Trojans, also on their unaware [nēpia] children,'

ὥς κεν Τυδέος υἱὸν ἀπόσχῃ Ἰλίου ἱρῆς

'so that [Diomedes] the son of Tydeus will be kept away by her [= Athena] from the sacred city of Ilion [= Troy],'

ἄγριον αἰχμητὴν κρατερὸν μήστωρα φόβοιο,

'[Diomedes,] that savage wielder of the spear, that harsh one, that master of making the enemy flee from him in terror.'

ὃν δὴ ἐγὼ κάρτιστον Ἀχαιῶν φημι γενέσθαι.

'He has become the most powerful, I say, of all the Achaeans.'

οὐδ' Ἀχιλῆά ποθ' ὧδέ γ' ἐδείδιμεν ὄρχαμον ἀνδρῶν,

'Not even Achilles have we ever feared so much—even [Achilles,] that leader of men,'

100 ὅν πέρ φασι θεᾶς ἐξέμμεναι· ἀλλ' ὅδε λίην

'the one they say was born of a goddess. But this one [Diomedes] is utterly'

μαίνεται, οὐδέ τίς οἱ δύναται μένος ἰσοφαρίζειν.

'berserk, and nobody can match him in power [menos].'

About two hundred verses later, Hector conveys this mantic formulation to his mother Hecuba:

(7) B *Iliad* 6.269–278

ἀλλὰ σὺ μὲν πρὸς νηὸν Ἀθηναίης ἀγελείης

'As for you, [Hecuba,] make your way to the temple of Athena, the one who drives livestock that is raided,'

270 ἔρχεο σὺν θυέεσσιν ἀολλίσσασα γεραιάς·

'going there with livestock-to-be-sacrificed, having assembled the venerable women'

πέπλον δ', ὅς τίς τοι χαριέστατος ἠδὲ μέγιστος

'and get a *peplos*—whichever one you think has the most pleasurable-beauty [kharis] and size'

ἔστιν ἐνὶ μεγάρῳ καί τοι πολὺ φίλτατος αὐτῇ,

'[of all the *peploi*] in the palace—the one [*peplos*] that is by far the most near-and-dear to you yourself—'

τὸν θὲς Ἀθηναίης ἐπὶ γούνασιν ἠϋκόμοιο,

'and place it on the knees of Athena, [goddess] with the beautiful head of hair,'

καί οἱ ὑποσχέσθαι δυοκαίδεκα βοῦς ἐνὶ νηῷ

'while promising, in the temple, that you will take twelve cows'

275 ἤνις ἠκέστας ἱερευσέμεν, αἴ κ' ἐλεήσῃ

'that are yearlings, not yet touched by the goad, and that you will sacrifice them, in hopes that she [= Athena] will take pity'

ἄστύ τε καὶ Τρώων ἀλόχους καὶ νήπια τέκνα,

'on the city, and on the wives of the Trojans, also on their unaware [*nēpia*] children,'

αἴ κεν Τυδέος υἱὸν ἀπόσχῃ Ἰλίου ἱρῆς

'so that [Diomedes] the son of Tydeus will be kept away by her [= Athena] from the sacred city of Ilion [= Troy],'

ἄγριον αἰχμητὴν κρατερὸν μήστωρα φόβοιο.

'that savage wielder of the spear, that harsh one, that master of making the enemy flee from him in terror.'

The material from lines 271–278 almost exactly repeats lines 90–97 in the passage two hundred lines earlier with differences introduced because of the need to change pronouns and associated verb forms: something like 'whichever one she thinks' in the first passage (line A 90) and 'whichever one you think' in the second (line B 271).[7]

These passages could easily be construed as part of a Margulis-like experiment. It would be interesting to read them to an appropriate audience, first with the second passage altered by deleting the repeated section; the second time with the deleted selection restored. One wonders if the listeners' reactions would parallel those reported by Margulis (2013b).[8]

I mentioned at the start of this chapter that it is a rare event in the history of scholarship when an article effects a sea change within a particular

CHART I

(Béowulf, ll. 1–25)

Hwæt, wé Gár-Dena on géar-dagum
þéod-cyninga þrymm gefrugnon,
hú þá æðelingas ellen fremedon.
Oft Scield Scéafing sceaðena þréatum,
5 manigum mǽgðum medu-setla oftéah,
egesode Eorle, siþþan ǽrest wearþ
féasceaft funden; hé þæs frófre gebád,
wéox under wolcnum, weorþ-myndum þáh,
oþ-þæt him ǽghwelc ymbsittendra
10 ofer hran-ráde híeran scolde,
gamban gieldan; þæt wæs gód cyning!
þǽm eafora wæs æfter cenned
geong on geardum, þone God sende
folce to frófre; firen-þearfe ongeat
15 þe híe ǽr drugon ealdorléase
lange hwíle; him þæs Líf-fréa,
wuldres Wealdend weorold-áre forgeaf
Béow wæs bréme — blǽd wíde sprang —
Scieldes eafora Sceden-landum on.
20 Swá sceal geong guma góde gewyrcan
framum feoh-giftum on fæder bearme
þæt hine on ielde eft gewunien
will-gesíðas þanne wíg cume,
léode gelǽsten; lof-dǽdum sceal
25 on mǽgða gehwǽm man geþéon.

Figure 9.2

First twenty-five lines of the Anglo-Saxon epic *Beowulf* with formulas underlined by Francis P. Magoun Jr. (1953, 464)

discipline. Milman Parry's work—in his case two articles and a French dissertation—certainly did that for the classics, although classicists by no means all agree over the single versus multiple authorship of the Homeric epics. Nonetheless, Parry's work has had significant influence outside the classics. In 1953 the philologist Francis Magoun wrote an article entitled "Oral-Formulaic Character of Anglo-Saxon Narrative Poetry" in which he accepts Parry's position lock, stock, and barrel. Examining the first twenty-five lines of *Beowulf*, he writes (1954, 449–450):

In a word, despite the relatively limited corpus of some 30,000 lines—about the same as the two Homeric poems—in which to find corresponding phrases, some seventy per cent of the text of this passage does occur elsewhere. Were the surviving corpus, say, twice as big and if, above all, we had other songs of any extent dealing with anything like the same thematic material, there well might be almost nothing in the language here used that could not be demonstrated as traditional.

Though usefulness rather than mere repetition is what makes a formula, it is instructive to look at the repeated formulas first since it is easier to recognize a formula as such when it occurs a second or third time, and from this regular use in various songs one readily sees how it helps this and that singer to compose his verses. Verses 1b, 3a, 3b, 4b, 5a, 5b, 8a, 10b, 11b, 13a, 14a, 15a, 16a, 17a, 23a, and 25a are of this sort. They occur exactly the same elsewhere or with only some insignificant change in inflection about which a singer would scarcely have to devote conscious thought in order to fit them into some different context or slightly different grammatical situation. The very fact of their recurrence in and/or outside of this passage bears witness to their usefulness not only to the singer of *Béowulf* but to singers of many other songs dealing with quite different themes.

In figure 9.2 Magoun underlines the phrases that he counts as formulas.[9]

So here we have another significant literature that is a candidate for the oral-formulaic mantle.

10 Repetition and Galant

In a remarkable study Robert Gjerdingen (2007) has undertaken to describe the galant style of music of the eighteenth century, that of great composers like Mozart and Haydn as well as lesser-known figures like Baldassare Galuppi and Pietro Locatelli. He sees in that style a method of composition that will resonate with readers of this book. As he writes (2007, 7–8):

> The art of galant music, like the art of figure skating, is replete with compulsory and free-style "figures." Whereas casual observers of ice-skating competitions may see only a variety of glides, spins, and jumps, a connoisseur sees salchows, axels, lutzes, and camels. Knowledge of the proper execution of each figure is a prerequisite for anyone officially assigned to judge a skater's abilities. Here are the figures used by the young Danish skater Mikkeline Kierkgaard in a recent performance:

> Triple salchow/double toe combination
> Steps into triple toe loop
> Flying camel spin
> Double axel
> Circular step sequence
> Combination spin including:
> Camel spin
> Sit spin
> Layback spin catching her foot
> (change of foot)
> Sit spin
> Upright spin
> Spiral sequence including:
> Forward outside spiral
> Backward outside spiral
> Forward outside Chinese spiral
> Layback spin

For comparison, here are the musical figures or schemata presented in the second half of a slow movement by the eighteenth-century Venetian composer Baldassare Galuppi (1706–1785 . . .):

> Quiescenza, diatonic, repeated
> Fonte/Monte combination
> Ponte, to Passo Indietro
> Comma, followed by Cudworth cadence
> Clausula Vera
> Meyer
> Ponte, tonic
> Monte/Converging cadence combination
> Fonte, repeated
> Monte, diatonic
> Clausula Vera
> Ponte
> Cudworth cadence . . . deceptive
> Passo Indietro to Mi-Re-Do cadence

Gjerdingen is saying that just as a figure-skating performance is put together by sequencing several discrete and independent elements, in the same fashion galant musical compositions came into being. Corresponding to entities like axel, salchow, and spin are elements with names like monte, fonte, and ponte. These are the names of self-contained musical building blocks about which Gjerdingen says (2007, 6), "[A] hallmark of the galant style was a particular repertory of stock musical phrases employed in conventional sequences." He goes on to say (p. 25) that these stock musical phrases arose from a method called partimento:

> The greatest maestros of the age worked in Italy, and they developed a unique method of instruction centered on the partimento—the instructional bass. A partimento resembled the bass part given to eighteenth-century accompanists, with the difference being the lack of any other players or their parts. The partimento was the bass to a virtual ensemble that played in the mind of the student and became sound through realization at the keyboard. In behavioral terms, the partimento, which often changed clefs temporarily to become any voice in the virtual ensemble, provided a series of stimuli to a series of schemata, and the learned responses of the student resulted in the multivoice fabric of a series of phrases and cadences. From seeing only one feature of a particular schema—any one of its characteristic parts—the student learned to complete the entire pattern, and in doing so committed every aspect of the schema to memory.

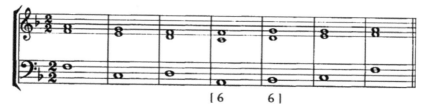

Figure 10.1

Example of a stock musical phrase of the galant period called the Romanesca (from Gjerdingen 2007, 26)

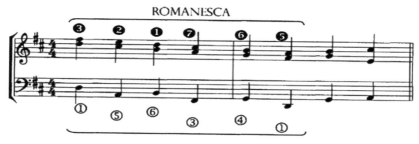

Figure 10.2

Fragment of Pachelbel's Canon in D Major, Andante, with the familiar melody line above the Romanesca (Gjerdingen 2007, 28)

For an example, see figure 10.1. The bass line (lower staff in the figure) is composed of notes in the F scale. The first measure contains the tonic, or F. The second contains the fifth of the scale, or C. The remaining notes in order are D (the sixth), A (the third), Bb (the fourth), C (the fifth), and back to F (the first, or tonic). This sequence was composed by Giacomo Tritto (1733–1824) and is from a partimento in F major (ca. 1810–1820). Gjerdingen has added the notes in the treble clef as an example of how a student might have fleshed out the bass line. In modern terms he has produced this chord progression: I-V-VI-I-IIm-V-I.

When pieced together, a string of bass lines, with added schemata, produces a composition. We've already seen this process in Gjerdingen's analysis of the second half of Galuppi's slow movement, which consists of thirteen schemata. Figure 10.2 shows a single fragment from Pachelbel's Canon in D Major, Andante (ca. 1680s). The light circles at the bottom represent the bass line in D major. The familiar melodic sequence over the

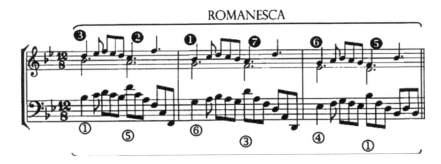

Figure 10.3
Fragment of Handel's exercises for Princess Anne (ca. 1724–1734) built on the Romanesca (Gjerdingen 2007, 28)

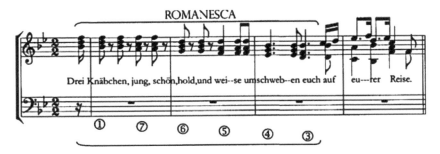

Figure 10.4
Variant on the Romanesca composed by Johann Schobert (Gjerdingen 2007, 31)

bass line comprises a schema of the form 3-2-1-7-6–5, where the numbers refer again to the notes of the D major scale. This figure is called the Romanesca. The bass line is often called a *leaping bass* because a straightforward descending line—1 5 3 1—is interrupted by steps up: 6 and 4. For a second instance of the Romanesca, this one from Handel's exercises for Princess Anne (ca. 1724–1734), see figure 10.3.[1]

By contrast Johann Schobert (1735–1767), a keyboard performer whose compositions were studied by Mozart (Gjerdingen 2007, 31), introduced a variant on the Romanesca, illustrated in figure 10.4. Here, the parallel thirds in the treble clef follow a straight descending line instead of the step-like descent of Pachelbel's Canon. Of this variant Gjerdingen says (2007, 32):

While both types of solutions result in the same sequence of sonorities, the leaping variant (Pachelbel and Handel) is more characteristic of the seventeenth and very early eighteenth centuries, while the stepwise variant (Mozart and Schobert) is more characteristic of the later eighteenth century. Neither, however, was the preferred type for most galant musicians.

According to Gjerdingen (2007, 25–26), students used these schemata in this way:

> As apprentices in the guildlike system of court musicians, students did not learn about the schemata through verbal descriptions or speculative theories, but rather learned them by rote, realizing them in every possible key, meter, tempo, and style.

Now compare this with Milman Parry's (1932, 6) observation about the oral poet, who

> makes his verses by choosing from a vast number of fixed phrases which he has heard in the poems of other poets. Each one of these phrases does this: it expresses a given idea in words which fit into a given length of the verse. Each one of these fixed phrases, or formulas, is an extraordinary creation in itself. It gives the words which are best suited for the expression of the idea, and is made up of just those parts of speech which, in the place which it is to fill in the verse, will accord with the formulas which go before and after to make the sentence and the verse. Each formula is thus made in view of the other formulas with which it is to be joined; and the formulas taken all together make up a diction which is the material for a completely unified technique of verse-making.

The two statements are remarkably similar. They point to a common method of composition in two quite different genres. In epic poetry a unit looks like θεὰ γλαυκῶπις Ἀθήνη 'divine wide-eyed Athena' (fifty-one times in the *Odyssey*). Its counterpart in galant music is, for example, the Romanesca. Both are a basic unit of composition. In the case of oral poets, it is what Parry calls a formula. In the case of galant composers it is what Gjerdingen calls a schema. At bottom they are the same. Or should I say, "at top" since at an abstract level these artists are doing exactly the same thing. They are combining minimal constructs to create a work of art.

Figure 10.5 shows a portion of a work by Domenico Gallo, Trio in G Major, mvt. 1, Allegro, m. 1 (ca. 1750s). It contains a Romanesca followed by a schema named for a seventeenth-century composer, Jacob Prinner (Gjerdingen 2007, 50). It illustrates a process of construction that Gjerdingen (2007, 51) describes in these terms:

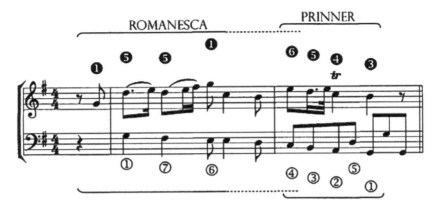

Figure 10.5
Fragment of a work by Domenico Gallo, Trio in G Major, mvt. 1, Allegro, m. 1 (ca. 1750s), containing the Romanesca followed by phrase (schema) named for seventeenth-century composer Jacob Prinner (Gjerdingen 2007, 50)

> The speed and confidence with which many of the best eighteenth-century composers wrote multivoice works has long been a subject of marvel for modern musicians. Though the skill and invention of those composers remains impressive however one might try to explain their abilities, there are obvious advantages that a stockpile of "interchangeable parts" would give to the rapid, secure crafting of complex compositions. Anyone who knew the above tradition of a Romanesca leading to a Prinner could draw upon a number of stock melodies, basses, and harmonizations—everything would fit together. Today we tend to equate "compose" with "invent," yet the older, more literal meaning of "put together" (*com + posare*) may provide a better image of galant practice.

Compare the sequence of schemata in figure 10.5 with the way that Parry (1930, 118) transcribes the first twenty-five lines of the *Iliad* in figure 10.6.[2] He underlines with a broken line "phrases which are of the same type as others" and with a solid line "phrases unchanged elsewhere." He notes that "[t]he expressions in the first twenty-five lines of the *Iliad* which are . . . unchanged elsewhere in Homer count up to 29." Magoun's (1953) analysis of the opening lines of *Beowulf* that we saw in figure 10.1 underscores why he was so inclined to adopt Parry's thesis. The point is that the Homeric and *Beowulf* poets put their constructions together in just the same way that the galant composers did.

But the larger point, namely, *that this technique builds repetition into a work of art and in so doing caters to the human predilection to find pleasure in*

ΙΛΙΑΔΟΣ Α

Μῆνιν ¹ ἄειδε θεὰ Πηληιάδεω 'Αχιλῆος ²
οὐλομένην ἣ ³ μυρί' ⁴ 'Αχαιοῖς ἄλγε' ἔθηκε,⁵
πολλὰς δ' ἰφθίμους ψυχὰς "Αιδι προίαψεν ⁶
ἡρώων, αὐτοὺς δὲ ⁷ ἐλώρια τεῦχε κύνεσσιν
οἰωνοῖσί τε πᾶσι, Διὸς δ' ἐτελείετο βουλή ⁸ 5
ἐξ οὗ δὴ ⁹ τὰ πρῶτα διαστήτην ἐρίσαντε
'Ατρείδης τε ¹⁰ ἄναξ ἀνδρῶν ¹¹ καὶ δῖος 'Αχιλλεύς.¹²
 Τίς τ' ἄρ σφωε θεῶν ἔριδι ¹³ ξυνέηκε μάχεσθαι; ¹⁴
Λητοῦς καὶ Διὸς υἱός· ¹⁵ ὁ γὰρ βασιλῆι χολωθεὶς
νοῦσον ἀνὰ στρατὸν ὦρσε ¹⁶ κακήν, ὀλέκοντο δὲ λαοί ¹⁷ 10
οὕνεκα τὸν Χρύσην ἠτίμασεν ἀρητῆρα
'Ατρείδης· ὁ γὰρ ἦλθε θοὰς ἐπὶ νῆας 'Αχαιῶν ¹⁸
λυσόμενός τε θύγατρα φέρων τ' ἀπερείσι' ἄποινα ¹⁹ ⎫
στέμμα τ' ἔχων ἐν χερσὶν ²⁰ ἑκηβόλου 'Απόλλωνος ²¹ ⎪
χρυσέωι ἀνὰ σκήπτρωι ²² καὶ λίσσετο πάντας 'Αχαιούς,²³ ⎬ = Α 372–5 15
'Ατρείδα δὲ μάλιστα ²⁴ δύω κοσμήτορε λαῶν· ²⁵ ⎭
'Ατρείδαι τε καὶ ἄλλοι ²⁶ ἐυκνήμιδες 'Αχαιοί,²⁷ = Ψ 272, 658.
ὑμῖν μὲν θεοὶ δοῖεν 'Ολύμπια δώματ' ἔχοντες ²⁸
ἐκπέρσαι Πριάμοιο πόλιν,²⁹ εὖ δ' οἴκαδ' ἱκέσθαι· ³⁰
παῖδα δ' ἐμοὶ λύσαιτε φίλην, τὰ δ' ἄποινα δέχεσθαι 20
ἀζόμενοι ³¹ Διὸς υἱὸν ἑκηβόλον 'Απόλλωνα.³²
 "Ενθ' ἄλλοι μὲν πάντες ³³ ἐπευφήμησαν 'Αχαιοί ³⁴ ⎫
αἰδεῖσθαί θ' ἱερῆα καὶ ἀγλαὰ δέχθαι ἄποινα· ⎪
ἀλλ' οὐκ ³⁵ 'Ατρείδηι 'Αγαμέμνονι ³⁶ ἥνδανε θυμῶι,³⁷ ⎬ = Α 376–9
ἀλλὰ κακῶς ἀφίει, κρατερὸν δ' ἐπὶ μῦθον ἔτελλε.³⁸ ⎭ 25

Figure 10.6
First twenty-five lines of the *Iliad* with recurring formulas underscored by Milman
Parry (1930, 118)

repetition, seems to have fallen between the cracks. When Magoun (1953, 450) says, in his commentary on the first twenty-five lines of *Beowulf*, "Though usefulness rather than mere repetition is what makes a formula, it is instructive to look at the repeated formulas first," the aesthetic value added by repetition is nowhere in sight. Magoun is not alone. Nagy (2022) also makes no mention of it.

In 1935 Milman Parry began a study cut short by his tragic early death. The study was to be called *The Singer of Tales*. In the few pages that he wrote he outlined his goal, quoted by Albert Lord (1960, 3):

> The aim of the study was to fix with exactness the form of oral story poetry, to see wherein it differs from the *form* of written story poetry. Its method was to observe singers working in a thriving tradition of unlettered song and see how the form of their songs hangs upon their having to learn and practice their art without reading and writing. The principles of *oral form* thus gotten would be useful . . . in the study of the great poems which have come down to us as lonely relics of a dim past: we would know to work backwards from their form so as to learn how they must have been made. (Italics original)

Lord finished Parry's work in his book of the same name, *The Singer of Tales*. He made use of materials that he and Parry had collected in Yugoslavia and that he (Lord) later collected in Albania.[3] The study demonstrated that the method hypothesized by Parry for the creation of the Homeric epics was alive and well in the Balkans.

I would like to turn now to a different kind of corroboration of the method of artistic composition that underlies the Homeric epics, galant music, and the oral epics of Yugoslavia. I have in mind jazz improvisation.

11 Repetition and Jazz

The affinity of jazz improvisation with the galant style of composition and with the Homeric epics has not gone unnoticed. In a review of Gjerdingen 2007, Paul Sherrill (2011, 229) writes:

> Gjerdingen also situates his claims about the galant style within a broader picture of eighteenth-century Italian musical practice. In particular, he argues that galant music was practiced within a tradition that relied as strongly on its oral components as its literate ones. Consequently, it is not surprising to find similarities between the products of galant musical culture and those of other orally-transmitted art forms: like the galant style, jazz improvisation, the commedia dell'arte, and epic poetry all seem to rely on an inventory of stock formulas that can be recombined on the spot to produce a new work.

And Gjerdingen himself (2007, 371) notes:

> In styles that favored improvisation, young musicians practiced how to select strings of patterns that helped to fashion larger formal or narrative designs:
>
>> They develop flexibility in the use of initially limited stores of vocabulary, devise a systematic way of relating vocabulary patterns one to another, and absorb the aesthetic principles that guide vocabulary usage. . . . Once thoroughly absorbed into a storehouse, new patterns take their place beside the multitude of other set patterns—the precise shapes from which musical thoughts are fashioned. There, within the artist's imagination, they lead a rich existence, continuously transformed in relation to other vocabulary patterns.
>> . . . As soloists call the figures repeatedly into action and redefine their relationships, however, they sometimes find that the figures occur to them more frequently in some settings than others, interact more comfortably with certain other individual patterns, and even evolve increasingly consistent forms of usage with specialized syntactic functions.

The above quotation might equally well describe how to select from the musical store-house of radif for a performance of classical Persian music, or how to string

together galant schemata to create a fantasia. The actual source is the ethno-musicologist Paul Berliner describing the employment of learned "licks" by jazz improvisers. (Ellipses Gjerdingen's)

According to Berliner (1994, 4) himself:

> From a comparative cultural viewpoint, other writings were also influential. Albert Lord's classic study of Serbo-Croatian epic sung poetry (19[60]) positing a theory of formulaic oral composition and re-creation, seems to me, as it has to several other scholars, to have relevance for the study of jazz.

Indeed, it does. This becomes abundantly clear from the work of Thomas Owens (1974). For his doctoral dissertation, Owens undertook the monu-mental task of transcribing about 250 improvised solos from a corpus of 900 recordings made of Charlie Parker's work as a jazz soloist. Parker (1920–1955) was, of course, one of the most important jazz musicians of his time, along with Dizzy Gillespie and the incomparable Thelonius Monk. They ushered in and then led the development of that genre of jazz known as bebop. Owens chose Parker because he was a master musician and he (Owens) believed (1974, 17) that

> every mature jazz musician develops a repertory of emotions and phrases which he uses in the course of his improvisations. His "spontaneous" performances are actually pre-composed to some extent. The master player will seldom, if ever, repeat a solo verbatim; instead he will continually find new ways to reshape, combine, and phrase his well-practiced ideas.

It was this practice that Owens surveyed. Having transcribed Parker's impro-visations, he searched the corpus for motives, small repetitions of melodic/rhythmic figures that comprise what he justly calls the "building blocks" of a Parker solo. His work led to a remarkable corroboration of Gjerdingen's and Berliner's surmises.

To begin with, Owens (1974, 25–26) notes that two short motives occur more frequently than any others, each appearing "once every eight or nine measures, on the average in the transcriptions." These are shown in figure 11.1. This is how he describes them:

> The first is an ascending arpeggio, usually played as a triplet, but also common in other rhythmic configurations. . . . The other ubiquitous motive, M.2A, is even simpler in construction and easier to play than the ascending arpeggio. In its main form it is nothing more than an inverted mordent [an inverted crescent-shaped figure] followed by a descent of a second, third, or fourth.

Figure 11.1
Most frequent motives ("licks") from Owens's (1974) transcriptions of 250 Charlie Parker solos

Figure 11.2
Longer motive made up of the shorter motives in figure 11.1

Figure 11.3
Opening four measures of Charlie Parker's "Ornithology"

He goes on to note that

> because of its brevity and simplicity, the motive appears in virtually any context. Indeed, it is an incremental component in a number of more complex motives. . . . It is also a central feature of one longer motive, M.2B [see figure 11.2].

And now let's look at the opening measures of Charlie Parker's composition entitled "Ornithology," one of the jazz classics of the bebop genre, shown in figure 11.3. Apart from the last eighth note of the first measure and taking into account the key change (M.2B is in F; "Ornithology" is in G), the phrase is identical to motive M.2B. In other words, this is the precise parallel of the kind of composition described by Gjerdingen. A motive, itself the product of two simpler motives, opens a Parker composition. The third and fourth measures (IIm-V progression to a new key, F) echo the motive.

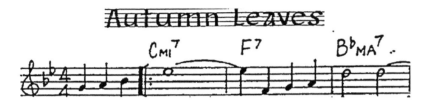

Figure 11.4
Opening three measures of "Autumn Leaves" with pickup illustrating the familiar
IIm-V-I chord progression in jazz tunes

The Parker motives, like the Gjerdingden galant schemata, involve spe-
cific note runs like the arpeggio and mordent combination in figure 11.2.
However, it is also possible to view the motives as strategies. In other words,
what is learned is not a specific set of notes but a formula that can be
applied in a variety of contexts.

Here is an example. In jazz standards it is very common to find a so-called
II_m-V-I sequence. This represents the chord sequence built on the second of
a scale, which happens to be a minor chord, followed by the chord built on
the fifth note of a scale, the so-called dominant degree of the scale. That II_m-V
sequence naturally resolves to the root. The first three measures of "Autumn
Leaves," shown in figure 11.4, are illustrative. There is a formula that allows
the player to navigate through the progression seamlessly. It goes like this:

(1) 1. Over the Cm7 chord, play C, E♭, G, B♭
 (i.e., 1, 3, 5, 7 of the chord)

 2. Over the F7 chord, play A, F, E♭, C
 (i.e., 3, 1, 5, 7 of the chord)

 3. Over the B♭7 chord, play anything in the chord but the root, which
 is "square."

If you were playing a solo on "Autumn Leaves," any one of those notes (or
all of them) would work within their assigned chord.

Now let's replace the chord-note-specific example in (1) with this for-
mula or schema—or, in jazz terms, lick:

(2) 1. Over a IIm7-V-I progression

 2. Play the 1, 3, 5, 7 of the IIm7 chord.

 3. Play the 3, 1, 7, 5 of the V chord.

 4. Play any note on the I chord, giving low priority to the 1 (root).

Figure 11.5

Example of Carl Fontana's use of the F minor blues scale in an improvisation on "A Beautiful Friendship"

Jazz musicians will internalize the "macro" in (2). They will practice it in all keys. They will practice various inversions of the sequences—for example, reversing the note sequence in each chord, or swallowing a note, or even leaving it out. The rhythmic variations that can be brought into play in that simple lick and its variations will provide the player with hundreds of different ways of navigating a IIm-V-I progression. And that's just one lick.

Jazz musicians are constantly borrowing or inventing new licks to make their way through a progression. Berliner (1994, 229) quotes Red Rodney, a member of the Charlie Parker quintet billed as "Albino Red" to avoid racial encounters in the South:

> We all have our little bag of tricks, our special riffs that are identified with us. You may gain some new ones and drop some of the old ones. You get different personality traits as you grow older. But you never lose your bag of tricks completely.

(2) is one of those bags and—truth in advertising—being a jazz trombone player myself, (2) is one of mine.

Alisha Ard (2004) brings to light several similar "tricks" used by the trombonist Carl Fontana, one of the greatest improvisers known to his instrument. One of these is to use specific scales over a chord progression. Figure 11.5 illustrates his use of the F minor blues scale, namely, F Ab Bb Cb C Eb. A slightly closer analysis of the figure suggests even more structure. There are ten notes in the figure. (I have eliminated the measure 71 final eighth note D because while it is the sixth degree of the F scale, it is not in the blues scale.) That said, if one assumes that notes 6, 7, and 8 are a mordent, then the structure of this lick is this:

(3) F Ab Bb Cb, Bb [Bb Ab Bb] Ab F
$$ mordent

That is, notes 6, 7, and 8 are a reversal of the initial mordent:

(4) F Ab [Bb Cb Bb] [Bb Ab Bb] Ab F

F A♭ B♭ C♭ B♭ A♭ F

Figure 11.6
Example of a common Carl Fontana F minor blues scale reversal lick from "Sweet and Lovely"

F A♭ B♭ C♭ C♭ B♭ B♭ A♭ F

Figure 11.7
A variation of the "Sweet and Lovely" lick of figure 11.6

Viewed this way, the Fontana figure is highly reminiscent of the Parker lick that begins "Ornithology" (see figure 11.3). The Parker lick is an arpeggio with a mordent attached to it. The Fontana lick is a blues scale arpeggio with a mordent attached to it, followed by a mirror image of the initial arpeggio. There's a formula if ever there was one.

A glance at other transcriptions by Ard suggests that this reversal lick is part of Fontana's "bag of tricks." Look at measure 204 from "Sweet and Lovely" (figure 11.6) and measures 171–172 from the same solo (figure 11.7). These measures show a variation of the same ascending and descending pattern with the addition of a C♭ B♭ repetition at the apex. If I looked harder, I have no doubt I would find more.

We saw earlier that repetition in music among other things exhibits the *same/except* constraint as in "Satin Doll" and in this respect, it parallels the use of end rhyme in poetry. The reversal of an ascending line of the kind just analyzed also meets the *same/except* constraint. The descending line uses the same notes as the ascending line, only in reverse order.

The Fontana reversal lick, then, is the musical version of rhetorical chiasmus as in (5):

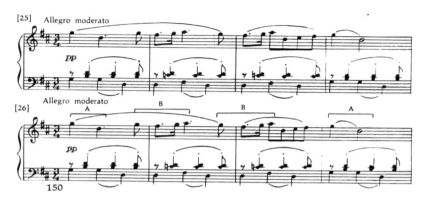

Figure 11.8
Example of chiasmus in Schubert's Symphony in B Minor (Bernstein 1976)

(5) a. Ask not what **your country** can do for **you**, but what **you** can do for **your country**.

 b. **your country** **you** ◀━━▶ **you** **your country**.

 A B B A

In his Norton lectures (1976, 150–153) Leonard Bernstein demonstrates his awareness of these figures in music. On Schubert's Symphony in B Minor he writes:

> What do you suppose is the rhetorical figure operating in this most unrhetorical Schubert melody [see [25] in figure 11.8]? It is a device that bears the proud name "chiasmus," a fancy word that means simply reversing the order of elements midway through a statement: "What's Hecuba to him, or he to Hecuba?" Or John Kennedy's: "Ask not what your country can do for you, but what you can do for your country." Notice again how this figure is based on repetition, as they all are—repetition subjected to reversal, AB:BA. And Schubert, blissfully unaware of chiasmus, just went ahead and created one in his Symphony in B Minor [see [26] in figure 11.8]. That melody is so obviously dependent on repetition that it barely needs mentioning; what's important is the variation of those A's and B's, which has transformed them into a musical metaphor—AB:BA.

He goes on to say:

> I was astonished one day suddenly to discover a huge chiasmus just squatting there, in so unpretentious a piece as Chabrier's rhapsody *España*. This chiasmus involves two different consecutive tunes, not just measures but whole tunes, one a chiastic version of the other. The first one [see [27] in figure 11.9] goes: A + B,

Figure 11.9
Example of chiasmus in Chabrier's *España* (Bernstein 1976)

which is then repeated. And then the chiasmus breaks open, B + A [see [28] in figure 11.9]. It's an exact and perfect reversal, AB:BA.

There is a difference between the chiasmus of Carl Fontana, on the one hand, and Schubert's and Chabrier's, on the other. Because Fontana's happens in an improvised solo, it has to obey locality (see discussion in chapter 2), even more so than end-rhymed poetry. The improvised line goes by so quickly. In fact, the use of chiasmus in improvisation is, I think, a player's "trick"—something one does while contemplating where to go next rather than a repetition designed to elicit pleasure in the listener, since it is unlikely the listener will ever hear it. The tempos of the Fontana selections are quite fast (180 and 142, respectively).

With respect to written chiasmus like Schubert's and Chabrier's, the mental space required to perceive it, let alone emulate it, would task any

player below the level of a Mozart, and it certainly would go over the head of the average listener. In all three cases, however, the chiasmus is there to be enjoyed if the listener has a score in hand.

But having the score in hand means something a bit different in jazz and in classical music. Since no two jazz performances are alike, the only way to capture a given performance is by freezing it—that is, by transcribing it from a record. Chiasmus is more easily accessible in a traditional classical performance because the score is immutable. In jazz, chiasmus has to be recovered through the arduous task of transcription undertaken by such stalwarts as Ard and Owens. With their transcriptions in hand, one can listen to the recording from which they were taken and follow along. In an actual performance, hearing reversals is a bit like trying to catch a fly in your bare hand.

I won't undertake a careful study of Fontana's licks here. I hope, however, to have shown enough to support the view that licks are the musical analogue of oral poetry's formulas and galant's schemata. All use formulas that are appropriate to their own genre. All make use of their respective formulas, what Rodney called their "bag of tricks," as building blocks for their art. In poetry the artist is building an oral epic. In jazz the artist is building a real-time composition. In galant music the composer is writing a formal work sufficiently fixed that musician after musician can play the same composition. In all cases the formulas are useful techniques in putting the larger structure together. In most cases the formulas have the added advantage that, being repetitive in nature, they elicit pleasure in their audiences. Jazz improvisation is the most difficult to hear because of its spontaneity and because of the common use of up tempos. This observation suggests that pleasure in a jazz performance is inversely related to its tempo: the faster the tempo, the less pleasurable the performance regardless of the skill of the performer.[1]

Before we leave the topic of chiasmus, it is worth looking at a literary counterpart of the Schubert example, a poem by Wallace Stevens called "Poetry Is a Destructive Force":

(6) That's what misery is,

 Nothing to have at heart.

 It is to have or nothing.

It is a thing to have,

A lion, an ox in his breast,

To feel it breathing there.

Corazón, stout dog,

Young ox, bow-legged bear,

He tastes its blood, not spit.

He is like a man

In the body of a violent beast.

Its muscles are his own . . .

The lion sleeps in the sun.

Its nose is on its paws.

It can kill a man.

Within the first four lines this repeating chiasmic pattern emerges:

(7) thing have have thing thing have

 A B B A A B

And then there is an echo in the closing stanzas:

(8) He is li ke a man

 It can k ill a man.

The reversal motif in this poem (and in others by Stevens and Edgar Allan Poe) is discussed in detail in Keyser 2011. Here it suffices to observe that the reversals are morphological and phonological analogues of the poem's content, which describes a poet as a man with a beast inside him reversing roles so that he is "like a man in the body of a violent beast." The point in the present context is that chiasmus is a form of repetition and repetition is a source of pleasure. One would expect poets to turn to this kind of repetition once end rhyme and meter have been abandoned.

12 Repetition and Parallelism

A common feature of Old Testament poetry is what James L. Kugel (1981, 2) calls *repetitive parallelism*. He illustrates it with the opening lines of Psalm 94 (see figure 12.1). He notes that the common element in the first verse is the repetition of the phrase *God of retribution*. In the second verse, each half begins with an imperative to God: *rise up* and *give*, respectively. The third verse repeats the phrase *How long shall the wicked*. The fourth verse "describes successively aspects of the evildoers' arrogant behavior."

However, Kugel is at pains to say that the essence of biblical poetry is not this repetitive parallelism, but essentially line lengths, or more accurately half-line lengths. Here is his view on the matter (1981, 51):

> This is not to say that paralleling isn't important—of course it is, it is the most strik-
> ing characteristic of this style. But focusing on it is just somewhat beside the point.
> What then is the essence? In asserting the primacy of our form

> we are asserting basically, a sequence: first part—pause—next part—bigger pause
> (and only secondarily the rough limits on the length of the clause and their
> approximate equivalence). But even this sequence is a bit of a shorthand for
> the real point, for what those pauses actually embody is the subjoined, hence
> emphatic, character of B [the half lines are typically labeled A and B]. The brief-
> ness of the brief pause is an expression of B's connectedness to A; the length of
> the long pause is an expression of the relative disjunction between B and the next
> line. What this means is simply: B, by being connected to A—carrying it further,
> echoing it, defining it, restating it, contrasting with it, it does not matter which—
> has an emphatic, "seconding" character, and it is this, more than any aesthetic of
> symmetry or paralleling, which is at the heart of biblical parallelism.

As part of his downplaying of repetitive parallelism Kugel (1981, 50) looks at the text of Psalm 23 and notes—with justice, I think—that repetitive

אל נקמות ה׳ / אל נקמות הופיע //
הנשא שפט הארץ / השב גמול על־גאים //
עד מתי רשעים ה׳ / עד מתי רשעים יעלזו //
יביעו ידברו עתק / יתאמרו כל פעלי און //

Figure 12.1
Psalm 94: God of retribution, Lord / God of retribution appear! //
Rise up, earth's ruler / give the arrogant their due //
How long shall the wicked, Lord / how long shall the wicked rejoice //
They brag, speak arrogance / all the evil-doers do act haughtily //

parallelism doesn't apply: "Certainly no one could argue that symmetry has governed the Psalmist's choices. . . . On the contrary, the use of similar forms is what the principle of parallelism seems badly in need of here."

There is, however, good reason for this particular failure of parallelism, rather like the exception that proves the rule. Fabb and Halle (2008, 268) note that while a major portion of the Old Testament is poetry, only a tiny percentage is metrical. As it happens, Psalm 23 falls into the latter category. So Kugel's rules are beside the point.

Fabb and Halle analyze Psalm 23 in terms of line lengths determined by a fixed number of syllables. That's it. No other structure need apply. Figure 12.2 shows the psalm in transliterated Hebrew and as translated by Fabb and Halle (2008, 274). The numbers separating the Hebrew from the English represent the number of syllables in the Hebrew counted by Fabb and Halle's rules. Let us take them as given.[1] Following Bazak (1987), Fabb and Halle point out that Psalm 23 contains a hidden message. Everything depends on gematria, the schema whereby letters are assigned numbers and secret messages are numerically encoded (Fabb and Halle 2008, 274–275):

We owe to Bazak (1987) the important observation that Psalm 23 consists of 55 words, and the suggestion that these 55 words should be subdivided into two subsequences of 26 words separated by a three-word sequence. It turns out that when this is done, the three-word sequence occupying the 'numerological' center of the poem, kî:-ʔattâ:h ʕimma:dî: ('for you are with me'), is the only six-syllable line in the psalm and, more important, also epitomizes the point of the poem. Bazak motivates the segmentation of the 55 words of the poem into 26+3+26 with reference to the fact that the letters of the Hebrew alphabet have numerical values; ʔalef = 1, beyt = 2, etc. Bazak notes that the numerical values of the Hebrew letters

yahwe:h ro:ʕî: lo:ʔ ʔeḥsa:r	7	Yahweh is my shepherd, I shall not want.
binʔô:t deʃeʔ yarbice:(nî:)	7	He makes me lie down on grassy pastures.
ʕal me:y mənuḥ:ôt yənahle:(nî:)	8	He guides me to still waters.
napʃi: yəʃô:be:b	5	He restores my soul.
yanḥe:nî: bəmaʕgəle:y-cedeq	8	He leads me on paths of righteousness 5
ləmaʕan ʃəmô:	5	for the sake of his name.
gam kî:-ʔe:le:k bəgêʔ calma:(wet)	8	Though I walk in the valley of the shadow
lo:ʔ-ʔî:ra:ʔ raʕâ:h	5	I shall fear no evil, [of death,
kî:-ʔattâ:h ʕimma:dî:	6	for you are with me.
ʃibtəka: ûmiʃʕante:(ka:)	7	Your rod and your staff 10
he:mmâh yənaḥmû:(nî:)	5	they comfort me.
taʕro:k ləpa:nay ʃulḥa:n	7	You prepare a table for me
neged co:rəra:y	5	in front of my enemies,
diʃʃanta: baʃʃemen ro:ʔʃi:	8	You anoint my head with oil;
kô:sî: rəwa:yâ:h	5	my cup runs over. 15
ʔak ṭô:b wa:ḥesed yirdəpû:(nî:)	8	Only goodness and mercy shall pursue me
kol-yəme:y ḥayya:y	5	all the days of my life.
wəya:ʃabtî: bəbe:yt yahwe:h	8	And I shall dwell in Yahweh's house
ləʔo:rek ya:mî:m	5	to the end of days.

Figure 12.2

Transliterated version of Old Testament Psalm 23 with English translation by Nigel Fabb and Morris Halle (2008)

composing the name of the deity yhwh, add up to 26 . . . Bazak proposes that there is a hidden message in the psalm, roughly that shown in ([1]).

([1]) YHWH, for you are with me, YHWH

Psalm 23 is a wonderful example of an Easter egg in the sense of Keyser 2020:

(2) YHWH, for you are with me, YHWH

 26 26

 God—for you are with me—God

The authors uncover a second Easter egg of their own. But their discussion of Bazak is sufficient to explain why Kugel thinks Psalm 23 diverges from the style of repetitive parallelism that characterizes so much of the poetry of the Old Testament. It does because it was meant to.[2]

So parallelism in the Old Testament appears to be a preference, not a rule. And meter in the Greek and Roman traditions, or the English tradition prior to the advent of modernism, is nonexistent. As Robert Alter (1985, 9) observes:

Some analysts, with an eye to the number of stresses in a verset [half line], have sought to detect a system of "meters" in biblical poetry. It is true that in many poems a particular count of stresses in each of the matched versets tends to predominate, the most common combinations being 3:3 and 3:2, but there is little

evidence that the counting of stresses was actually observed as a governing norm for a poem, in the way a Greek or Roman poet watched his iambs or hexameters throughout a poem, and so the term meter should probably be abandoned for biblical verse.

The operative phrase here is *governing norm*. If it means anything at all, it should mean "observed religiously." Thus, in metrical poetry every line must conform to the metrical rules in which it is written. This occurs in the Old Testament in Psalm 23.

It is not too much of a reach to say that, for Kugel, the essence of biblical poetry is a discourse phenomenon—the kind of thing that I discussed with respect to (1) and (2) in the introduction (repeated here). Sentences like those in (3), when conjoined, elicit a narrative. Thus, conjoin (3.1) and (3.2) as in (4).

(3) 1. The car hit the wall.

 2. The headlights went out.

(4) The car hit the wall and the headlights went out.

Our strong intuition is that the two halves of the conjoined structure are related by causality; that is, the headlights went out because the car hit the wall. Reverse the order and the opposite interpretation is enforced. Indeed, connecting the two sentences with the phrase *and then* entrenches the causality between two events.

(5) 1. The car hit the wall and (then) the headlights went out.

 2. The headlights went out and (then) the car hit the wall.

Consequently, repetitive parallelism at all levels, from sentential on down to phonological, is a stylistic maneuver placed over the armature of the half line structure to enhance the half-line relationship. But it is not a metrical exigency. That is the half-line construction itself.

In this regard it is worth comparing Kugel's conception of parallelism to free verse as practiced after the advent of modernism. During the transition to modernism (see Keyser 2020), English poetry abandoned metrical rules altogether. The boundary between poetry and prose hung by a thread. For free verse, it was simply the line break, which had to be observed visually since it couldn't be heard. The extent to which poetry acquired a visual dimension is no more clearly apparent than in the work of e. e. cummings (1950):

(6) dim

 i

 nu

 tiv

 e this park is e

 mpty (everyb

 ody's elsewher

 e except me 6 e

 nglish sparrow

 s)a

 utumn & t

 he rai

 n

 th

 e

 raintherain

This poem can't possibly be read aloud and made sense of as a poem as can, for example, Poe's "Raven." It has to be seen for its poetry to become apparent. And, of course, the line lengths are anything but systematic.

Comparing this to Kugel's conception of the Bible's parallel structure in (7)

(7) _____ / _____ //

makes it clear that Old Testament verse, though free, is not quite as "free" as modern free verse. Kugel's description, repeated here, is explanatory. The pauses are based in large part on traditional rules of cantillation:[3]

> The briefness of the brief pause is an expression of B's connectedness to A; the length of the long pause is an expression of the relative disjunction between B and the next line. What this means is simply: B, by being connected to A—carrying it further, echoing it, defining it, restating it, contrasting with it, it does not matter which—has an emphatic, "seconding" character, and it is this, more than any aesthetic of symmetry or paralleling, which is at the heart of biblical parallelism.

So, Kugel believes that the bedrock of biblical poetry is the line just as it is in modern free verse, but crucially the former contains half lines (versets) while the latter has no such constraint.

Once Kugel has postulated the half lines, however, he postulates the need to somehow connect the two. And now he is in the land of Anglo-Saxon verse, of which we have already seen an example in chapter 1—namely, the opening lines of *Beowulf*, repeated here:

(8) Hwæt! Wé Gárdena in géardagum
 Listen! We — of the Spear Danes in the days of yore

 þéodcyninga þrym gefrúnon.
 of those clan-kings— their glory we have heard.

Kugel's schematic applies:

(9) _____ / _____

Thus, biblical verse and *Beowulf* share the unit of a line divided into two half lines. But they differ in regularity. In *Beowulf* and, in fact, all of Anglo-Saxon poetry, there is a rule-governed link between the half lines involving stress and alliteration, as described earlier. The half lines must alliterate. Since only stressed syllables can alliterate, each must contain at least one stressed syllable. No such obligatory linkage exists between the half lines in biblical poetry. Quite often the half lines are "seconded," to use Kugel's trenchant term, but seconding is not obligatory; a half-line pause is.

Parallelism at the syntactic level is no stranger to American poetry. For example, Walt Whitman's "When I Heard the Learn'd Astronomer" (1865), where it adorns free verse:

(10) When I heard the learn'd astronomer,

 When the proofs, the figures, were ranged in columns before me,

 When I was shown the charts and diagrams, to add, divide, and measure them,

 When I sitting heard the astronomer where he lectured with much applause in the lecture-room,

 How soon unaccountable I became tired and sick,

 Till rising and gliding out I wander'd off by myself,

 In the mystical moist night-air, and from time to time,

 Look'd up in perfect silence at the stars.

It is obvious that Whitman's line lengths are all over the place, ranging from nine syllables to twenty-three syllables. There isn't a half line in sight.

Rather, Whitman uses parallelism to divide the eight lines. In fact, the overall structure is precisely like the narrative one intuits in (11)—a causal conjunction where the first and second half are connected by *and*:

(11) The car hit the wall and the headlights went out.

That is to say, the first four lines exhibit parallel repetition with the phrase *When I* The next four are the result of (caused by) the parallelism:

(12) I heard the learned astronomer (etc.) and (then) I became sick and tired (etc.).

Roman Jakobson (1966, 403) notes the use of repetitive parallelism in Longfellow's *The Song of Hiawatha* (1855), presumably written after Longfellow encountered the technique in Anton Schiefner's German translation of the Finnish national epic, *Kalevala* (1852). Here are a few lines of Longfellow's imitation:

(13) Should you ask me, whence these stories?
 Whence these legends and traditions,
 With the odors of the forest
 With the dew and damp of meadows,
 With the curling smoke of wigwams,
 With the rushing of great rivers,
 With their frequent repetitions,
 And their wild reverberations
 As of thunder in the mountains?
 I should answer, I should tell you,
 "From the forests and the prairies,
 From the great lakes of the Northland,
 From the land of the Ojibways,
 From the land of the Dacotahs,
 From the mountains, moors, and fen-lands
 Where the heron, the Shuh-shuh-gah,
 Feeds among the reeds and rushes.
 I repeat them as I heard them
 From the lips of Nawadaha,
 The musician, the sweet singer."

Longfellow differs from Whitman in that he superimposes parallelism over a regular trochaic tetrameter. But notice the similarity in the use of parallelism:

(14) Ask me whence (etc.) and (then) I will answer (etc.).

We've encountered another example of syntactic parallelism as well, Shakespeare's Sonnet 30:

(15) When to the sessions of sweet silent thought

 I summon up remembrance of things past,

 I sigh the lack of many a thing I sought,

 And with old woes new wail my dear time's waste:

 Then can I drown an eye, unus'd to flow,

 For precious friends hid in death's dateless night,

 And weep afresh love's long since cancell'd woe,

 And moan th' expense of many a vanish'd sight;

 Then can I grieve at grievances foregone,

 And heavily from woe to woe tell o'er

 The sad account of fore-bemoaned moan,

 Which I new pay as if not paid before.

 But if the while I think on thee, dear friend,

 All losses are restor'd, and sorrows end.

Clearly there is a great deal of syntactic repetition at play here. The tree diagram in (16) shows what the structure looks like:

(16)

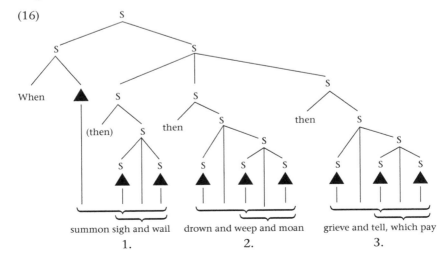

To make the parallelism more legible, each sentence is abbreviated by a dark triangle. The main verb of each sentence is shown beneath its triangle. Inspecting the tree shows that three subordinate clauses are associated with the *When* clause:

(17) 1. When I summon,

(then) I sigh and wail

2. Then I drown

And I weep and moan.

3. Then I grieve

And I tell and (appositive which) pay.

These three groups make up the first twelve lines. The numbered brackets at the bottom of (16) are meant to show this. Taken together, this symmetry offers a good example of syntactic parallelism. But there is more. Within the long brackets are three smaller brackets. Each of these embraces a conjoined sentence structure. There are three such compound structures, each a complement of the main verb *summon*. The first complement is a straightforward conjunction of two sentences, *I sigh* and *wail*. The second is the complement of the subordinate clause verb *drown*. The third is also the complement of a subordinate clause, *I grieve*. However, the conjunction is not *and* but the appositive relative pronoun *which*, as in this example:

(18) a. *The Invincible Armada*, which was Spain's pride and joy, was not so invincible.

b. *The Invincible Armada*, and it was Spain's pride and joy, was not so invincible.

All three compound structures comprise a triple conjunction of *then* clauses (the first *then* understood) that are complements of the main verb *summon*. But we can see that each of the conjoined structures is in a *same/except* relationship. The second structure is the same as the first except that it is embedded in an additional clause, *drown*. The third is the same as the second except that its conjoining word is *which*, not *and*.

Finally, let's look at the tree for the closing couplet:

(19)

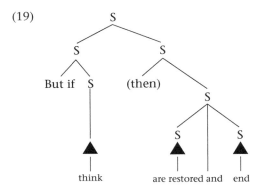

Compare (19), repeated in (20b), with the beginning of the poem as laid out in (20a):

(20) a.

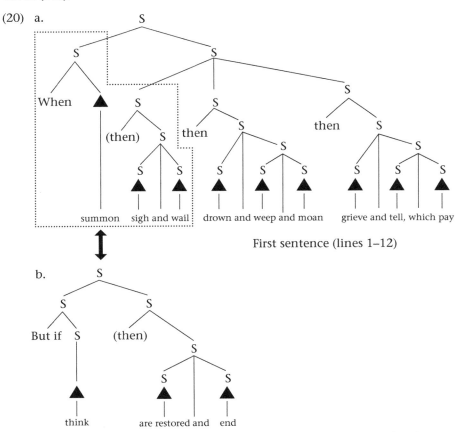

First sentence (lines 1–12)

Second sentence (lines 13–14)

The structure in (20b) is identical to the structure enclosed in dotted lines in (20a). The final couplet recapitulates the opening couplet and provides the template for the elaboration of the *then* clauses that mark the distinctive syntactic repetition of the sonnet.

I would like to comment on the function of what I have discussed with respect to Sonnet 30. To begin with, the content of the sonnet, its narrative if you will, is straightforward. The poet thinks on past woes that cause him to *sigh*, *wail*, *cry*, *weep*, *moan*, and *grieve*. He mulls them over again (*tell o'er*) and pays for that mulling all over again (*paid*). But then he thinks of his dear friend and all the pain washes away. So the poem builds a kind of scale of justice. On one side is past pain. On the other side is (presumably) present pleasure. In the balance pleasure wins. That is why the poem opens with the metaphor of a courtroom session in which past pain is "summoned" to be weighed against present pleasure.

Though I have no doubt critics will amplify this account (see, e.g., Vendler 1997), for present purposes let's assume that is the essential content. Well, then, where do end rhyme and syntactic parallelism come in? My view is that these are two kinds of repetitive ornamentation, both governed by the *same/except* relationship, meant to supply the poem with its own hardwired pleasure much the way powdered sugar, sprinkled on top of a cookie, adds its own kind of gastronomic pleasure. Indeed, I think that is a large portion of the poet's art, combining artfully expressed content (*sessions of sweet silent thought*, *drown an eye*, *death's dateless night*, etc.) with artful forms of repetition.[4]

One might argue that this does not go far enough—that the various modes of repetition carry their own kind of meaning. For example, commenting on the syntactic parallelism, Helen Vendler (1997, 168) says:

> And yet the successive phases of feeling . . . seem to melt into one another because of the resemblance of their syntactic structures, as if they were all one long process, each generating the next.

This kind of comment does not reflect the meaning of the three repeated syntactic structures. There is no meaning attached to this repetition the way meaning is attached to verbs like *summon*, *drown*, and *grieve*. There is nothing in the syntactic repetition that says, like a stage direction, "Melt into one another." Rather, Vendler's remark is about what the structures evoke in her. That is quite different from meaning. In the mind of another critic, these structures might evoke inevitability. In the mind of yet another, they might evoke self-flagellation. None of these evocations would be wrong in

the way that specifying the meaning of *sessions* as 'what you call the silence when a very loud noise—like the sound of a jackhammer—suddenly stops' is wrong. These evocations are not the meaning of the syntactic repetitions. They are simply occasions for evocation. In fact, I think a great deal of modern poetic criticism consists of evocation in that sense.

That said, there is always the potential for a poet to extract more than repetition from the syntax. I have written extensively elsewhere (Keyser 2020, 105ff.) about a remarkable poem by Wallace Stevens called "The Snow Man." I will not repeat my exposition here but will reproduce the poem and its structure:

(21) One must have a mind of winter

 To regard the frost and the boughs

 Of the pine-trees crusted with snow;

 And have been cold a long time

 To behold the junipers shagged with ice,

 The spruces rough in the distant glitter

 Of the January sun; and not to think

 Of any misery in the sound of the wind,

 In the sound of a few leaves,

 Which is the sound of the land

 Full of the same wind

 That is blowing in the same bare place

 For the listener, who listens in the snow,

 And, nothing himself, beholds

 Nothing that is not there and the nothing that is.

(22)

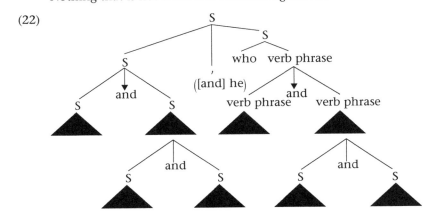

Stevens's poem shares certain similarities with Shakespeare's Sonnet 30. Both are sonnets, though "The Snow Man" consists of fifteen lines. In both cases the closing couplet recapitulates the structure of the entire poem—with an important difference. Sonnet 30 consists of two sentences, a twelve-line sentence and a two-line closing sentence. "The Snow Man" is a single fifteen-line sentence whose closing couplet repeats the entire structure that goes before it. A glance at its structure in (22) reveals the repetitive structural parallelism built into the poem. But what isn't obvious is that this structure forces its readers to parse the poem in a way that directly reflects the poem's meaning. Using normal parsing routines, readers are led down one garden path only to encounter another marked by a signpost labeled *and*. Specifically, readers come to what they think is the end of a clause only to encounter an *and* that shows their analysis thus far was wrong. They are forced to reanalyze. This forced analysis and reanalysis of the poem's syntactic structure parallels the content of the poem, which says essentially that one must constantly reanalyze one's perception of reality until one arrives at the truth expressed in the very last line.

If one asks which is the better sonnet, Shakespeare's Sonnet 30 or Stevens's "The Snow Man," one enters a maze without an exit. *Better* can mean any number of things to a reader. The evocations associated with each poem will depend in part on the life histories of individual readers and no two of those are at all likely to be the same. But ask a different question—which sonnet is more intricate?—and the maze has a well-marked exit. For example, which is more intricate, an Easter egg or a Fabergé egg? Ask the same question of Sonnet 30 and "The Snow Man." Shakespeare's sonnet uses syntactic repetition as ornament. Stevens's makes double use of syntactic repetition, namely, as ornament and as syntactic allegory. Parsing the poem as you read it is a metaphor for what the poem is about. So, which poem is more intricate? For me the answer is a no-brainer. Which is better? Your call.

The "new" rules under which "The Snow Man" was written stripped away occasions for repetition in the form of meter and rhyme, leaving syntactic repetition as a source of pleasure. There are other ways that poetry might have held onto repetition. For example, one might have supposed that lexical repetition would have increased to take up the slack left by the abandonment of meter and rhyme. But that doesn't seem to be uniformly the case. One poem that *does* rely on lexical repetition is Eugene Gloria's

"Rizal upon Hearing David Bowie's 'The Rise and Fall of Ziggy Stardust and the Spiders from Mars'" (*Poetry*, October 2022):

(23) He walks like that just to walk for five
 years, never averting his eyes. Five
 years before, he planted five
 year-old conifers amidst five
 towering sand dunes and the five

 Great Lakes reverting into meadows
 narrating their own stories of being stuck
 in that folding and unfolding motion
 like a car wheel churning in the mud
 There's sun and hands unclasping

 Five years of holding up his head
 Five years in those imperishable hands
 Five years with nothing to hitch his star on
 Five years of time spent and five on parole
 Five years of building five end-stopped lines

 I've grazed on these streets for five years
 I've cracked the steps of these five years
 I've retreated in peace for all of five years
 And wore the facade of time in five years
 I've etched all this rage inside for five years

 Five years and five arterial rainbows
 Five years and thirty seconds of doubt
 Five years of inhabiting dilapidated silos
 Five years of burning and gathering
 Five years' worth of ashes from five eloquent ruins

The poem consists of, not surprisingly, five five-line stanzas. Why five? Perhaps because the Filipino poet who is the subject of the poem, Jose Rizal, has five letters in his last name.[5] Read the poem with an eye for the inventive ways in which Gloria exploits repetitive parallelism around the word

five and the noun phrase *five years*. In the first stanza every line ends with the word *five*, parallel to the fourth stanza where every line ends in the word *years* preceded by the numeral *five*. The fifth stanza begins the way every line in the fourth stanza ends, namely, with the phrase *five years*. In this it parallels the third stanza. Nothing this complicated appears in the Old Testament, where parallelism is constrained to welding half lines together.

There are other morphological repetitions—for example, the repetition of *-ing* in *averting, towering, reverting, narrating, folding, unfolding, churning, unclasping*. The last six occur one (or two) to a line in the second stanza, the only stanza that does not use the numeral *five*. So the different ways the poem inserts repetition are in complementary distribution. This kind of intense repetition is unusual in postmodern poetry. But it does demonstrate how the slack produced by the absence of meter and rhyme can be taken up by lexical and morphological repetition. Think of the opening of T. S. Eliot's *The Waste Land* where five of the first six lines end with *breeding, mixing, stirring, covering, feeding*. That modern poets don't often use these devices suggests that ornamentation/pleasure is not on their minds when they write.[6]

Before we leave the topic of parallelism altogether, there is one more avenue to explore. Can a poet make use of repetitive parallelism in a poem that is completely devoid of meaning? And if so, why would a poet do it? The answer to the first question is yes. One such example is "Karawane," a Dada sound poem by Hugo Ball:

(24) 1. joli**fanto bambla ô falli bambla**
 2. grossiga m'pfa habla horem
 3. égiga goramen
 4. higo bloiko russula huju
 5. **hollaka hollala**
 6. **anlogo bung**
 7. **blago bung**
 8. **blago bung**
 9. bosso fataka
 10. **ü üü ü**
 11. schampa **wulla wussa** ólobo
 12. hej tatta gôrem

13. eschige zunbada

14. **wulubu ssubudu uluw ssubudu**

15. tumba **ba- umf**

16. Kasugauma

17. **ba- umf**

I have boldfaced the portions of this sound poem that exhibit repetitive parallelism. Lines 6–8 all end in *bung*. Lines 7–8 are repetitions and line 6 is a near repetition. Line 14 begins with the phrase *wulubu ssubudu* and ends with the phrase *uluw ssubudu, uluw* being *wulubu* backward, minus the *-bu,* which is repeated twice more in the line. *Ba- umf* ends line 15. And line 17. There is enough parallelism going on at the phonological level to label it an important property of the poem.

Thus, the answer to the first question—Can repetitive parallelism be found in a sound poem?—is yes. Now to the second question: Why do it? After all, a nonsense poem could easily be written without phonological repetition. So the answer seems straightforward. It is the only way to introduce pleasure into the text.

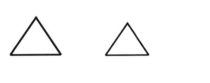

13 Repetition in Painting and Photographs

Let us turn to repetition in painting, starting with Andy Warhol's *Campbell's Soup Cans* (1962) (see figure 13.1). The painting consists of thirty-two replicas of a can of Campbell's soup. Each one is the same as every other except for one thing, the kind of soup in the can. Starting from the upper left-hand corner and reading from left to right, the top row consists of *tomato, vegetable, green pea, clam chowder, beef, asparagus, celery,* and *beef broth*. Think of the cans as the counterpart of the nucleus of a syllable and the soup types as onsets, and you have a perfect visual *same/except* rhyme.

Made at the highpoint of Kline, de Kooning, and Pollock, *Campbell's Soup Cans* was a poke in the eye of abstract expressionism. Not only was it blatantly mimetic, but it was being blatantly mimetic with a mundane commercial product found in every supermarket and corner grocery store in America. Some people, among them the philosopher of art Arthur Danto, think *Campbell's Soup Cans* pulled the legs out from under art as ideology (see Keyser 2020, chap. 11, for some discussion). Danto (1995, 125) argues that Warhol's giant replica of a Brillo box (*Brillo Box (Soap Pads),* 1964) changed the nature of the debate about what constitutes a work of art:

> The example made it clear that one could not any longer understand the difference between art and reality in purely visual terms, or teach the meaning of "work of art" by means of examples. But philosophers had always supposed one could. So Warhol, and the pop artists in general, rendered almost worthless everything written by philosophers on art, or at best rendered it of local significance. For me, through pop, art showed what the proper philosophical question about itself really was. It was this: What makes the difference between an artwork and something which is not an artwork if in fact they look exactly alike?

Not all repetition is as in-your-face or as disruptive as *Campbell's Soup Cans*. One painting from the impressionist period is particularly pertinent.

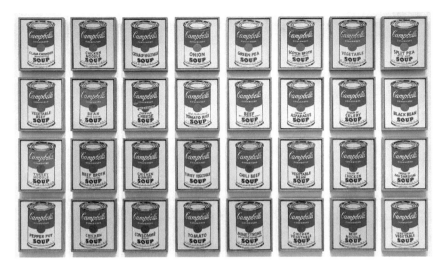

Figure 13.1
Andy Warhol's *Campbell's Soup Cans*. © The Andy Warhol Foundation for the Visual Arts, Inc. / Licensed by Artists Rights Society (ARS), New York.

I am thinking of *Paris Street; Rainy Day* (1877) by Gustave Caillebotte (1848–1894) (see figure 13.2). Currently housed in the Art Institute of Chicago, it was originally exhibited at the Third Impressionist Exhibition in Paris in 1877. It is probably Caillebotte's best-known work. I consider it a masterpiece and regret that I have never seen the real thing. Even so, it never ceases to bowl me over. Discussions of it typically focus on the incredible verisimilitude of the painting, the sense that it is photographic in its vivid capture of an ordinary moment. Thus, art critic Sebastian Smee observes in an article in *The Washington Post* dated January 20, 2021:

> Caillebotte compressed different sensations of time and movement into the same picture. A stroll to the farthest visible point could chew up half an hour. But this current predicament—a potential pedestrian collision—will play out in seconds. Do we veer left or right? Our instinctive hesitation is complicated by the man coming into the frame from the right. The space is simply too tight. And all these umbrellas aren't helping!

Smee's comments are directed not at the form of Caillebotte's masterpiece, but at its content. That is, of course, not unusual. It is reminiscent of critics of poetry recording their personal evocations for public consumption. But is it helpful? Well, in some cases when a scene from history or mythology is

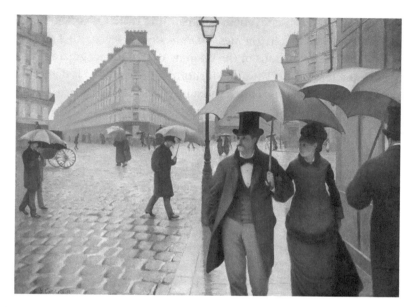

Figure 13.2
Paris Street; Rainy Day (1877) by Gustave Caillebotte (1848–1894)

portrayed, it is nice to know what is going on. Think of *Judith with the Head of Holofernes* by Botticelli (ca. 1495), the bodiless head held dangling by its hair from Judith's left hand, a sword in her right. Explaining what is going on is the stuff of iconography, but it doesn't help much in shedding light on why the painting is deemed a masterpiece.

When the French painter Paul Delaroche first saw a daguerreotype in 1839, he is supposed to have said, "From today, painting is dead." He must have been coming from the view that the image was all. From that starting place, it is not unreasonable to ask, What is the point of going to all the trouble of making an image on canvas when a camera can do it much more accurately and much more efficiently?[1] Obviously, Delaroche's five-word obituary for painting was, like reports of Mark Twain's demise, premature. But why? What is it about painting that has kept photography from slaying it?

I will try to shed some light on that. I begin by asking, Where does the pleasure come from? Smee's description implies that he finds the painting a source of pleasure. I do as well. But describing the scene isn't much help. Anyone can do that, though perhaps not as eloquently as Smee.

The first thing to observe about this painting is that it is wholly about faces, places, and bodies. In *The Mental Life of Modernism* (2020), I talk about recent discoveries of sections of the brain dedicated to recognizing specific entities in the real world. Thus, the fusiform face area (FFA) is dedicated to face recognition. Its neurons fire if the subject is looking at a face. But if the subject is shown a tree, or a car, or anything other than a face, the FFA stays quiet. Nearby is an area called the parahippocampal place area (PPA). This is its description taken from Wikipedia:

> The parahippocampal place area (PPA) is a sub-region of the parahippocampal cortex that lies medially in the inferior temporo-occipital cortex. PPA plays an important role in the encoding and recognition of environmental scenes (rather than faces). fMRI studies indicate that this region of the brain becomes highly active when human subjects view topographical scene stimuli such as images of landscapes, cityscapes, or rooms (i.e. images of "places"). Furthermore, according to work by Pierre Mégevand et al. in 2014, stimulation of the region via intracranial electrodes yields intense topographical visual hallucinations of places and situations.
>
> Damage to the PPA (for example, due to stroke) often leads to a syndrome in which patients cannot visually recognize scenes even though they can recognize the individual objects in the scenes (such as people, furniture, etc.). The PPA is often considered the complement of the fusiform face area (FFA), a nearby cortical region that responds strongly whenever faces are viewed, and that is believed to be important for face recognition.

As you can imagine, both areas are going to light up like the sky on the Fourth of July in the brain of anyone standing in front of *Rainy Day*. A third area is also relevant: the extrastriate body area (EBA). As Wikipedia defines it:

> [The EBA is] a specific area of the lateral occipitotemporal cortex that responds selectively to visual images of human bodies and body parts, with the exception of faces. [In an experiment by Downing et al. (2001),] [this] region was determined to have increased activity when shown visual stimuli of body parts and even more activity when viewing whole bodies.

So *Paris Street; Rainy Day* is an image that caters directly to three areas of the brain dedicated to what it depicts: faces, places, and bodies. In that regard it is precisely like the eight centuries of Western painting that went before it, from Cimabue's *Crucifix* (1288) through Meissonier's *Campaign of France* (1864) and Caillebotte.[2]

But that doesn't get us closer to why Caillebotte's painting is so pleasant to look at. Or does it? In their seminal work on tonal music, Lerdahl and

Jackendoff (1983a, 2) describe how they see the task of capturing what we do when we listen to tonal music:

> Where, then, do the constructs and relationships described by music theory reside? The present study will justify the view that a piece of music is a mentally constructed entity, of which scores and performances are partial representations by which the piece is transmitted. One commonly speaks of musical structure for which there is no direct correlate in the score or in the sound waves produced in performance. One speaks of music as segmented into units of all sizes, of patterns of strong and weak beats, of thematic relationships, of pitches as ornamental or structurally important, of tension and repose, and so forth. Insofar as one wishes to ascribe some sort of "reality" to these kinds of structure, one must ultimately treat them as mental products imposed on or inferred from the physical signal. In our view, the central task of music theory should be to explicate this mentally produced organization. Seen in this way, music theory takes a place among traditional areas of cognitive psychology such as theories of vision and language.

Exactly. And any discussion of visual art must do the same. Art critics regularly bring to a painting history, culture, schools of painting, and so on. But one of the things most often left behind is an understanding of the mental structures propagated in the viewer's brain in the act of viewing. Neuroscience hasn't advanced far enough to give us a definitive answer. That doesn't mean it hasn't paid attention. For example, Marr and Vaina (1982, 501–502) outline the desiderata for an appropriate representation like this:

> In their study of how to represent 3-D shape information, Marr & Nishihara (1978) laid down three criteria that such representations should satisfy to account for the efficiency with which the human visual system recognizes 3-D objects.
>
> *Criterion 1 (accessibility)*. The representation should be easy to compute from the pictorial image.
>
> *Criterion 2 (scope and uniqueness)*. The representation should provide a description of a sufficiently large class of shapes, and for each shape within its scope, it should provide a description that is unique from *any point of view*. Otherwise, if the description is to be used for recognition, the difficult problem will at some point arise of whether two descriptions describe the same shape.
>
> *Criterion 3 (stability and sensitivity)*. The representation should reflect the similarity between two like shapes while also preserving the differences. As Sutherland (1979) put it, it is important to be able to recognize both that a shape is a man and that it is Jones or Smith.

Criterion 3 is especially interesting given the *same/except* emphasis of this book. It says that the ability to perceive shapes requires the ability not only

to discern sameness, but also to detect differences while retaining the sense of sameness. This seems like a good place to recall William James's (1890, 528) remark quoted in chapter 1:

> The perception of likeness is practically very much bound up with that of difference. That is to say, the only differences we note *as* differences, and estimate quantitatively, and arrange along a scale, are those comparatively limited differences which we find between members of a common genus. . . . To be found *different*, things must as a rule have some commensurability, some aspect in common, which suggests the possibility of their being treated in the same way. (James's italics)

Let's look, then, at Caillebotte's *Paris Street; Rainy Day* not as a recognizable street scene but as an arrangement of geometric objects as depicted in figure 13.3. The first thing that pops out is the extent to which triangles dominate the canvas. The foreground and midground contain five umbrellas. The umbrellas are themselves rounded distortions of a triangle. But notice that the umbrellas are made up of smaller triangles within a triangle. Here is a painting that luxuriates in representations that "reflect the similarity between two like shapes while also preserving the differences." It is chock-full of visual rhymes. The triangle motif does not end with the umbrellas. Notice the three figures to the left. They make up the points of a triangle.

The triangle motif is also picked up by the buildings. The building to the left of the dominant couple is triangular. Inside the outlines of the building are more triangles defined by the long rows of balconies that run along the facades. Now look at the cupolas on the two buildings to the right. They are each triangular, and taken together they form three points of another triangle.

Repetition of the *same/except* variety appears elsewhere, most notably in the cobblestones. An interesting property here is that the closer the cobblestones get to the lower left-hand edge of the painting, the more elongated they become, thereby lending a ramp affect to that portion of the painting, inviting the viewer to step in and enhancing the sense of depth that the painting exudes. But repetition appears elsewhere as well. Notice the facades of the visible buildings. Their windows, parapets, and balconies are repeated over and over again. This is obvious in the original image in figure 13.2.

There is another triangle, more subtle than the ones we have just seen, but just as real. In the original painting the wall on the right is reddish-brown.

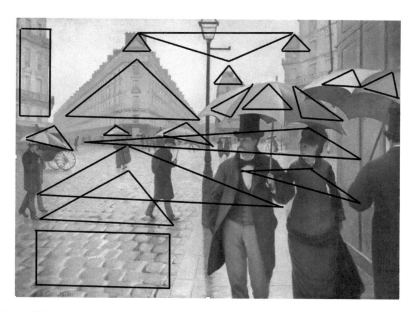

Figure 13.3
Triangle and rectangle superimposition on *Paris Street; Rainy Day*

That color is repeated across the boulevard—seven major avenues meet at the Place de Dublin—and if you draw a line to connect the two reddish-brown walls, you have one side of a triangle. If you connect both ends of that line with the most distant single figure, to the left, you have another triangle that encloses the heads of the two main figures on the right, thereby focusing on their line of sight. We are not finished. There is another triangle made up of the three figures on the right about to collide. And this triangle is paralleled by the triangle noted earlier of the figures walking in the street.

And now we can conjecture. Margulis has shown us that human beings find repetition pleasurable. Caillebotte's painting is filled with objects that provide the viewer with the opportunity to construct triangles. That humans can do this is demonstrated by the famous Kanizsa triangle illustrated in figure 13.4. Looking at this figure, you cannot help but construct a triangle and interpret the illusion as a white triangle sitting on top of three black discs. In reality there is no triangle. There are simply three Pac-Man-like objects placed in such a way that you see a triangle. Caillebotte has

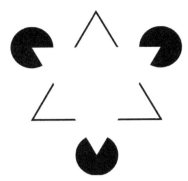

Figure 13.4
The Kanizsa triangle illusion

done much the same thing. He has painted objects that induce the viewer to construct triangles and he has made the triangles in *same/except* pairs. The discovery of this visual *same/except* relationship is the source of the painting's pleasure no less than rhyme is a source of pleasure in a poem. Indeed, Caillebotte's *Paris Street; Rainy Day* is designed to elicit visual rhyme as a source of pleasure. The same is true of the rectangular and square motifs in the painting.

It is noteworthy that as strikingly photographic, familiar, dramatic—what have you—the painting is, one source of its pleasure has nothing to do with the content of the image but its shape, a shape that forces the viewer to find the rhymes.

There is one more property of *Rainy Day* that I would like to draw attention to, one that has nothing to do with triangles. It has to do with parerga. An interesting line of inquiry in aesthetic theory concerns the *parergon*. What is a parergon? Kant gives one definition in his *Critique of Aesthetic Judgment* (1911, §14, 110–111):[3]

> Even what is called ornamentation (parerga), i.e., what is only an adjunct and not an intrinsic constituent in the complete representation of the object, in augmenting the delight of taste does so only by means of its form. Thus it is with the frames of pictures or the drapery on statues, or the colonnades of palaces. But if the ornamentation does not itself enter into the composition of the beautiful form—if it is introduced like a gold frame merely to win approval for the picture by means of its charm—it is then called finery [i.e., decoration] and takes away from the genuine beauty.

So Kant distinguishes between ornamentation, something that is related to the subject but is not central to it, and finery (decoration), something that detracts from the beauty of the object. Given the above passage, I am certain that Kant would grant the category *parergon* to the *Madonna della Sedia* frame that we looked at in chapter 8.

The notion of parergon has a long history. Strabo discusses it in his *Geography* in a story about the Greek painter Protogenes (fourth century BCE), who painted a satyr leaning against a column playing a flute. A partridge sat atop the column. The partridge was so well drawn that admirers of the painting ignored the satyr. So Protogenes expunged the partridge because it was not central to his painting. It was a parergon.

As Paul Duro (2019, 23) notes in his very helpful historical survey, Jacques Derrida resurrected the idea of the parergon:

> From the time Jacques Derrida introduced the term into contemporary critical theory in *The Truth in Painting*, its character and function have been largely understood as referencing a threshold or boundary—in particular, that of the border of the artwork. Yet a review of the term's long history suggests a meaning that differs in significant ways from its current near-univocal characterization as a synonym for a frame.

In 1533 Lucas Cranach the Elder painted a portrait of the Roman matron Lucretia's tragic suicide (see figure 13.5). Derrida (1987, 57) discusses the painting from the point of view of the parergon. It is interesting to read his struggle with the term:

> Where does a *parergon* begin and end. . . . For example, Cranach's Lucretia holds only a light band of transparent veil in front of her sex: where is the parergon? . . . A parergon, the necklace that she wears around her neck? . . . If any parergon is only added on by virtue of an internal lack in the system to which it is added . . . what is it that is lacking in the representation of the body so that the garment should come and supplement it. And what would art have to do with this!

I suppose there might be some value in categorizing the contents of a painting in terms of what is central and what is peripheral, for example, the ornate armrest in the *Madonna della Sedia*. But I think the notion contains within it a certain danger, namely, not seeing the forest for the trees. Look again at Cranach's *Lucretia*. There are two horizontal lines in the painting. One is Lucretia's necklace. The other is the transparent veil just beneath her mons pubis. These strike me as important markers in the painting—the one underscoring her face, the second underscoring her sex. They constitute a

Figure 13.5
Lucretia, painting (1533) by Lucas Cranach, the Elder (1472–1553)

frame within a frame; that is, they embody the current meaning of *parergon* (see the quotation from Duro 2019 above). They confine what is important in the image, the dagger aimed at Lucretia's heart because of Tarquin's abomination. This frame within a frame says these are the important places in the painting. If this is true, then what seem to be candidates for parerga, the veil and the necklace, are not.

This brings us to *Paris Street; Rainy Day* and the lamppost. Is the lamppost an integral part of the painting or is it, like Protogenes's partridge, a parergon, a subsidiary ornament that can be done away with or, at the least, downplayed? To begin with, it cuts the painting in two. Indeed, as figure 13.6 shows, the painting is made up of two separate paintings. Each half can easily stand alone.[4] Now look at the doctored version in figure 13.7. What's missing is the bisecting lamppost. Taking out the lamppost flattens the painting. The dimension that Smee talks about, the sense of distance between the dominating couple in the foreground and the spot at

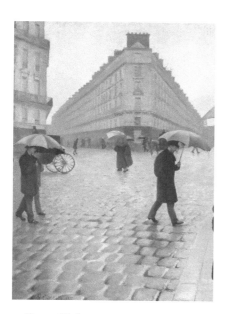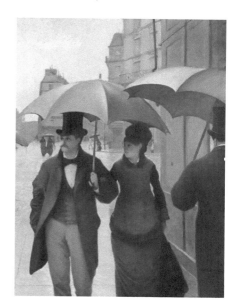

Figure 13.6
Paris Street; Rainy Day split into two separate paintings along the line of the lamppost

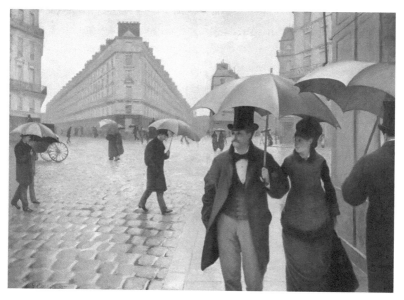

Figure 13.7
Paris Street; Rainy Day without lamppost

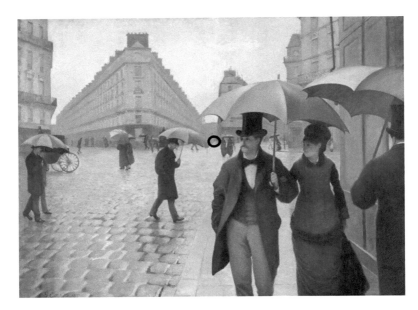

Figure 13.8
Paris Street; Rainy Day without lamppost and with one of the many vanishing points encircled

the painting's central vanishing point, disappears. (See the circle in figure 13.8.) The foreground fades into the background. But insert the lamppost and the sense of depth pops out (see figure 13.9).[5]

This strongly suggests that the lamppost, on first viewing a reasonable candidate for a parergon, is in fact the opposite. It is an essential part of the painting. Evidence for this is that when Caillebotte painted *Rainy Day*, there was no lamppost in that spot. There couldn't be. That style of lamppost had been removed from the Place de Dublin years before. So Caillebotte put it in for a reason, namely, to enhance the painting's sense of depth. The overarching point is that we need to have a coherent view of what makes a painting work before we can begin to decide what is a parergon and what is not.

I do not think that it is stretching the point to suggest that Caillebotte's *Paris Street; Rainy Day*, Poe's "The Raven," and Duke Ellington's "Satin Doll" are works of art from three distinct genres each appealing to the same cognitive function: namely, the ability to make *same/except* judgments

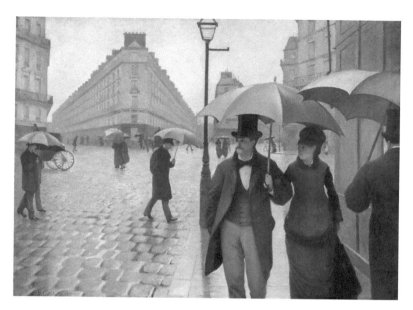

Figure 13.9
Paris Street; Rainy Day with lamppost restored

establishing repetitive patterns, the detection of which, per Margulis, elevates one's aesthetic enjoyment.[6]

Let's turn to some photographic examples. The introduction to the eighth edition of the well-known *Janson's History of Art: The Western Tradition* (Davies et al. 2010) discusses in detail a photograph by Lee Friedlander, *Albuquerque, New Mexico* (1972), coincidentally in the collection of the Art Institute of Chicago, along with Caillebotte's *Paris Street; Rainy Day*. Presumably Davies et al. had two goals in mind when they included this photograph in their introduction. The first was to underscore that photography is an art form worthy of a place alongside painting. The second was to demonstrate how to think about a work of art in general and photographs in particular.

Take a look at the photograph in question, in figure 13.10. And now consider a sample of Davies et al.'s commentary (p. xxix):

> In *Albuquerque*, Friedlander portrays a modern America that is vacuous and lifeless, which he suggests is due to technology. How does he do this? The picture has a haunting emptiness. It has no people, and it is filled with strange empty

Figure 13.10
Lee Friedlander, *Albuquerque, New Mexico.* © Lee Friedlander. Courtesy of Fraenkel Gallery, San Francisco and Luhring Augustine, New York

spaces of walkway and street that appear between the numerous objects that pop up everywhere. . . .

Everywhere, nature has been cemented over, and besides a few scraggly trees in the middle ground and distance, only the weeds surrounding the hydrant thrive. In this brilliant print, Friedlander captures his view of the essence of modern America: the way in which technology, a love of the artificial and a fast fragmented lifestyle were spawning alienation and a disconnection with nature and spirituality.

Like Sebastian Smee's account of *Paris Street; Rainy Day*, this commentary focuses on the content of the photograph and not on its form. To that extent it is telling us about how Davies et al. feel about the image rather than how the image works as art. In other words, like Vendler's comment about the repeating structures in Sonnet 30, it is an evocation. Thus, Davies et al. are "disturbed" by various features in the photograph, and shadows appear to be "mysterious" (p. xxix):

Disturbing features appear throughout the composition. The street sign—which cannot be seen because it is cropped at the top of the print—casts a mysterious shadow on the wall. A pole visually cuts the dog in two, and the dog has been separated from his attribute, the fire hydrant, as well as from his absent owner.

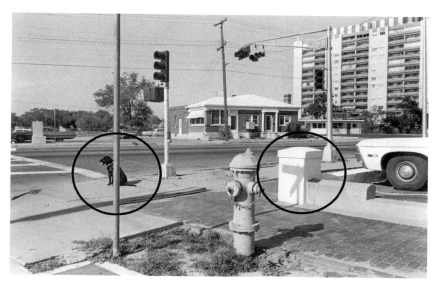

Figure 13.11
Albuquerque with real dog and shadow dog encircled

Criticism that talks of images as being "disturbing" or "mysterious" has its place. One might think of it as evocative reportage. My interest lies elsewhere, namely, in explaining why this superficially mundane photograph works so well.

Let's take a closer look. A dog is sitting on the sidewalk. It is the only living thing in the photograph, although its collar hints at an owner waiting in the wings. The eye is drawn to the living dog. But it is not the only dog in the photograph. At virtually the same latitude, a larger shadow dog is mimicking the real dog (see figure 13.11). Both dogs have open mouths and extended tongues. The shadows of the shadow dog and the shape of the concrete wall make it easy to read back, body, and behind. The shadow dog is created by the sun shining behind a street sign atop the pole that bifurcates the real dog but is out of sight at the top of the photograph. It is the street sign that connects the two images. The pole cuts the real dog in half only to make him whole again in the shadow that it casts. Looked at this way, Davies et al.'s "mysterious" shadow loses its mystery.[7]

The calculated nature of this photograph was not lost on the authors:

Friedlander did not just find this composition. He very carefully selected it and he very carefully made it. He not only needed the sun, he had to wait until it was

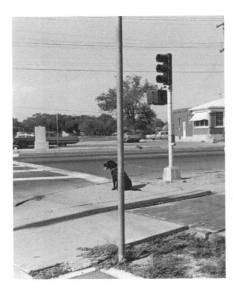

Figure 13.12
Albuquerque bisected to underscore the similarity of the two halves

in the right position (otherwise, the shadow of the fire hydrant would not align with the street).

I agree with all that, except it wasn't the shadow of the fire hydrant that had caught Friedlander's eye. It was in fact the dog and shadow dog described above. The calculated character of the photograph is supported by this simple operation. Cut the photograph in two, as shown in figure 13.12. Now in your mind's eye superimpose one half over the other. Shadow dog (not hydrant) and real dog are in precisely the same spot. In other words, the right half is a copy of the left half with respect to the dog. They are the same, except one dog is real and one dog is a shadow. The photograph is another example of a visual rhyme, only it was not constructed à la Caillebotte with paint. It was constructed à la Friedlander with a camera. And we have seen that *same/except* repetition elicits pleasure.

Amid the certainty that a significant number of readers will shake their heads in vigorous disagreement, I would like to mention the way a group of thirty-seven viewers reacted when viewing this photograph. On December 9, 2023, I gave an online PowerPoint presentation of *Albuquerque, New Mexico* at the Fifth New York Institute (V-NYI). I used the occasion to conduct a

straw poll. After showing the photograph and describing the shadow dog, I asked how many of those in the audience saw the shadow dog and how many did not. The results were that twenty-seven viewers (63%) saw it, and ten (37%) did not. Although the majority saw the shadow dog, a significant number did not. That cannot be ignored, even though the poll was taken on the spur of the moment and the sample size was small. Still, I think this divergence is quite likely real and worth thinking about.

There are photographs, of which *Albuquerque* is one, that exploit the entire spectrum of gray shades from black to white. In such photos the ends of the spectrum, pure black and pure white, tend to be the first focal point. As it happens, in *Albuquerque* the real dog is the purest black and the area around the shadow dog, the column with the shadow dog image, is the whitest. I suggest that seeing the shadow dog depends on which focal point you view first. If the first place you look at is the whitest area, then your eye will encounter the image on the column before it encounters the dog. In that case, you are far more likely to see the shadow as the number 7 rather than as a shadow reflection of a dog.

I think this is crucial—the order in which you encounter the shadow and the dog. If you encounter the real dog first, then you are more likely to see the image on the column as a shadow dog. Why? Because the number 7 does not prime the figure of a dog, but the image of a dog primes its shape in a shadow. The reason why the majority of viewers in my poll saw the shadow dog is because one's eye tends to go to the blackest area first.

That at least is my conjecture. It is easily testable. If only I were in a position to test it.

The work of the American-born artist Roni Horn makes an interesting parallel to Warhol's *Campbell's Soup Cans*, discussed earlier. Two examples are found in *Becoming a Landscape* (figures 13.13 and 13.14). Each indicates a recurrent technique in Horn's work, pairing two images that are the same except for tiny differences. Just as Warhol's soup cans constitute a form of visual rhyme in painting, Horn's works do the same in photography. The viewer is invited to inspect the images to tease out their *same/except* character. There are differences, very small ones; but as we have seen, we humans are hardwired to make those determinations and doing so as an artistic task is pleasurable. I believe Horn is exploiting this aspect of our *same/except* detection capability.

Figure 13.13
Roni Horn, *Becoming a Landscape* (detail) 1999–2001 © Roni Horn. Courtesy of the artist and Hauser and Wirth

Figure 13.14
Roni Horn, *Becoming a Landscape* (detail) 1999–2001 © Roni Horn. Courtesy of the artist and Hauser and Wirth

When you glance from one portrait to the other in figure 13.13, there is no doubt that the expressions are not identical. But it is a matter of great subtlety to pinpoint exactly what the difference is. Are the eyes wider in one? Are the lips slightly different?

On a website that carries Horn's work,[8] the image pair in figure 13.14 is described like this:

> The two photos are almost identical, but if one looks at the splash of water, you will see the difference. Horn requires that you look and discover. The "identity" is always different.

Or to put it differently, the rhyming images are always the *same/except*.[9]

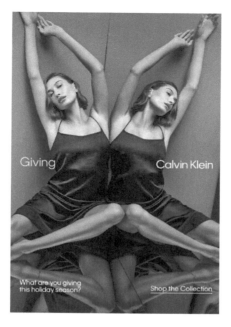

Figure 13.15
Calvin Klein mirror image ad

It is not surprising to find Roni Horn's technique exploited in the advertising world. I was reading a *New York Times* article on my iPhone[10] when, in scrolling down, I encountered an ad for Calvin Klein (see figure 13.15). The ad wants to persuade you to give someone Calvin Klein gifts for Christmas. But the image isn't just hawking lingerie. It's an example of the Roni Horn strategy. It is intended to stop you from scrolling past by offering a puzzle. You are invited to determine whether the figures are identical mirror images (see (4) in the introduction) or the *same, except* for a small difference (see (10) in the introduction). The hope, I suspect, is that you will accept the invitation because it presents a visual *same/except* puzzle, a potential source of pleasure. Once you have become invested in the image, you will be inclined to investigate the product.

One doesn't have to look hard to find examples of visual rhyme everywhere where photos are the lingua franca. Figure 13.16 shows one posted by a friend on Facebook. When I pointed out the rhyme to her, she said she hadn't seen it when she took the photograph. Now she can't unsee it.

Figure 13.16
Ada Brunstein, *Carriage Barn, Cooper's Pond, Bergenfield, NJ.* December 1, 2023. Courtesy of Ada Brunstein

In Keyser 2020 I discuss visual puns, illustrating the notion with, among other things, a *Rhymes with Orange* cartoon (p. 96). In this cartoon the visual pun resides in a horizon line that separates blue sky from desert in one panel being interpreted by the action figure in the next panel as a bowstring that he draws back in slingshot fashion so that he can, like an arrow in an archer's bow, propel himself out of the desert. In the final panel he is rendered by a blotch labeled "Splat." The sky, it turns out, is not the sky but a solid blue brick wall. It is a double visual pun.

In that same book (p. 20) I discuss the FedEx logo in terms of an Easter egg, a hidden structure embedded in a work of art by the artist (see figure 13.17). If at first glance you do not see the "hidden" arrow, then the logo is just an abbreviation for *Federal Express*. But once the arrow outlined by the juxtaposition of the *E* and the *x* is pointed out to you, you can never unsee it.[11] The logo shifts from a mere hypocorism like *ConEd*

Figure 13.17
The FedEx logo

a.

b.

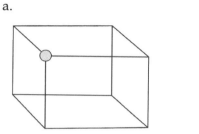

Figure 13.18
a. Necker cube. b. Rubin vase

(Consolidated Edison) or *Nabisco* (National Biscuit Company) to a visual pun that revolves around seeing the space between the *E* and the *x* in two different ways, either as meaningless space or as an arrow.[12] Unlike the cases discussed thus far, the FedEx logo is not an example of *same/except* visual rhyme. Rather, it is an example of visual rhyme of the identical variety. It is the counterpart of *ham:ham* rather than of *ham:Spam*. Many optical illusions are based on this kind of ambiguity. For example, in the Necker cube in figure 13.18a, the gray dot is either at the outside front upper left corner or at the inside back upper left corner. In figure 13.18b the illusion is based on a figure/ground focus. If you focus on the black, you see a vase against a white background. If you focus on the white, you see two faces looking at one another against a black background.

Let me close this chapter the way I opened it, with an image that is saturated with a *same/except* motif. The photograph is *Girls in the Windows 1960*, the photographer, Ormond Gigli. This photograph is among the highest-grossing photographs of all time, perhaps the highest. With prices ranging between $15,000 and $30,000 a print, the sale of 600 copies has added up to $12,000,000 and it is still selling all over the world. The vision to produce

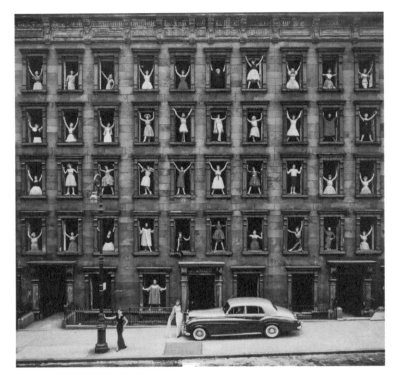

Figure 13.19
Ormond Gigli, *Girls in the Windows 1960*

an inventory of prints belongs to Gigli's son, Ogden, a photographer in his own right. In a *New York Times* article, David Segal (2023) quotes Ogden Gigli as saying, "It was my belief that the appeal of this image would carry on forever." Segal claims that an important part of the photograph's appeal

> starts with the image, of course, which is a brassy, joyful combination of glamour and urban grit with a dash of "Mad Men"–era nostalgia. The building embodies a glorious slab of vanishing New York City, and those women look like they're ready to break into song.

That description could fit several images—for example, Marilyn Monroe's encounter with a subway vent. But it doesn't explain the photo's eternal appeal. For that I think you have to look to its form. *Girls in the Windows*, which predates Andy Warhol's *Campbell's Soup Cans* by two years, is a perfect example of visual rhyme. The photograph contains forty models in

forty windows. What is the same are the windows. What is different is each model in her self-selected gown and pose. Think of the photo as a visual representation of multiple rhyme schemes. In every case, the window will be the same except for the model in it. In other words, the windows are to the Campbell's soup cans as the models are to the different Campbell's soup can labels.

The pleasure taken in this photograph is exactly that taken in the Warhol painting, the Lee Friedlander and Roni Horn photographs, the Calvin Klein ad, and my friend's casual shot of the barn on Cooper's Pond. The eye flickers back and forth, finding the difference amid the sameness, finding the visual rhymes and taking pleasure in finding them. The pleasure in problem solving noted by Bever (1986) and Chatterjee (2014) (see the introduction) is undoubtedly a strong component of this kind of pleasure.

14 P⁴ = Parallelism, Priming, Prediction, and Pleasure

In the introduction I suggested that repetition in the arts is a form of priming. I cited this passage from Steven Pinker's *Sense of Style* (2014, 124–125), where he offers contemporary examples of biblical parallelism. We've already looked at one of these, from Winston Churchill:

> We shall fight on the beaches, we shall fight on the landing grounds, we shall fight in the fields and in the streets, we shall fight in the hills; we shall never surrender.

Recall that Pinker suggests (p. 124) this use for the rhetorical device in this quotation:

> *Structural parallelism.* A bare syntactic tree, minus the words at the tips of its branches, lingers in memory for a few seconds after the words are gone, and during that time it is available as a template for the reader to use in parsing the next phrase. If the new phrase has the same structure as the preceding one, its words can be slotted into the waiting tree, and the reader will absorb it effortlessly. The pattern is called structural parallelism, and it is one of the oldest tricks in the book for elegant (and often stirring) prose.

In this chapter I return to the role of priming in the arts in finer detail to suggest that Pinker's account of priming can be extended to rhyme in poetry, to music, and to painting. I have deliberately omitted meter and will return to it later to explain why.

Recall also Martin J. Pickering and Victor S. Ferreira's (2008, 427) term *structural priming*:

> In the past couple of decades, research in the language sciences has revealed a new and striking form of repetition that we here call *structural priming*. When people talk or write, they tend to repeat the underlying basic structures that they recently produced or experienced others produce.

The first systematic investigation of this phenomenon, according to the authors (p. 428), was reported by Jim Schenkein (1980), who observed syntactic priming in walkie-talkie conversations among, of all people, burglars.

Pickering and Ferreira go on to say (2008, 42):

> Structural priming has also been heavily scrutinized because it helps us understand particular important types of repetitive phenomenon. Specifically, it may reflect processes of learning . . . or it may reflect critical communicative, imitative, or social functions.

To this litany of structural priming's important types of repetitive phenomena, I would like to add its use in poetry, music, and painting where, by encouraging repetition, it gives rise to pleasure. Thus, the pleasures one derives from biblical parallelism, from end rhyme, and from alliteration are all based on creating a priming object and following it with a target object that exhibits the same structure.[1]

The implicit identification of biblical parallelism at the sentence and phrasal level with end rhyme is not a new observation. As noted earlier, Roman Jakobson (1987, 82) once said (going on to quote from Gerard Manley Hopkins), "Rhyme is only a particular, condensed case of a much more general, we may even say the fundamental, problem of poetry, namely *parallelism*."

Let's take a closer look at the mechanism behind Jakobson's (and Hopkins's) insight. Consider the first line of Psalm 94, repeated here:

(1) God of retribution, Lord /God of retribution appear! //

Rise up, earth's ruler / give the arrogant their due //

How long shall the wicked, Lord / how long shall the wicked rejoice? //

They brag, speak arrogance, / all the evil-doers do act haughtily. //

In the first line the phrase *God of retribution* has the syntactic structure shown in (2):

(2)

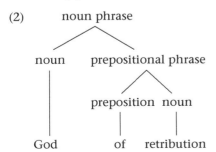

Once the phrase has been heard or read, according to the evidence Pickering and Ferreira (2008) provide, for a short period of time (3) lingers in memory:

(3) noun phrase

noun prepositional phrase

preposition noun

When the words associated with the second member of the parallelism come along—*God of retribution*—the listener/reader simply fills in the bottom of the tree. Constructing a new tree is unnecessary—hence the efficiency of priming.

This process is like rhyme, but at a phrasal level. Indeed, it is quite likely, although I am not aware of any experiments along these lines, that in a rhyming couplet, for example, Alexander Pope's memorable epigram engraved on the collar of a puppy he gifted to Frederick, Prince of Wales,

(4) I am his highness's dog at Kew;

Pray tell me, sir, whose dog are you?

the syllable structure for the first member of an end-rhyming word primes the syllable structure for its partner, with the proviso that the reader is aware that in poetry with end rhyme there must be an *except* (the onset) as well as a *same* (the rime):

(5) syllable

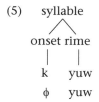

onset rime

k yuw

φ yuw

The listener/reader constructs the structure for *Kew*. Knowing how rhyme works, the listener/reader holds the syllable structure of *Kew* in memory. Then when the appropriate point in the rhyme scheme occurs, the listener/reader fills in the tree with the phonological segments of *you*. If the *you* fits, wear it. This is how priming works with rhyming.

But there is a difference.

I hypothesized earlier that there are constraints on repetition. One of those constraints deems that exact repetition is less pleasurable than *same/ except* repetition. The assumption is that (6a) is not as pleasurable as (6b):

(6) a. I pray, dear father, are you sure

That nothing in this life is sure?

b. I pray, dear father, are you sure

That in life nothing will endure?

At first glance this doesn't seem to be true at the sentential level. In Psalm 94 both lines 1 and 3 exhibit exact parallelism. There are differences, of course. In line 1 the first half ends with the vocative, *Lord*. The second half ends with the verb *appear*. The same kind of pairing characterizes line 3. The first half of line 3 ends with the vocative, *Lord*. The second half ends with the verb *rejoice*: thus, *Lord . . . appear* and *Lord . . . rejoice*.

Perhaps a nod to the principle of *same/except* is provided by what James Kugel (1981, 51) describes as the connectedness between half lines:

> B, by being connected to A—carrying it further, echoing it, defining it, restating it, contrasting with it, it does not matter which—has an emphatic, "seconding" character, and it is this, more than any aesthetic of symmetry or paralleling, which is at the heart of biblical parallelism.

So, using Pickering and Ferreira's terminology, the seconding character of the B target repetition will always distinguish it from the A prime. Hence, *same/ except* is built into the practice of parallelism at the level of discourse. That is to say, the syntactic structure will always be the same. The words that fit that structure will always be different. The semantic force of the B target will always have a "seconding" sense with respect to the A prime in Kugel's sense.

Figure 14.1 shows a typical example from verse 10 of Psalm 106, transliterated and translated as in (7):

וַיִּגְאָלֵם, מִיַּד אוֹיֵב / וַיּוֹשִׁיעֵם, מִיַּד שׂוֹנֵא

Figure 14.1
Psalm 106, verse 10

(7) waYig'älëm miYad ôyëv / waYôshiyëm miYad sônë[2]

He saved them from the foe's hand / A

and redeemed them from the enemy's hand // B

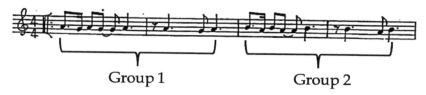

Figure 14.2
Opening four measures of "Satin Doll"

The syntactic structure of the B half line is identical to that of the A half line. The only difference is that the aggregate meaning of the words at the bottom of the syntactic tree in the B half line seconds the aggregate meaning of the words at the bottom of the syntactic tree in the A half line. That is to say, being "saved from the foe's hand" is restated as being "redeemed from the enemy's hand." The *same/except* shoe fits perfectly with the poetic expectation of rime identity and onset nonidentity. The structure is the same. The meaning is slightly different—exemplifying Kugel's seconding.

This calls to mind an earlier musical example. Recall the opening four measures of "Satin Doll" (see figure 14.2). There is a similarity to Psalm 106, verse 10. Lerdahl and Jackendoff (1983a,b) postulate that the ability to parse music, like the ability to understand natural language, entails knowledge of rules that provide structure over the relevant inputs. In natural language it is this ability that provides the structure in (2) and therefore the psychological basis for understanding a phrase like *God of retribution*. Lerdahl and Jackendoff show what those rules look like for music.

They propose four types of rules: grouping rules, metrical rules, time-span reduction rules, and prolongation rules. It will not be necessary to explicate their conception of a grammar for music to state the point I wish to make.[3] Suffice it to say that they show the importance of abstract representation when it comes to understanding the human ability to parse music just as linguists have shown the same for natural language. They propose quite explicitly what those representations look like. And, crucially, these representations involve hierarchical structures just as linguistic representations do.

The hierarchical tree in figure 14.3 is an example. It is meant to represent a time-span reduction tree that "establishes the relative structural importance of pitch-events within the heard rhythmic units of a piece" (Lerdahl and Jackendoff 1983b, 231). The way to read the tree is to assume that left

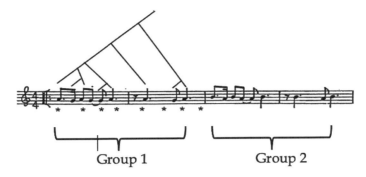

Figure 14.3
Time-span reduction tree of opening measures of "Satin Doll"

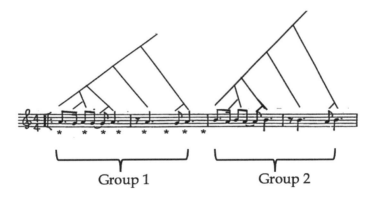

Figure 14.4
Time-span reduction tree of measures 3 and 4 of "Satin Doll" as if primed by measures 1 and 3

branches are subordinate to right branches in terms of relative importance. Thus, the second note in the first measure is less dominant than its partner designated by the right branch and so on. If we assume that structural priming applies in music as well as in language, then the tree that represents the note relationship of the first two measures will linger in the memory for a few seconds while the next two measures are played. Consequently, it will be available for the listener, who is on the verge of parsing measures 3 and 4. As in sentential structural priming, the tree's "afterimage" will be filled in by the notes in measures 3 and 4 to yield the structure in figure 14.4. In sentential structural priming, the repetition of the syntactic structure of a

speaker's utterance in the response of the speaker's listener is taken to be evidence of an afterimage. That is what is meant by saying the speaker has primed the listener. The counterpart of this in music would be the listener filling a lingering time-span reduction tree that dangles noteless with a new string of notes accurately filling the same structure. Margulis's experiment suggests that this repeated tree fulfillment is pleasurable.

Distance between the primer and the primed remains a problem. The participants in Margulis's experiment preferred repetition when the repeated segments were several segments away as well as when they were adjacent. The same is true of rhyme schemes. The rhyming pairs can be in nonadjacent lines but not too far apart. This needs to be explained. Perhaps the expectation factor at play when we experience a poem or a piece of music works to increase the longevity of the priming tree. That is, perhaps time-span reduction trees are more long-lived than sentential trees in normal conversation because the person experiencing poetry or music expects priming—that is, repetition—to occur.[4]

Another factor that plays a role is the length of the segment being repeated. Thus, Margulis (2012) describes an experiment testing participants' ability to detect a repeated segment in tonal music. She reports that there is a relationship between the length of the repeated segment and the accuracy of its identification. Specifically, the longer the segment the more likely it will be identified correctly as a repetition. And the more the exposure—the trial for each repetition was repeated four times—the more accurate for longer repetitions and the less accurate for shorter ones. Participants judged longer adjacent musical phrases more accurately than shorter adjacent ones. The same trends were evident when the pairs were separated by intervening material, though the experiment is silent on the length of the intervening material. In terms of the present study, participants' greater success with longer segments may represent a greater degree of accuracy in constructing and then retaining the segment's time span reduction tree. Shorter segments may not be long enough to permit constructing an accurate tree. These are just speculations, of course.[5]

Whatever accounts for the longevity of priming trees in works of art, the similarity between end-rhyming and musical and structural priming cannot be denied. It would indeed be odd to suppose that priming was limited to the language function alone, since it looks very much like a general cognitive phenomenon. There is nothing strictly linguistic about

it. Rather, it appears to be a phenomenon associated with trees and, as Lerdahl and Jackendoff (and Heinrich Schenker before them) have shown, to listen to music is to parse trees. When structural priming, literature's end rhyme, and musical rhyme are arrayed as in figure 14.5, their similarity becomes apparent.

Before I try to put all this together as a conjecture, I would like to say something about meter. In chapter 8 I suggested that in a given metrical pattern—say, WSWSWSWSWS—the metrical elements W and S are aligned with the syllables of a sentence or partial sentence on a one-to-one basis. (There are variations, but these need not concern us here.) This ten-syllable alignment automatically includes distribution of primary- and lesser-stressed syllables. The problem is to determine whether each line of the so-aligned verse exhibits a distribution of its stresses as licensed by the correspondence rule, keeping in mind that lots of distributions are allowed and lots are not. The correspondence rule distinguishes between them.

This raises a question. In sophisticated verse like Sonnet 30, does metrical priming occur? The answer is no. Successful priming requires an identity between the priming tree and the primed tree, as is apparent in figure 14.5. In sophisticated poetry two adjacent lines are rarely metrically identical. For example, in Sonnet 30 (see chapter 7, (4)) no adjacent lines repeat the same distribution of stressed and unstressed syllables. In fact, the distribution of stressed and unstressed syllables in each line of Sonnet 30 is unique. Not one line repeats any adjacent line anywhere in the poem. Priming at the level of stress distribution would be impossible.

Rather, it seems as if determining metricality in a given syllabo-tonic line of verse is like determining grammaticality in an English sentence. Given an arbitrary string of words, the rules of the grammar determine whether it is grammatical (i.e., well-formed) or not. Similarly, given an arbitrary distribution of stressed and unstressed syllables across a metrical expanse like WSWSWSWSWS, the rules of the meter determine whether the line is metrical (well-formed) or not.

Figure 14.5
How priming might work with respect to trees in sentence parallelism, end rhyme in poetry, and melodic rhyme in music

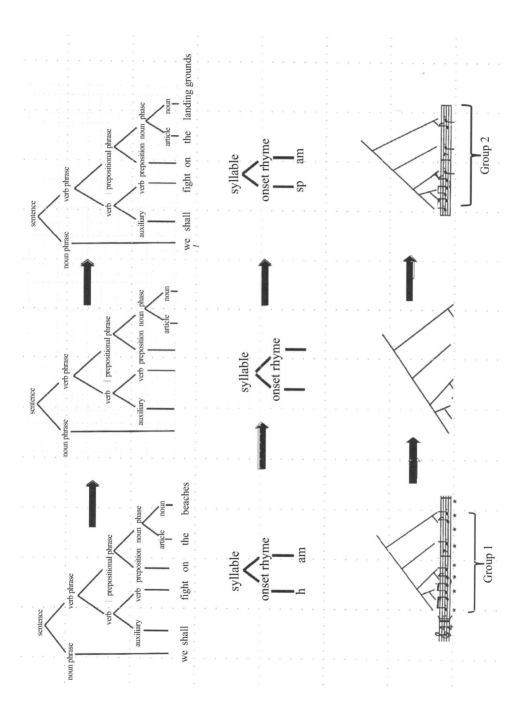

In this respect, the distribution of stressed syllables in children's poems like "Hickory Dickory Dock" resembles priming phenomena much more than the distribution of stressed and unstressed syllables in sophisticated verse. In children's verse every S position is occupied by a stressed syllable. That does not vary from line to line. What varies is the number of unstressed syllables from line to line as well as the occurrence of stressed syllables in W positions (see chapter 7, (11b) for an example of both). So it might be possible to characterize children's verse (and doggerel) in terms of something like a priming coefficient. That is, children's verse is far more amenable to priming than sophisticated verse.[6]

In what follows, then, I limit the conjecture to artifices that involve trees, namely, sentential parallelism as in biblical Hebrew verse, end rhyme, and melodic rhyme in music.

Let me put all this together into a single four-point conjecture:

(8) *Parallelism, Priming, Prediction, and Pleasure: The P^4 Conjecture*

 1. Poetry, painting, and music employ parallelism.

 2. Parallelism entails priming.

 3. Priming entails prediction.

 4. Prediction entails pleasure.

With respect to P^4.1, we have seen that parallelism (i.e., repetition) is amply employed in poetry (end rhyme) and nonmetrical biblical Hebrew poetry, in painting (triangles and rectangles in *Paris Street; Rainy Day*), and in music (rhythmic repetition with uniform pitch variation as in "Satin Doll").

Now let's turn to P^4.2. With respect to psycholinguistic experiments, priming refers to the mental inertia that keeps a syntactic tree in memory while attention is focused elsewhere, typically on a drawing that the subject is asked to describe aloud (see Pickering and Ferreira 2008). The experiments work like this. Participants are asked to read a sentence out loud, and are then shown a drawing and asked to describe the action it depicts. To a significant degree the participants' descriptions are framed in terms of the syntactic structure of the sentence that they read aloud just before exposure to the drawing. For example, if the sentence was in the passive voice, then participants tend to use the passive voice to describe the action in the drawing. The conclusion is that the abstract structure of the sentence read aloud remains in memory long enough to influence the way participants frame their descriptions.

Let us take ghost trees that linger after the words have faded as a fact of human sentence processing. Now let's commandeer that property for poetry. Biblical parallelism is an obvious instance. The whole idea is to replicate a preceding structure, sometimes identically, sometimes similarly, as we have seen.

But now, taking a leaf from Jakobson's and Hopkins's books (see the introduction), assume that the abstract trees we have examined here—those associated with sentence structure, syllable structure, and time-span reduction structure (see figure 14.5)—all participate in priming. With respect to poetic rhyme, including end rhyme and alliteration, the tree is the syllabic structure associated with the rhyming words.

Now we extend Jakobson's and Hopkins's proposals to include the kinds of trees that Lerdahl and Jackendoff (1983a) propose for music. Let us also assume that the abstract structures that paintings are built on—triangles, squares, and rectangles in Caillebotte; cubes in Picasso and Braque—are triggered by looking at a painting and that they linger as the eye wanders across the canvas—a big assumption, I know, but this is just a conjecture, and the assumption is not unreasonable.

We come next to P⁴.3. It is a small step, at this point, to suggest that the abstract structures that linger after being triggered by some prior event of listening, reading, or seeing function as predictions of what is to come. In the case of the arts, one might even say that individual works of art are constructed to ensure that those predictions come true.

This brings us to P⁴.4. Getting the prediction right brings pleasure just as getting the right answer to a puzzle brings pleasure. From this perspective art is a form of pleasure production via the human propensity to prime that sets up expectations and then meets them.

So we might say that the result Margulis achieved when she doctored pieces from Berio and Carter by brute force copying and pasting was not so surprising. Like a chef with a spice rack, she was adding a new source of pleasure into the mix.

In 1993 Frances Rauscher, Gordon Shaw, and Catherine Ky wrote an article that captured the imagination of the scientific, political, and commercial world. The authors showed a relationship between listening to Mozart and enhanced spatiotemporal reasoning. They played Mozart's Sonata for Two Pianos in D Major to more than thirty college students. They then tested them on a series of spatiotemporal puzzles. They compared the

An example PF&C question; subjects are told that the paper is folded and cut as
shown on top, and asked which of the letters corresponds to the unfolded paper
(in this case, the answer is C).

Figure 14.6
An example question from the Stanford-Binet Paper Folding and Cutting subtest

results with those of college students who took the spatiotemporal puzzle
exam cold (*Rondo alla*) *Turca* (forgive the pun), that is, without the benefit
of the Mozart preamble. The result was that the Mozart-prepped students
did significantly better. This result became known as the Mozart effect. Five
years later the Mozart effect had taken such hold on the public imagina-
tion that in 1998 Zell Miller, then governor of Georgia, proposed that every
newborn be given a tape cassette of classical music. Tennessee followed
suit and Florida required daycare centers to play classical music, admirable
despite the absurdity of the motivation.

Rauscher and her colleagues had no patience with the notion that
Mozart made people smarter. The commercializing of the notion leading
to books, CD series, and other money-making enterprises was out of their
hands. On NPR's "Morning Edition" (June 28, 2010), Rauscher expressed
astonishment at the viral spread of the notion of a "Mozart effect."

But there was something going on, and Rauscher and her colleagues had
uncovered it. What that "something" was is very likely priming of precisely
the kind described above. It looks as if hearing the Sonata for Two Pianos
primes listeners to do well on the Stanford-Binet Paper Folding and Cutting
subtest (see figure 14.6). Why that should be so is still a mystery.[7] But the
result does demonstrate that one cognitive subsystem, the ability to parse
music, can prime another subfunction of the brain. This constitutes cor-
roboration (of a sort) that music can act as a priming object as suggested in

figure 14.5 and in the P⁴ conjecture. With respect to the examples in this book, music priming is intramodal while the Mozart effect is intermodal. At the very least this suggests that priming is a far more important property of human cognition than previously appreciated.[8] Indeed, one might go so far as to say that the point of this book has been to show that priming is the reason why repetition in the sister arts is so ubiquitous.

I have discussed the role of meter as a line validation mechanism that allows readers/listeners to determine that two lines are indeed metrically repetitive despite great variation in stress placement in each line. I have related this to time signatures in music. Finally, I have discussed the role of formulas, schemata, and jazz licks in building repetition into epic poetry and into galant and jazz compositions and performances. All of these are "primable" patterns related by being repetitions, with pleasure as a byproduct.

Let us return to our starting point, Elizabeth Margulis's experiment. If we restate Margulis's discovery (see chapter 1) in terms of the P⁴ conjecture (see (9) below), we can understand the sequences shown in figure 14.7 in this way. Immediate Repetition is Segment 1 acting as a prime for the immediately following Segment 1. Delayed Repetition is Segment 1 priming itself two segments down the line. In both types, Segment 1 is the prediction that its copy fulfills sooner or later, mediated by the lingering binary time-span reduction tree associated with Segment 1. This assumes that time-span reductions can be held in memory despite the intervention of segments with different reductions. I take this as being an ability that is special to music. Listeners anticipate such repetitions and hold them in memory for as long as possible. (See the Hindemith quotation below where he intimates such an activity on the part of the listener.)

The restatement of Margulis's endorsement of repetition as a source of pleasure might look like this:

(9) The phenomenon of *priming*, independent of artistic aims or principles, elevates people's enjoyment, interest, and judgments of artistry. This suggests that *priming* is a powerful and often underacknowledged aesthetic operative.

Something like priming may have been in Paul Hindemith's mind when he wrote (1952, 16–17):

[The listener's] activity can be described as follows. While listening to the musical structure, as it unfolds before his ears, he is mentally constructing parallel to it

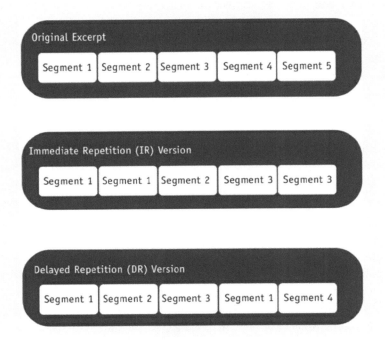

Figure 14.7
Graphic representations of the three types of stimuli used in Margulis 2013b: original excerpts, excerpts with immediate repetitions inserted, and excerpts with delayed repetitions inserted (Margulis 2013b)

> and simultaneously with it a mirrored image. Registering the composition's components as they reach him he tries to match them with their corresponding parts of his mental construction. Or he merely surmises the composition's presumable course and compares it with the image of a musical structure which after a former experience he had stored away in his memory.

And Gombrich (1979, 293–294) touches on what would be, in my terms, the issue of how long priming structure is retained in short-term memory as follows:

> It is all-important in listening to speech that we can remember and hold what has gone before sufficiently long to construct the meaning of the sentence, the phrase, the paragraph. We could not relate the predicate to the preceding subject, the adjective to the noun, unless they were simultaneously present in our mind. Listening to speech always confronts us with a series of completion tests . . . and

it is here that our attention fluctuates as we are keyed up for information or relax once we have stored it away. The patterning of speech in any type of chant or poetry reflects and facilitates this kind of alternation.

This observation by Gombrich was published in 1979. The classical experiments by Kathryn Bock demonstrating priming in language were published in 1986.

I would like to conclude by saying something about how works of art are put together. The Homeric epic, galant music, and jazz improvisation all have something in common. Each uses a vocabulary of building blocks that artists connect however they please. For the Homeric epics, Anglo-Saxon poetry, and Macedonian guslar songs, these building blocks are what Parry calls formulas. For galant music they are what Gjerdingen (2007) calls schemata.[9] For jazz musicians they are licks. But whether formula, schema, or lick, they all are the building blocks of an art form and they all benefit from the side effects of repetition. In this regard they are reminiscent of a far more common human function, namely, the ability to produce grammatical sentences.[10] These, too, are the result of manipulating building blocks—in this case called words (and parts of words called morphemes)—into more complicated constructions. The import of all of this is that building blocks inserted into ever more complicated hierarchical structure may be the lingua franca of cognition.

Gombrich (1979, 163) touches on this in a passage dealing with the similarity between the way things are made and the way they are seen. He introduces the notion of "chunks" in the perception of buildings:

> In the development of skills engineers speak of "chunks," the units of movements from which a larger skill is built in hierarchical orders—thus the five-finger exercises teach the beginner "chunks" of piano playing which he can use or modify in a future performance without having consciously to attend to them. Are there "chunks" also in the perception of structures? The example of reading seems to suggest that there are, and so does the experience of looking at buildings in a familiar style. We can take in the constituent elements, the doors and windows, the columns and the pilasters, with much greater ease than we could absorb exotic buildings.

The analysis of *Paris Street; Rainy Day* in chapter 13 suggests that in mimetic painting the building blocks are geometrical shapes—circles, spirals, cylinders, cones, spheres, squares, triangles, rectangles, and so on—around which a scene is constructed, rather like sculpting in clay over an armature.

This recalls the myriad "how to draw faces" tutorials one finds online where the basic building block is the oval. Gombrich writes of these techniques in these terms (1979, 116):

> The systems of mathematical proportions, the workshop tricks for the construction of a human head from an egg-shape solid, that cruelly misunderstood advice of Cézanne to Bernard to look at the world in terms of cylinders, cones and spheres—all confirm the importance of these basic structures for our domination of the visual world.[11]

Minimally, a grammar of geometric shapes is what one would require to construct an account of how paintings like Caillebotte's are put together. As it happens, one has been proposed by Mathias Sablé-Meyer et al. (2022, 1):

> In various cultures and at all spatial scales, humans produce a rich complexity of geometric shapes such as lines, circles or spirals. Here, we formalize and test the hypothesis that all humans possess a compositional language of thought that can produce line drawings as recursive combinations of a minimal set of geometric primitives. We present a programming language, similar to Logo, that combines discrete numbers and continuous integration to form higher-level structures based on repetition, concatenation and embedding, and we show that the simplest programs in this language generate the fundamental geometric shapes observed in human cultures.

The authors describe two experiments intended to give psychological credence to their grammar. I take it as a given that their grammar or something like it must be part of the cognitive arsenal of *Homo sapiens*.

But, putting to one side the immense question of how one moves from cylinders and ovals to full-blown figures out walking on a rainy day, there is also the (simpler?) question of ornamentation that Gombrich (1979, 116) addresses:

> The history of representation is the history of the modification of geometric shapes, the history of ornament shows us mankind taking them for what they are, and making them combine and interact in countless permutations for the delectation of the eye.

It is this notion of the delectation of the eye that I would like to expand upon. Think of your last visit to an art museum. You looked at the pictures. Not the frames, even though, as the *Madonna della Sedia* shows, there are some extremely elaborate frames to be looked at. The reason for this is clear. The figurative image demands your attention. You can no more ignore it than you can the meaning of a sentence when you hear or read it.

Certainly, you can ignore the speaker or the content. If it is a question, you can refuse to answer it. But you can't ignore what it means. This is not the same with ornamentation—with this, you can take it or leave it. Writing of the vast amount of ornamentation throughout the Alhambra, Gombrich (1979, 116) suggests this might even have been the crafter's goal:

> Those critics who feel overwhelmed by the assault on their senses made by the profusion of ornament and have therefore condemned it as tasteless and barbaric may have misunderstood what was expected of them. The skill and inventiveness of the master craftsman is not only aimed at our conscious awareness. It rests on the experience that we can sense the all-important distinction between confusion and profusion without piecemeal examination.

The idea is that viewers, able to intuit the ornamental pattern because of an internalized grammar of geometric shapes, need not attend to it. They can perceive the order within the ornament and that is enough. They can elect not to pay attention to a particular design and then can elect to return to it again (Gombrich 1979, 116):

> Standing in the Alhambra we know that we cannot sample all these infinite elaborations, but we do not have to, either. They do not obtrude, but they will repay attention if we are so inclined.
>
> We must resist the temptation to regard global perception as no more than careless perception. . . . We are able to absorb much more of the general character of a decoration than we can ever consciously analyse, let alone describe.

Figure 14.8—which shows just one part of one facade of the vast Alhambra palace—offers some sense of what Gombrich means by "profusion."

One of the principal reasons for our being able to discern profusion and not confusion is our understanding of the role of repetition in ornamentation. One might even go so far as to say that without repetition there can be no ornamentation. And here we make contact with music. Recall the central role of repetition noted by Bernstein in chapter 1:

> I cannot stress this point strongly enough. In fact, it has been authoritatively suggested that the main reason a serious theory of musical syntax has been so slow to develop is the refusal of musical theorists to recognize repetition as the key factor.

The similarity of repetition in melody and ornamentation was already evident a hundred years earlier when Ralph Wornum, author of *Analysis of Ornament* (1869) (quoted in Gombrich 1979, 37), wrote:

> The first principle of ornament seems to be repetition . . . a measured succession in series, of some detail, as a moulding . . . this . . . corresponds with melody

Figure 14.8
Mullioned windows of the Hall of the Two Sisters in the Alhambra, by Juan Laurent,
c. 1874. Stucco decoration can be seen on the upper walls while geometric tile mosaic
is seen below. (https://commons.wikimedia.org/wiki/File:Alhambra_by_Juan_Laurent
.jpg)

in music . . . the system of both arising from the same source, rhythm . . . [see
figure 14.9]

The second stage in music is harmony, or a combination of simultaneous
sounds or melodies; it is also identical in ornamental art: every correct orna-
mental scheme is the combination . . . or measured succession of forms . . .
called in the first counterpoint, and in the other symmetrical contrast.[12] (Gom-
brich's ellipses)

While the comparison is apt, there is an important difference that Wor-
num does not consider. Unlike in music, nothing like the Rule of Three plays
a role in ornamentation. That is very likely because music is a linear—that

Figure 14.9
Egg-and-dart molding (Ralph Wornum) (Gombrich 1979, 38)

is, temporal—art form whereas ornamentation is a visual one. Thus, Gombrich's notion of ornamentation as involving "global perception" separates it from music, which comes one beat at a time. Linearity allows for one event to follow another. The global perception of the mullioned windows in the Hall of the Two Sisters in the Alhambra is a single event tout court.

However, Wornum's emphasis on repetition does put into perspective one of Schoenberg's rules of composition: namely, that after having selected a tone row of twelve notes, you may not reuse any one until you have first used all. Schoenberg's atonal innovation is a direct assault on repetition.

One normally thinks of the shift to atonality in music and the shift to abstraction in art as being a pull in the same direction. But seen from the perspective of repetition, quite the opposite is the case. Atonality back-burnered repetition. Abstract art tended to front-burner it as Gombrich suggests (1979, 62):

> The relations between decoration and abstraction are too complex to be summed up in any formula, but . . . the theory of twentieth-century abstract painting owes indeed more to the debates on design that arose in the nineteenth century than is usually allowed. Ruskin's emphasis on the expressive, "graphological" characteristics of spontaneous handiwork, Wornum's comparison of ornament with the art of music, and most of all the growing devaluation of illusionism in favour of a purely formal ordering of elements, not to speak of the frantic search for an authentic new art expressive of the new age, all these are elements in the story of the rise and acceptance of abstract painting. During these times of ferment around the turn of the century the words ornament and decorative were not yet dirty words in the criticism of painting.

In Keyser 2020, 6, I argue that the turn of the twentieth century saw a sea change in the way art is created:

> The sister arts of poetry, painting, and music all depend upon a shared set of rules in precisely the same way that communicating depends upon a speaker

and a hearer having internalized the shared rule set of their language, called grammar.

Like many others, I presuppose a natural aesthetic. However, unlike the others, I have in mind an aesthetic based on sets of rules, shared between an artist and the artist's audience. These rules reflect hardwired functions of the brain, such as the ability to speak a language, the ability to parse tonal music, the ability to perceive metrical units like poetic feet, and, as we will see, certain built-in predispositions of the visual system.

My assumption is that the exercise of these rules in the minds of the audience caused by the works of artists sharing the same sets of rules is the source, at least in part, of the pleasure we experience from these art forms. It is this interaction via rule sets between artist and audience that I refer to as the natural aesthetic.

My claim is that the rule systems that formed the basis for the natural aesthetic were abandoned by the modernist poets, painters, and composers, who replaced shared rules with private formats, formats that were in no sense "natural" because they were the individual constructs of the artist.

Given the contents of the present book, we can now take a closer look at what precisely it is that artists and audiences shared when they were sharing rule systems. In large measure this was the use of shared rule systems to introduce repetition into works of art. Those rule systems gave rise to meter and to rhyme, to tonal music, and to mimetic representation in painting. I have given several examples of how those rule systems abetted repetition in the sister arts. I think it is safe to say that when at the turn of the century artists abandoned those rule systems for art based on novel and not necessarily hardwired predilections of the brain, they were inadvertently (or perhaps in some cases advertently) giving up the aesthetic yield of repetition.

After all, when Schoenberg declared that no member of an arbitrarily selected twelve-note tone row be used again until all members had been used, he was, if not eliminating repetition (read pleasure), certainly diminishing it. "Satin Doll," "Ain't She Sweet," and "My Funny Valentine" were *melodia non grata*.

Pleasure also took a back seat when free verse jettisoned meter and rhyme. The reason why the residue is called "free verse" is that the only vestige of metrical behavior left after rhyme and meter disappeared is the line. But its length became variable without meter to constrain it. That is to say, the line was no longer repetitive.

Compare the opening lines of Jorie Graham's "San Sepolcro" in (10)

(10) In this blue light
 I can take you there,
 snow having made me
 a world of bone
 seen through to.

with those of Andrew Marvell's "To His Coy Mistress":

(11) Had we but world enough and time,
 This coyness, lady, were no crime.

There is no way an audience can perceive the steplike indentations of "San Sepolcro" other than by looking. And, because of the absence of meter and rhyme, there is no way comparable to Marvell's rhymed and metered (iambic tetrameter) couplet to identify line endings.

I have suggested that when rhyme and meter were gone, the focus had to be on the meaning. There was still the line, but it was a pale reflection of its ancestors. With the abandonment of meter and rhyme, content and shape were all that was left to fashion a poem. And as poetry became more and more the reflection of the poet's personal psyche, even that relationship was strained. It was as if poems were drifting into the world of personal hallucination. The diminution in accessibility from (11) to (10) was, if not inevitable (witness the poetry of Billy Collins), certainly understandable. Poetry had become unmoored from shared form. Indeed, John Ashbery licensed its inaccessibility (see Keyser 2020, 127).

The shift away from mimesis was a different story. As Arthur Danto (1995, 28) writes of artistic schools after the birth of modernism:

> An historian of my acquaintance, Phyllis Freeman, has taken the manifesto as her topic of research, of which she had unearthed roughly five hundred examples, some of which—the surrealist manifesto, the futurist manifesto—are nearly as well known as the works they sought to validate.

As art exploded in hundreds of directions, one of the most important schools to emerge was German expressionism. One figure originally associated with that school was Paul Klee. An artist of amazing diversity, he produced paintings such as *Heroic Tale à la Hoffman Roses* (1938) whose debt to ornamentation is unmistakable, as the image in figure 14.10a demonstrates. Figure 14.10b is from a nineteenth-century handbook on decoration by H. Mayeux (1888) reproduced in Gombrich 1979, 133. The resemblance to

a. b.

Figure 14.10
a. Paul Klee, *Heroic Roses*, 1938. b. Decorative design, H. Mayeux, 1888

repetition in the Klee painting is obvious. Much the same can be said of other modernist painters, for example, Joan Miró, whose paintings are an altar to ornamentation and decoration. Still other works, like Andy Warhol's *Campbell's Soup Cans* or his *Marilyn Monroe* series, consist of in-your-face repetitions, less apparently so the fractal works of Jackson Pollock.

Thus, the tectonic shifts wrought by the Great Abandonment that ushered in the era of modernism seems to have produced an unexpected schism based on repetition. Unlike tonal music and metrical poetry, both disciplines marked by repetition, the visual arts abandoned catering to the fusiform gyrus, the parahippocampal area, and the extrastriate body area, but nonetheless clung to repetition in the form of geometric figure representation—witness Picasso and the cubists, Jackson Pollock, and Andy Warhol. As different as they all are, their creations share repetition because to one extent or another they clung to ornamentation.

If I am right, then repetition helps to explain why the visual arts seem to have fared better in the public arena than either atonal music or free verse.

This book began with a quotation from Italo Calvino. I would like to end the same way, with one from his *Collection of Sand* (2002, 5–6):

In a recent Paris exhibition about bizarre collections—collections of cowbells, bingo games, bottle-tops, terracotta whistles, train-tickets, spinning-tops,

toilet-paper packaging, collaborators' badges during the German occupation, embalmed frogs—the case with the collection of sand was the least showy but also the most mysterious, the one that seemed to have most things to say, even through the opaque silence imprisoned behind the glass of the jars.

Surveying this anthology of sands, the eye initially takes in only the samples that stand out most, the rust-coloured sand from a dry riverbed in Morocco, the carboniferous black and white grains from the Aran Islands, or the shifting kaleidoscope of reds, whites, blacks and greys that has on its label a name that is even more polychromatic: Parrot Island, Mexico. *After this, the minimal differences between one kind of sand and another demand a level of attention that becomes more and more absorbing, so much so that one enters into another dimension, into a world that has no other horizons except these miniature dunes, where one beach of tiny pink pebbles is never the same as another beach of tiny pink pebbles (they are mixed with white grains in Sardinia and in the Grenadine Islands in the Caribbean, whereas they blend with grey grains in Solenzara on Corsica), and a sample of minuscule black shingle from Port Antonio in Jamaica is not the same as one from Lanzarote in the Canary Islands, nor as another that comes from Algeria, maybe from the middle of the desert.*

One has the feeling that this set of samples from the universal Waste Land is on the point of revealing something important to us: a description of the world? (Italics mine)

Calvino's insight is that what drives the collector is the joy of gathering objects that participate in the *same/except* relationship: "*[T]he minimal differences between one kind of sand and another demand a level of attention that becomes more and more absorbing.*" It is intriguing to think, as Calvino does, of collecting as an arcane artistic genre, "*so much so that one enters into another dimension, into a world that has no other horizons except these miniature dunes, where one beach of tiny pink pebbles is never the same as another beach of tiny pink pebbles.*" Calvino suggests that these collections are on the point of revealing to us *a description of the world.*

For my part, I would say that what is revealed is how human beings extract pleasure from the world and its echoes.

Appendix 1

I wandered lonely as a cloud
That floats on high o'er vales and hills,
When all at once I saw a crowd,
A host, of golden daffodils;
Beside the lake, beneath the trees,
Fluttering and dancing in the breeze.

Continuous as the stars that shine
And twinkle on the milky way,
They stretched in never-ending line
Along the margin of a bay:
Ten thousand saw I at a glance,
Tossing their heads in sprightly dance.

The waves beside them danced; but they
Out-did the sparkling waves in glee:
A poet could not but be gay,
In such a jocund company:
I gazed—and gazed—but little thought
What wealth the show to me had brought:

For oft, when on my couch I lie
In vacant or in pensive mood,
They flash upon that inward eye
Which is the bliss of solitude;
And then my heart with pleasure fills,
And dances with the daffodils.
—William Wordsworth

In 1798 William Wordsworth and Samuel Taylor Coleridge published one of the most influential collections of poems to come down the English language pike. Its title was *Lyrical Ballads* and it ushered in Romanticism's response to the Enlightenment, a kind of harbinger of C. P. Snow's *Two Cultures*. One of the many poems by Wordsworth included in that collection is "The Tables Turned":

(1) Up! up! my Friend, and quit your books;
 Or surely you'll grow double:
 Up! up! my Friend, and clear your looks;
 Why all this toil and trouble?

 The sun above the mountain's head,
 A freshening lustre mellow
 Through all the long green fields has spread,
 His first sweet evening yellow.

 Books! 'tis a dull and endless strife:
 Come, hear the woodland linnet,
 How sweet his music! on my life,
 There's more of wisdom in it.

 And hark! how blithe the throstle sings!
 He, too, is no mean preacher:
 Come forth into the light of things,
 Let Nature be your teacher.

 She has a world of ready wealth,
 Our minds and hearts to bless—
 Spontaneous wisdom breathed by health,
 Truth breathed by cheerfulness.

 One impulse from a vernal wood
 May teach you more of man,
 Of moral evil and of good,
 Than all the sages can.

Sweet is the lore which Nature brings;

Our meddling intellect

Mis-shapes the beauteous forms of things:—

We murder to dissect.

Enough of Science and of Art;

Close up those barren leaves;

Come forth, and bring with you a heart

That watches and receives.

So much of poetic criticism focuses on meaning that perhaps, at the outset, I should say a bit about it. Wallace Stevens once replied to a young woman (Anna Wirtz) who had written him about the meaning of "The Emperor of Ice Cream": "If the meaning of a poem is its essential characteristic, people would be putting themselves to a lot of trouble about nothing to set the meaning in a poetic form." (See Keyser 2020, 34 for discussion.) The implication of Stevens's comment is clear enough: whatever is essential to a poem, it is not meaning. This is clear from "The Tables Turned," a good poem whose meaning is completely transparent but, objectively speaking, off the wall.

How can you take seriously "We murder to dissect" when you think of Isaac Newton's discovery roughly one hundred years earlier of the principle of action at a distance and the light it shed not only on the motion of the planets—why it is elliptical and not circular—but also on the motion of the tides. His insight laid the foundation for virtually all of modern physics. If Newton is arguably the greatest scientist who ever lived, Wordsworth's paean to anti-intellectualism a hundred years after Newton's stroke of genius ranks him among the foremost of flat-earthers.

This is wrong, as Wordsworth, in *The Prelude* (Book III, ll. 60–63), shows us. He was writing a poem, not a scientific paper.[1] He was taking a particular point of view—he may not even have believed it—and put it into a particular form. In other words, Wordsworth was attending not so much to what he was saying as to how he was saying it. And why was he doing that? Presumably to give pleasure rather than impart knowledge. If the latter had been his goal, he would have been much better off, as Stevens's remark implies, writing a treatise.

However, there is a poem—even more memorable, I daresay, than "The Tables Turned"—in which, Stevens notwithstanding, meaning or

rather the lack thereof is indeed essential. I am thinking of Lewis Carroll's "Jabberwocky."

(2) 'Twas brillig, and the slithy toves
 Did gyre and gimble in the wabe:
 All mimsy were the borogoves,
 And the mome raths outgrabe.

 "Beware the Jabberwock, my son!
 The jaws that bite, the claws that catch!
 Beware the Jubjub bird, and shun
 The frumious Bandersnatch!"

 He took his vorpal sword in hand;
 Long time the manxome foe he sought—
 So rested he by the Tumtum tree
 And stood awhile in thought.

 And, as in uffish thought he stood,
 The Jabberwock, with eyes of flame,
 Came whiffling through the tulgey wood,
 And burbled as it came!

 One, two! One, two! And through and through
 The vorpal blade went snicker-snack!
 He left it dead, and with its head
 He went galumphing back.

 "And hast thou slain the Jabberwock?
 Come to my arms, my beamish boy!
 O frabjous day! Callooh! Callay!"
 He chortled in his joy.

 'Twas brillig, and the slithy toves
 Did gyre and gimble in the wabe:
 All mimsy were the borogoves,
 And the mome raths outgrabe.

Readers expect a poem to mean something. And Carroll doesn't disappoint them. But like a magician's use of misdirection, Carroll has included words that are tantalizingly meaningless, "tantalizingly" because they teeter on the edge of comprehensibility.

Take *slithy*, for example. It walks like a word. It talks like a word. It looks like a word. It has sound. It has what look like parts, *slith* (think *slime*) + *y* (think *slimy*). It is a portmanteau. (It could easily be a real, live English adjective.) The thing is, it doesn't have meaning. Readers are forced to supply their own. That is the fun of it. And because he is playful, not malicious, Carroll shows how it is done in a conversation between Humpty Dumpty and Alice:

Humpty Dumpty interrupted: "There are plenty of hard words there. 'Brillig' means four o'clock in the afternoon—the time when you begin broiling things for dinner."

"That'll do very well," said Alice: "and 'slithy'?"

"Well, 'slithy' means 'lithe and slimy.' 'Lithe' is the same as 'active.' You see it's like a portmanteau—there are two meanings packed up into one word."

"I see it now," Alice remarked thoughtfully: "and what are 'toves'?"

"Well, 'toves' are something like badgers—they're something like lizards—and they're something like corkscrews."

"They must be very curious-looking creatures."

"They are that," said Humpty Dumpty: "also they make their nests under sundials—also they live on cheese."

"And what's to 'gyre' and to 'gimble'?"

"To 'gyre' is to go round and round like a gyroscope. To 'gimble' is to make holes like a gimblet."

"And 'the wabe' is the grass-plot round a sun-dial, I suppose?" said Alice, surprised at her own ingenuity.

"Of course it is. It's called 'wabe,' you know, because it goes a long way before it, and a long way behind it—"

"And a long way beyond it on each side," Alice added.

"Exactly so. Well then, 'mimsy' is 'flimsy and miserable' (there's another portmanteau for you). And a 'borogove' is a thin shabby-looking bird with its feathers sticking out all round—something like a live mop."

"And then 'mome raths'?" said Alice. "I'm afraid I'm giving you a great deal of trouble."

"Well, a 'rath' is a sort of green pig: but 'mome' I'm not certain about. I think it's short for 'from home'—meaning that they'd lost their way, you know."

"And what does 'outgrabe' mean?"

"Well, 'outgribing' is something between bellowing and whistling, with a kind of sneeze in the middle: however, you'll hear it done, maybe—down in the wood

yonder—and, when you've once heard it, you'll be quite content. Who's been repeating all that hard stuff to you?"

"I read it in a book," said Alice.

Unlike "The Tables Turned," where every word wears its heart on its sleeve, "Jabberwocky" provides exotic empty shells of words and challenges you to fill them. And in case you are disinclined to, Carroll offers to do it for you.

I mentioned earlier that "Jabberwocky" provides the reader with meaning, just not all of it. Consider the third and fourth stanzas with the nonsense words blocked out:

(3) He took his ~~vorpal~~ sword in hand;

 Long time the ~~manxome~~ foe he sought—

So rested he by the ~~Tumtum~~ tree

 And stood awhile in thought.

 And, as in ~~uffish~~ thought he stood,

 The Jabberwock, with eyes of flame,

Came ~~whiffling~~ through the ~~tulgey~~ wood,

 And burbled as it came!

What's going on is perfectly clear without the nonsense words, most of them adjectives and therefore marginal to the action. (A vorpal sword is, after all, a sword.)[2]

So "Jabberwocky" isn't really a nonsense poem. It would be better described as a "just for fun" poem. For a bona fide nonsense poem you would have to go to Hugo Ball's "Karawane." Ball, the founder of Dadaism, originally performed it at his Café Voltaire in Zurich in 1916. Ball was dressed like a cardboard Tin Man in *The Wizard of Oz*. So attired, this is what he recited:

(4) jolifanto bambla ô falli bambla

 grossiga m'pfa habla horem

 égiga goramen

 higo bloiko russula huju

 hollaka hollala

 anlogo bung

 blago bung

 blago bung

bosso fataka

ü üü ü

schampa wulla wussa ólobo

hej tatta gôrem

eschige zunbada

wulubu ssubudu uluw ssubudu

tumba ba- umf

kusagauma

ba- umf

Now that is meaningless. Indeed, according to Dada principles, its meaning is its meaninglessness. Next to it, "Jabberwocky" is a monument of lucidity.

Both "Jabberwocky" and "The Tables Turned" are very good poems. The two are quite similar in form. In "The Tables Turned" the meter is the so-called ballad meter, where iambic tetrameter lines alternate with iambic trimeter lines. In "Jabberwocky" the ballad meter is truncated slightly. The alternation is limited to the last two lines of each stanza. The rhyme scheme is x_1 x_2 x_1 x_2 in both, again with "Jabberwocky" showing a variation. The sixth stanza's rhyme scheme is x_1 x_2 x_3 x_2. Carroll substitutes a line-internal rhyme in line 3: *O frabjous day! Callooh! Callay!* Both poets show an easy mastery of the rhymes. None of them seem forced. The syntax is straightforward. There is very little departure from normal word order and what there is falls trippingly off the tongue.

Despite their formal similarity, in the world of literary commentary the poems are viewed differently. "The Tables Turned" is treated as a serious poem even though what it is about is nonsense. "Jabberwocky" is treated as a nonsense poem even though what it is about is perfectly clear. The truth is, the two poems are far more alike than one would imagine. For example, it is an easy matter to Jabberwock "The Tables Turned":

(5) Up! Mimsy friend, and quit your books;

Or surely you'll grow double:

Up! Mimsy friend, and clear your looks;

Why all this toil and trouble?

The sun above the Jubjub's head,

A freshening lustre mellow

Through all the manxone fields has spread,
His first sweet uffish yellow.

Books! 'tis a dull and mimsy strife:
Come, hear the whiffling linnet,
How sweet his tove is! on my life,
There's more of wisdom in it.

And hark! how blithe the Tumtum sings!
He, too, is no mean preacher:
Come forth into the light of things,
Let Nature be your teacher.

She has a world of frabjous wealth,
Our minds and hearts to bless—
Spontaneous wisdom galumphing health,
Truth breathed by cheerfulness.

One impulse from a tulgey wood
May teach you more of man,
Of moral evil and of good,
Than all the mome raths can.

Sweet is the lore which Nature brings;
Our frumious intellect
Mis-shapes the beauteous forms of things:—
We murder to dissect.

Enough of Science and of Art;
Close up those vorpal wabes;
Gyre forth, and bring with you a heart
That gimbles and outgrabes.

Well, if their meanings can be pushed around like taffy in a taffy pull, what
is there that remains constant in these two poems? We have already touched
on that. It is the metrical pattern to which all the lines must conform and
the rhyme scheme to which all the words that end the lines must conform.

Appendix 2

Once upon a midnight **dreary**, while I pondered, weak and **weary,** x_1

Over many a quaint and curious volume of forgotten **lore**— a

While I nodded, nearly **napping**, suddenly there came a **tapping,** x_2

As of some one gently **rapping, rapping** at my chamber **door.** a

"'Tis some visitor," I muttered, "**tapping** at my chamber **door**— a

Only this and nothing **more.**" a

Ah, distinctly I **remember** it was in the bleak **December;** x_1

And each separate dying **ember** wrought its ghost upon the **floor** a

Eagerly I wished the **morrow;**—vainly I had sought to **borrow** x_2

From my books surcease of **sorrow—sorrow** for the lost **Lenore**— a

For the rare and radiant maiden whom the angels name **Lenore**— a

Nameless *here* for **evermore.** a

And the silken, sad, **uncertain** rustling of each purple **curtain** x_1

Thrilled me—filled me with fantastic terrors never felt **before;** a

So that now, to still the **beating** of my heart, I stood **repeating** x_2

"'Tis some visitor **entreating** entrance at my chamber **door**— a

Some late visitor **entreating** entrance at my chamber **door;**— a

This it is and nothing **more.**" a

Presently my soul grew **stronger;** hesitating then no **longer,**

"Sir," said I, "or Madam, truly your forgiveness I **implore;**

But the fact is I was **napping,** and so gently you came **rapping,**

And so faintly you came **tapping, tapping** at my chamber **door,**

That I scarce was sure I heard you"—here I opened wide the **door;**—
 Darkness there and nothing **more.**

Deep into that darkness **peering,** long I stood there wondering, **fearing,**
Doubting, dreaming dreams no mortal ever dared to dream **before;**
But the silence was **unbroken,** and the stillness gave no **token,**
And the only word there **spoken** was the whispered word, "**Lenore?**"
This I whispered, and an echo murmured back the word, "**Lenore!**"—
 Merely this and nothing **more.**

Back into the chamber **turning,** all my soul within me **burning,**
Soon again I heard a tapping somewhat louder than **before.**
 "Surely," said I, "surely **that is** something at my window **lattice;**
Let me see, then, what **thereat is,** and this mystery **explore**—
Let my heart be still a moment and this mystery **explore;**—
 'Tis the wind and nothing **more!**"

Open here I flung the **shutter,** when, with many a flirt and **flutter,**
In there stepped a stately Raven of the saintly days of **yore;**
 Not the least obeisance **made he;** not a minute stopped or **stayed he;**
But, with mien of lord or **lady,** perched above my chamber **door**—
Perched upon a bust of Pallas just above my chamber **door**—
 Perched, and sat, and nothing **more.**

Then this ebony bird **beguiling** my sad fancy into **smiling,**
By the grave and stern decorum of the countenance it **wore,**
"Though thy crest be shorn and **shaven,** thou," I said, "art sure no **craven,**
Ghastly grim and ancient **Raven** wandering from the Nightly **shore**—
Tell me what thy lordly name is on the Night's Plutonian **shore!**"
 Quoth the Raven "**Nevermore.**"

Much I marvelled this **ungainly** fowl to hear discourse so **plainly,**
Though its answer little meaning—little relevancy **bore;**
 For we cannot help **agreeing** that no living human **being**
 Ever yet was blessed with **seeing** bird above his chamber **door**—

Bird or beast upon the sculptured bust above his chamber **door**,
 With such name as "**Nevermore**."

But the Raven, sitting **lonely** on the placid bust, spoke **only**
That one word, as if his soul in that one word he did **outpour**.
 Nothing farther then he **uttered**—not a feather then he **fluttered**—
 Till I scarcely more than **muttered** "Other friends have flown **before**—
On the morrow *he* will leave me, as my Hopes have flown **before**."
 Then the bird said "**Nevermore**."

Startled at the stillness **broken** by reply so aptly **spoken**,
"Doubtless," said I, "what it utters is its only stock and **store**
 Caught from some unhappy **master** whom unmerciful **Disaster**
 Followed fast and followed **faster** till his songs one burden **bore**—
Till the dirges of his Hope that melancholy burden **bore**
 Of 'Never—**nevermore**.'"

But the Raven still **beguiling** all my fancy into **smiling**,
Straight I wheeled a cushioned seat in front of bird, and bust and **door**;
 Then, upon the velvet **sinking**, I betook myself to **linking**
 Fancy unto fancy, **thinking** what this ominous bird of **yore**—
What this grim, ungainly, ghastly, gaunt, and ominous bird of **yore**
 Meant in croaking "**Nevermore**."

This I sat engaged in **guessing**, but no syllable **expressing**
To the fowl whose fiery eyes now burned into my bosom's **core**;
 This and more I sat **divining**, with my head at ease **reclining**
 On the cushion's velvet **lining** that the lamp-light gloated **o'er**,
But whose velvet-violet lining with the lamp-light gloating **o'er**,
 She shall press, ah, **nevermore**!

Then, methought, the air grew **denser**, perfumed from an unseen **censer**
Swung by Seraphim whose foot-falls tinkled on the tufted **floor**.
 "Wretch," I cried, "thy God hath **lent thee**—by these angels he hath
 sent thee

Respite—respite and **nepenthe** from thy memories of **Lenore**;
Quaff, oh quaff this kind nepenthe and forget this lost **Lenore**!"
 Quoth the Raven "**Nevermore**."

"Prophet!" said I, "thing of **evil**!—prophet still, if bird or **devil**!—
Whether Tempter sent, or whether tempest tossed thee here **ashore**,
 Desolate yet all **undaunted**, on this desert land **enchanted**—
 On this home by Horror **haunted**—tell me truly, I **implore**—
Is there—*is* there balm in Gilead?—tell me—tell me, I **implore**!"
 Quoth the Raven "**Nevermore**."

"Prophet!" said I, "thing of **evil**!—prophet still, if bird or **devil**!
By that Heaven that bends above us—by that God we both **adore**—
 Tell this soul with sorrow **laden** if, within the distant **Aidenn**,
 It shall clasp a sainted **maiden** whom the angels name **Lenore**—
Clasp a rare and radiant maiden whom the angels name **Lenore**."
 Quoth the Raven "**Nevermore**."

"Be that word our sign of **parting**, bird or fiend!" I shrieked, **upstarting**—
"Get thee back into the tempest and the Night's Plutonian **shore**!
 Leave no black plume as a **token** of that lie thy soul hath **spoken**!
 Leave my loneliness **unbroken**!—quit the bust above my **door**!
Take thy beak from out my heart, and take thy form from off my **door**!"
 Quoth the Raven "**Nevermore**."

And the Raven, never **flitting**, still is sitting, *still* is **sitting**
On the pallid bust of Pallas just above my chamber **door**;
 And his eyes have all the **seeming** of a demon's that is **dreaming**,
 And the lamp-light o'er him **streaming** throws his shadow on the **floor**;
And my soul from out that shadow that lies floating on the **floor**
 Shall be lifted—**nevermore**!

Acknowledgments

This book is the product of several years of thinking, reading, and chatting. Much help needs to be acknowledged. Scholarship rarely grows out of isolation. But how to acknowledge the help?

Well, the book is the acknowledgment of thinking and the reference section the acknowledgment of reading. It's the chatting that presents a problem. So many conversations begun with my answering the question "And what are you working on?" have led me to greater clarity, less error, more understanding. I will undoubtedly have omitted people who need to be acknowledged. For all of you, forgive me. I will try to be as complete as I can.

I am grateful to my son and daughter, Benjamin and Beth Keyser, for their comments, criticisms, and endless support.

I can't say enough about my jazz improvisation teacher, Dave Burdett, for sharing with me his incomparable mastery of jazz harmony or about his wife, Noreen, for offering me a short course in music theory because she realized that I really needed it. She is a superb instructor.

There is my friend and fellow trombone player, Matthias Heyne, whose explanations of chord progressions in jazz standards were invaluable. The same is true of my friend of over forty years and a terrific and forgiving duet partner, Michael Strauss. Then there is George Darrah, who became principal drummer of the Boston Pops during the writing of this book. His knowledge of theory, his talent as a composer, and his skill as a musician have shaped the musical sections in many ways. Between conversations with George and with his teacher and my longtime friend Everett Longstreth, I have learned far more than I have a right to. They have answered innumerable questions, provided me with helpful lead sheets, and, in Everett's case, alerted me to the Rule of Three.

Speaking of which, Fred Lerdahl has my undying gratitude for pointing me in the direction of "Goldilocks and the Three Bears" and sensitizing me to its structural importance. My colleague at the University of Pittsburgh, William Scott, has been of erudite help in pointing out important areas of modern poetry and their significance with respect to my work. It has been a pleasure to talk to Tom Bever about his work on the role of pleasure in problem solving. Suzanne Frampton helped clarify formulas in the Homeric epics, and Len Muellner has been an extraordinary help in guiding me through the work of Milman Parry on Homer. I am grateful to Elizabeth Margulis for providing material relating to her important research.

My colleague and longtime friend Eric Reuland is an amazingly careful reader, and his comments on an early version of this manuscript were crucial to its current content. I am fortunate to know him and to work with him. The support of Noam Chomsky and Steve Pinker has been a major source of the impetus that kept me writing, even when I was just too tired. My debt to both will be apparent in these pages.

I am grateful to Daniel Shanahan for his generosity in sharing his amazing database on jazz standards with me and for useful discussions surrounding them. I am also grateful to David Huron for pointing me in just the right direction.

My thanks to Donka Minkova, author of the excellent *Alliteration and Sound Change in Early English*, for her guidance with respect to alliteration in the Anglo-Saxon corpus.

My friend and colleague of over fifty years, François Dell, read the manuscript with the eye of an accomplished scholar blessed with a deep sense of the issues, having worked in the same area himself throughout his scholarly life. He has caught errors of erudition and enriched the discussion in several places, while at the same time correcting minute errors that only full-time copy editors are expected to find.

My wife Nancy is my unfailing sounding board. Writers are often advised to write for a specific audience. Mine was Nancy, who always had time to hear me out no matter what she might have been doing. Her ability to detect obfuscation is uncanny. Without her support in this and in all things that make it possible for me to work, there would be no book.

Librarians are the unsung heroes of scholarship. My debt to those at MIT's Hayden Library and at the Cambridge Public Library is boundless. Their assistance over the years has been more than vital. Because of Covid

and my being wheelchair bound, it has been indispensable. No amount of "thank you's" can be enough.

I am grateful to the three anonymous readers of the manuscript who, despite their favorable judgments, underscored problems in presentation that resulted in a complete reorganization of the original manuscript, hopefully for the better. My thanks to them for their critiques and their candor.

I am grateful to Phil Laughlin, senior acquisitions editor at the MIT Press, for his sure-handed guiding of this manuscript from the moment of submission to the day of publication.

I am certain my readers will join me in expressing gratitude to David Hill for an exhaustive index, an indispensable tool that must accompany a work of this sort.

I have worked with Yasuyo Iguchi for over fifty years. If there is a better designer in the business, I will eat my hat. She is a marvel. Special thanks are more than due to Professor Daniel Jackson for the use of the portrait of me on the book cover.

My copy editor and friend for over fifty years, Anne Mark, is widely acknowledged as being the best in the business, the very top of her craft. Her tastefulness and meticulous attention to every word, paragraph, and punctuation point, to the point of every argument is visible on every page of this book. Working with Anne on this book and on previous ones and, in fact, for the last fifty some years has been a gift I would wish for anyone who has ever set pen to paper or its surrogates.

Finally, Ray Jackendoff and I have talked for several hours every Thursday over the course of the past decade on topics that have ranged from his work on parentheticals to mine on modernism and repetition. Ray is a superb classical clarinetist with a composer's grasp of musical form. Over a lifetime of mature scholarship Ray has pursued the notion of parallel architecture in questions of human cognition. He has never lost sight of the goal of linguistics being to understand how the mind works and not just how language works. That lesson infuses this work. I daresay that this book would not have come into being were it not for our friendship and our weekly chats.

Notes

Introduction

1. This book is available gratis through MIT Press's Open Access portal at https://direct.mit.edu/books/book/4607/The-Mental-Life-of-ModernismWhy-Poetry-Painting.

 I imagine that many readers will have realized that Ingrid Bergman never actually said the title of this book. Rather, her line was a gentle entreaty, "Play it, Sam." It has, over the years, acquired the adverb *again* the way an old shoe acquires a bulge where the big toe fits. So why did I choose the incorrect version? I liked the idea of using as a title the line that anyone who ever saw *Casablanca* recognizes, even though it was never actually in the film. It is a gentle reminder that scholarship never gets it right. At its very best it gets us closer to the truth than we were before.

2. Falk Huettig, Jenny Audring, and Ray Jackendoff (2022) make the following comment about the role of prediction in current cognitive studies:

> In what might be called the "predictive turn," many in the cognitive and brain sciences have come to consider the human mind a "predictive engine" or "prediction machine." Some have gone so far as to describe the last decade as a true paradigm shift in the sense of Kuhn (1970), comparable to the change from behaviorism to cognitivism in the 1950s.

The P^4 Conjecture is certainly within this "predictive turn."

3. See the reference in chapter 1 to Plato's discussion in the *Phaedo*.

4. I am indebted to François Dell for this incomparable example.

5. For a discussion of where rhyme came from (there are recorded instances as early as 1000 BCE) and its place in English, an excellent place to start is McKie 1997.

6. The poem was written to Frances Sargent Osgood. She was, like most of Poe's loves, inaccessible. She was married. Her name is encoded in every line, with the first letter, *F*, beginning the poem. The second letter of the second line is *r*, the second letter of her name, and so on. There are twenty letters in her name and twenty lines in the poem. In (11), you will see the name spelled out in boldfaced letters, one in each line. Thus, it is no accident that the poem begins with the letter *F*

and that the twentieth letter of the twentieth line is *d* and that it occurs in the word *riddle*. Poe was a clever fellow.

7. Culicover and Jackendoff examine the same relationship in English in anaphora, ellipsis, and contrastive stress. In Jackendoff and Audring 2020, 76–80, the authors extend the 2012 analysis in an interesting way to include morphology, treating pairs like *construct:construction* as participating in the *same/except* relationship.

8. Marcus (2008, 123) makes precisely the same point when he writes, "My dictionary defines happiness as 'pleasure'—and pleasure as a feeling of 'happy satisfaction and enjoyment.'" As if that weren't circular enough, I find that in the *Oxford English Dictionary* a feeling is defined as "a perceived emotion" while an emotion is defined as a "strong feeling."

9. Girija Kaimal et al. (2017, 91) note, "Some clinical implications include: the recognition that art-making evokes reward pathways." The art-making activities in their study were coloring, doodling, and free drawing. And Vered Aviv (2014, 3), writing about studies involving not art making but art viewing, concludes:

> Supported by recent experimental studies, I claim that abstract art frees our brain from the dominance of reality, enabling the brain to flow within its inner states, create new emotional and cognitive associations and activate brain-states that are otherwise harder to access. This process is apparently rewarding as it enables the exploration of yet undiscovered inner territories of the viewer's brain.

10. Marcus (2008, 2) defines *kluge* this way:

> A kluge is a clumsy or inelegant—yet surprisingly effective—solution to a problem. Consider, for example, what happened in April 1970 when the CO_2 filters on the already endangered lunar module of *Apollo 13* began to fail. There was no way to send a replacement filter up to the crew—the space shuttle hadn't been invented yet—and no way to bring the capsule home for several more days. Without a filter, the crew would be doomed. . . . Fortunately, the ground crew was able to meet the challenge, quickly cobbling together a crude filter substitute out of a plastic bag, a cardboard box, some duct tape, and a sock.

11. For an argument against this view and in favor of our one day being able to describe intelligently such things as "pleasure," see David Deutsch's *The Beginning of Infinity* (2011, 152ff.) and references there. I hope Deutsch is right. I have my doubts. But even so, I have no choice but to act as if he were. So, in practice, at least for me, neither view will have any effect on how I go about thinking about things.

12. Actually, the original line, "I know it when I see it," was suggested to Judge Potter by his clerk, Alan Novak, according to a brief article in the *Wall Street Journal* (https://www.wsj.com/articles/BL-LB-4558). It is important to give credit where credit is due.

Chapter 1

1. At the beginning of many of the chapters that follow I will indicate with triangles which kind of repetition is to be discussed. The large and small triangle pair signals

same/except repetition. The identical triangle pair signals identical repetition. Some chapters will have both. Some will have neither.

2. Or as my friend and colleague Eric Reuland has paraphrased Gombrich (personal communication):

> In order to cope with this world, humans (and other animals) developed pattern recognition strategies, which involve paying attention to repetition. So repetition triggers our attention. And since few events are full repetitions, we are attentive to small changes.

3. As I mention in note 7 of the introduction, Culicover and Jackendoff examine the same relationship in English in anaphora, ellipsis, and contrastive stress.

4. Culicover and Jackendoff (2012) offer a formal analysis of the *same/except* relationship and a framework within which to represent the results of that relationship.

Chapter 2

1. We will see a bit later that the reference in this passage to "the *Beowulf* poet" requires alteration.

2. Rhyme occurs in much earlier cultures. The earliest known use of rhyme is in the Old Chinese Book of Songs, the *Shijing*, written in the tenth century BCE.

3. It is always the first onset in a word that moves in Pig Latin. Stress plays no role as it does in end rhyme, as we will see momentarily. However, I simplify the discussion of both Pig Latin and end rhyme since my major concern is repetition. A more nuanced account can be found in Keyser 2020, 41ff.

4. The plural *word(s)* is included in (6a) because of rhymes like *linnet/in it* in "The Tables Turned."

5. The Pig Latin for *receives* is *eceivesray*. This shows that stress is irrelevant in forming Pig Latin words whereas rhymes like *receives:leaves* show that it is all-important in English. Not everything has to be the same when it comes to rules.

6. Interestingly, without reference to *onset* the notion of an identical rhyme (*ham:ham*) would be incoherent since the sequences preceding the primary stressed vowels of the candidate words would of necessity always be different. Poems do not produce two lines that are exact copies of one another unless they contain a refrain, and it would be very odd to limit identical rhyme to refrains.

7. This list of properties of vowels and consonants is typically represented in a phonological theory that makes use of a set of abstract entities called *distinctive features*: [continuant], [voice], [high], [low], [back], [round], and so on. There is no need to introduce that terminology here. The point is that some rhyme schemes make use of properties of vowels and consonants at this featural level—that is, whether vowels are high, front, and unrounded like /i/ in *seed* or high, back, and rounded like /u/

in *lewd*. A rhyming dialect that paid attention only to vowel height would rhyme *seed/lewd*.

8. A French speaker could not possibly approach a rhyming French poem the way an English speaker approaches a rhyming English poem. The reason is that English is a stress-assigning language with respect to words in its lexicon. French is not. French has one less parameter around which to build a definition of rhyme. There is no prominent dividing line in a French word that corresponds to the properties of English encoded in rule (6): "everything before the stressed vowel" and "everything after the stressed vowel including the stressed vowel itself." This is quite natural, of course. The artifices of poetry must conform to the linguistic givens of the language in which they appear.

9. Out of curiosity, I asked ChatGPT for an example of an identical rhyme in the English canon and the best it could do was to make one up.

10. Minkova (2003, 37) notes, "Of the 26,088 verses of O[ld] E[nglish] poetry in Hutcheson's [1993] corpus, only 36, or 0.001 percent, lack alliteration."

11. For an exhaustive account of alliteration, see Minkova 2003.

12. Here is a remarkable passage from Poe (1850, 491) shedding light on the role of repetition and pleasure in rhyme and music, even presaging the Rule of Three:

> What, in rhyme, first and principally pleases, may be referred to the human sense or apprecia-
> tion of *equality*—the common element, as might be easily shown, of all the gratification we
> derive from music in its most extended sense—very especially in its modifications of metre
> and rhythm. We see, for example, a crystal, and are immediately interested by the equality
> between the sides and angles of one of its faces—but, on bringing to view a second face, in
> all respects similar to the first, our pleasure seems to be *squared*—on bringing to view a third,
> it appears to be *cubed*, and so on: I have no doubt, indeed, that the delight experienced, if
> measurable, would be found to have exact mathematical relations, such, or nearly such, as I
> suggest—that is to say, as far as a certain point, beyond which there would be a decrease, in
> similar relations. (Poe's italics)

13. This line also contains assonantal repetition in the initial syllable of the word *purple* repeating the root syllables of *uncertain* and *curtain*. The repetition of [s] in *silken*, *sad*, and *uncertain* with the coda-final [s] of *rustling* is not strictly speaking alliteration (hence the dashed arc) since the former occupy onsets and the latter does not.

14. The shift is obviously related to the shift of stress assignment from Old English to Middle English—that is, from root stress assigned by an Anglo-Saxon rule to end stress assigned by a Latinate stress rule originally borrowed into English through Anglo-Norman. But this is a book about repetition. So I'll stick to the point.

15. A prediction made by this account is that there will be no cases of identity allit-eration to be found in English alliterative poetry. This is apparently true of Old Eng-lish. (I am grateful to Professor Donka Minkova (personal communication) for this

observation.) However, it is not true of Modern English, as a glance at Poe's "The Raven," stanzas 1 and 4 (see appendix 2) demonstrates: for example, *tapping/tapping* and *rapping/rapping*. Not surprisingly, there are undoubtedly different poetic dialects with respect to the practice of alliteration just as there are different metrical dialects.

16. I say "possibly" because the occurrence of *my* four times in lines 4 and 5 of stanza 17 seems to me to be on a par with the repetitions in the other stanzas.

17. I use the x_a notation to indicate a free variable. Any syllable(s) can be inserted for the x, free of an end-rhyme expectation (*w-eary, t-apping*). By contrast, the alphabetic notation dictates which lines must exhibit the same end-rhyming syllable(s) (*d-oor, l-ore, m-ore*). Thus, x_a, a, x_b, a, a, a represents the general rhyming pattern of the poem: *weary, lore, tapping, door, door, more* in stanza 1; *December, floor, borrow, Lenore, Lenore, more* in stanza 2; and so on. The second a always rhymes identically with the third a. The third a always end-rhymes with the fourth a.

18. In chapter 5 I talk a great deal about the predominant role that "sentences" play in jazz standards. We will see that there is a very real constraint on the way in which sentences are allowed to repeat within the typical form of the jazz standard. This same constraint is observed by Mozart in his *Rondo alla Turca*. However, I have not been able to find a discussion of the constraint in Caplin 1998.

Chapter 3

1. The rhythmic pattern of a measure is, of course, a function of the duration of the beats assigned to the measure. In the case of "Satin Doll" the number is four beats to the measure.

2. I think Ellington did this to begin the long note of measure 7 not at the beginning of measure 7 but on the "backside" of the final quarter note of measure 6. This "anticipation" gives the rhythm more of a swing feel. In what follows I return to the special case of measures 5 and 6. But here it is worth noting that I suspect many bands will play measure 6 precisely like measure 5. This brings up the thorny question of the "original" published score. That, oddly, is something very hard to come by. Making this determination for many, many tunes would constitute something of a parallel career. There is no common repository. I am using "consensus" charts in this book, charts whose agreement is based on lack of variation from one source to another.

3. The lead sheet I have used in the explication of this tune (see figure 3.1) does not match the original as displayed in Hyman 1986. I have chosen the one in the figure because it is rhythmically simpler. From the point of view of the argument, however, nothing changes. The original melody rhymes just as the variant does and in exactly the same ways.

4. Ray Jackendoff has pointed out to me that the first eight measures of "Over the Rainbow" also consist of a descending C scale.

5. The dark edge of the lyrics is unmistakable. In the musical from which it comes, *Babes in Arms*, the female protagonist Billie sings it to her lover Valentine. The love object's looks are laughable—weak mouth, figure less than Greek, and as far as brains are concerned, he may not be playing with a full deck. One explanation for this is that the lyrics reflected Lorenz Hart's view of himself as an unattractive and unlovable self. The lyrics are gender-neutral, however. It is a brilliant lyric in which one size fits all.

6. I am indebted to Ray Jackendoff for bringing this work to my attention and for several hours of fruitful discussion concerning its form.

Chapter 4

1. Some of these fairy tales (e.g., "Goldilocks") are of English origin. Others are of non-English provenance. For example, "The Three Billy Goats Gruff" was originally collected by the Norwegian scholars Peter Christen Asbjørnsen and Jørgen Moe under the name "De tre bukkene Bruse." A great deal of work has been done on the structure of fairy tales, Vladimir Propp's (1968) *Morphology of the Folktale* being an important impetus for that line of inquiry. However, my concern here is not with the larger question of the structure of fairy tales. I want to focus on the ubiquitous number three. Propp offers countless examples of it in his monograph.

2. Shortly we will come to the notion of a *tricolon crescens*, a series of three things increasing along some dimension. This will play a role in the duck joke just parsed. It also plays a role in fairy tales: for example, in "The Three Little Pigs," strength of building material (straw sticks bricks); in "The Three Billy Goats Gruff," bulk (thin fat fattest); in "The Tinderbox," value (copper silver gold) and ferocity (indicated by the size of the guard dogs' eyes: teacups mill wheels towers); and value again in "Rumpelstiltskin" (necklace ring firstborn baby). Significantly, "Goldilocks" does not exhibit a *tricolon crescens*. We will look at the tricolons in "Goldilocks" in detail in a moment.

3. There are other dimensions that unite many of the tricolons in (2). Thus, my friend and colleague François Dell (personal communication) points out other significant dimensions that unite the members of a tricolon:

(i) Blood, sweat, and tears (secretions)

 Red, white, and blue (colors)

 Faith, hope, and charity (positive mindsets)

 Mind, body, spirit (components of a human being)

 Hook, line, and sinker (parts of a fishing rod)

 Veni, vidi, vici (Latin verbs)

 Bacon, lettuce, and tomato (edibles)

 Stop, look, and listen (attention getters)

 Lock, stock, and barrel (parts of a gun)

François provided the first four examples and generalizations. I joined in the game and added the rest. But he is right to point out these agrammatical dimensions. They underscore the idea that tricolons are like miniature poems, the English version of the haiku, perhaps.

4. A headline above the editorial in the *Boston Globe* (September 7, 2022) supports this. It reads: "Oyez! Oyez! Let the public hear the Supreme Court's arguments and opinions in real time."

5. If you will allow me to interject a personal comment, I find it the most beautiful and the most profound writing in all of Shakespeare.

6. The appendix where this list appears is an addition to Horn's write-up of his presidential address presented on January 8, 2022, at the annual meeting of the Linguistic Society of America. As interesting as the write-up is, to my mind the appendix is the tail/tale that wags the dog. I encourage you to read Horn's appendix for its richness of example and its historical and theoretical insights.

7. For an interesting and enlightening discussion, see https://tvtropes.org/pmwiki/pmwiki.php/Main/RuleOfThrees.

8. There is one other interesting characteristic of (3). But I have to delay any discussion until we have looked at the special way in which the Rule of Three plays out in music.

9. There is doubtless more to say about the duck joke. It is extraordinary how complex seemingly simple narrative events can be. But I am deliberately skirting narrative theory in this book because I want to limit my observations to artistic devices that are correlated with a theory of abstract representation. Narrative theory has not reached that empyrean level, to the best of my knowledge, undoubtedly because the problem is very hard.

10. There is one other example that I would like, somewhat hesitantly, to put on the table. When I was able to travel extensively, essentially following my wife around the world—I chronicled this part of my life in Keyser 2012—I was struck by how many times I saw fellow tourists at the extreme ends of things. If there was a pier or a breakwater, they would walk to the end; a mountain trail, to the top; a rocky outcropping, ditto; a cliff, to the very edge; a ship, to the prow; a train, to the last car. The drive to reach the highest, the farthest, the last seemed to me to be a very real one, albeit one I had no trouble resisting. But my intuition tells me that it is the same pleasure-seeking force that drives the *tricolon crescens*.

11. I am indebted to Fred Lerdahl for awakening my interest in "Goldilocks" and to Ray Jackendoff for many enlightening conversations that helped shape what follows.

12. The full version complete with illustrations can be found here: http://aversimasini.blogspot.com/2010/12/robert-southey-story-of-three-bears.html. The account

that follows is a slightly altered form of an essay (Keyser 2022) that appeared in the sadly now defunct e-magazine *Berfrois*, edited by the talented Russell Bennett. The *Berfrois* archives can still be accessed here: https://www.berfrois.com.

13. https://www.youtube.com/watch?v=-SjoZIkYnbQ.

14. The original text and a translation can be found here: https://archive.vcu.edu /germanstories/struwwel/daumendual.html.

15. The Cundall version destroys this symmetry: "Out little Silver-hair jumped; and away she ran into the wood, and the Three Bears never saw anything more of her."

16. Although Margulis's experiment establishes the reality of aesthetic pleasure attached to repetition, it does not shed light on why this should be so. That is something for neuroscientists to cogitate.

Chapter 5

1. In the case of "My Funny Valentine" the Rule of Three is observed by shifting the second A section a third higher, an unusual way of honoring the constraint.

2. Here are the actual numbers. N1 stands for the first ending, N2 for the second.

Number of tunes		Form of tunes	
296	=	[A,N1,A,N2,B,A2]	AABA
108	=	[A,B]	AB
106	=	[A,B,A2,C]	ABAC
84	=	[A,A,B,A2]	AABA
29	=	[A,N1,A,N2]	AA
23	=	[A,B,C,D]	ABCD
23	=	[A,A2,B,A3]	AABA
22	=	[A,B,A2]	ABA
22	=	[A,B,C]	ABC
21	=	[A,N1,A,N2,B,C]	AABC
19	=	[A,N1,B,A,N2,C]	ABAC

3. There is an interesting corroboration of this view performed not in a laboratory of neuroscience but in the laboratory of history. I defer discussion of it to the end of chapter 6 so that I can present the relevant historical background first.

4. Much the same form can be found in French limericks.

 (i) Un cer<u>tain</u> habi<u>tant</u> d'Aubus<u>son</u> 3-3-3

 N'avait <u>pas</u>, dans sa <u>têt</u>', que du <u>son</u>. 3-3-3

Il sau<u>va</u> sa fa<u>mille</u>	3-3
En cré<u>ant</u> la cé<u>dille</u>.	3-3
Car dès <u>lors</u>, on les <u>nomm</u>' "les Du<u>çon</u>."	3-3-3

A certain resident of Aubusson

Whose head was not filled with sawdust

Saved his family

By creating the cedilla.

From then on they were known as "The Duçons."

5. There is, however, one dimension along which the limerick and children's verse might make a sufficiently strong connection with music to invoke Music's Rule of Three. Both limericks and children's verse share a common characteristic. To a far greater extent than literary verse, these forms occupy every S position of the meter with a stressed syllable, as the nursery rhymes in (5) attest. The singsong rhythm typical of doggerel thus shares with music an overt metrical beat. This may be enough to treat limericks and children's verse as being subject to Music's Rule of Three. However, this is merely speculation.

6. The markings include, among others, *pianissimo* (*pp*) 'very soft', *piano* (*p*) 'soft', mezzopiano (*mp*) 'medium soft', *mezzoforte* (*mf*) 'medium loud', *forte* (*f*) 'loud', *fortissimo* (*ff*) 'very loud', *triple forte* (*fff*) 'very, very loud', *crescendo* (>) 'gradually louder', *decrescendo* (<) 'gradually softer', and so on. It is no accident that the number of different dynamic markers used in musical notation parallels the number of distinct sound volumes human beings are able to discern.

7. I say *canonical form*, but there isn't always universal agreement on what that looks like. For example, there is considerable discussion about what the first note of the ascending three-note figure in measure 7 of "Für Elise" actually is.

Chapter 6

1 This passage from Schlegel 1801, 225 (quoted from Chomsky 2009, 103n34) is illustrative of Schlegel's more interesting insight into the role of poetry among the arts:

> In poetry the expressive potentiality that is found in the arts is found to an even higher degree since other arts do after all have in light of their restricted media or means of representation [*Darstellung*] a determinate sphere of activity that could allow itself to be circumscribed to some degree. The medium of poetry is precisely the medium through which the human spirit awakens to itself at all, and through which it fastens on to its presentations [*Vorstellungen*] in arbitrary associations and expressions—that is, language. Poetry is therefore not even bound to objects, it rather makes its own object for itself; it is the most comprehensive of all the arts and is, as it were, the omnipresent universal spirit in them. That which, in the representations of the remaining arts raises us up out of everyday reality into a world of fantasy, is called their poetical element. Poetry therefore designates in this general sense artistic invention, the wondrous act whereby it enriches nature; as its name asserts, it is a true

creation and bringing forth. Every outward material representation is preceded by an idea in the mind of the artist in which language always comes into play as the mediator of awareness; consequently one can say that they always emerge from the womb of poetry. Language is not a product of nature, rather it is an imprint [*Abdruck*] of the human mind which exhibits the emergence and connections of its presentations as well as the operating mechanism [of the human mind]. Thus in poetry what has already taken shape is given shape again, and its plasticity is just as limitless as spirit's ability to turn back on itself in reflections of ever-increasing potentialities. (Chomsky's brackets)

For a fuller discussion of Schlegel's interesting position, see Chomsky 2009 and Keyser 2020, 35–37.

2. Something like this seems to be hidden in Shelley's *A Defence of Poetry* (1821) when he says:

But poetry in a more restricted sense expresses those arrangements of language, and especially metrical language, which are created by that imperial faculty, whose throne is curtained within the invisible nature of man. And this springs from the nature itself of language, which is a more direct representation of the actions and passions of our internal being, and is susceptible of more various and delicate combinations, than colour, form, or motion, and is more plastic and obedient to the control of that faculty of which it is the creation. For language is arbitrarily produced by the imagination, and has relation to thoughts alone; but all other materials, instruments, and conditions of art have relations among each other, which limit and interpose between conception and expression.

3. The blues was developing during the last forty years of the nineteenth century. Grétry wrote his famous remark in 1845, three-quarters of a century before the first blues recording was ever made (August 10, 1920) by The Jazz Hounds. The vocalist was Mamie Smith, the tune, "Crazy Blues."

4. I am not certain what other dimensions Kivy has in mind, but their relationship to the collapsed items 1 and 2 will not have changed under the collapse.

5. The philosopher Paul Grice discusses this phenomenon in a set of maxims governing normal conversation. In this case the relevant maxim is the Maxim of Quantity, according to which in a conversational exchange, each participant expects the other to provide just the amount of information required and no more (Grice 2002, 22–41). A violation of the maxim would be responding to "Where did you have lunch?" by not only giving the name of the restaurant but also describing the table setting. In conversation, repeating the same sentence is an extreme violation of the Maxim of Quantity. In the blues, on the other hand—or any other lyric or in poetry, for that matter—the maxim is violated time after time.

I am indebted to my copy editor, Anne Mark, for bringing this to my attention.

6. Huron's discussion (2007, 228–231) is very enlightening and is well worth the effort to find it.

7. I reproduce that survey here (Broyles 1980, 341n3):

A total of 347 pieces was examined and then statistically divided into decades and, to an extent, types of composition and composer. In order to ensure accuracy, only the following

were admitted: autograph manuscripts; eighteenth-century manuscript copies; early editions; and modern critical editions in which it is reasonably certain that sufficient care was exercised in the text to guarantee accuracy of repeat marks. Only those compositions that could be dated with some certainty were included. A conscious attempt was made to include a large number of works by Haydn, Mozart, and Beethoven on the assumption that their influence upon both their time and future generations was significant. Other composers were chosen more or less at random, principally depending upon the availability of sources which met all of the above requirements. Pieces by the following composers were examined: Ludwig van Beethoven, Luigi Boccherini, Muzio Clementi, Karl Ditters von Dittersdorf, J. L. Dusik, François Gossec, Joseph Haydn, Michael Haydn, Thäddeus Huber, Johann Hummel, Leopold Koželuch, Wolfgang Amadeus Mozart, Ignace Pleyel, Henri Rigel, Louis Rague, Antonio Soler, Carl Stamitz, J. F. Sterkel, and Johann Baptist Vanhal. The investigation was also limited to first movements. While not denying stylistic developments to other movements, since the first movement was normally the most substantial and contained the most fully developed sonata structure, any change in repeat signs of aesthetic significance should appear there. The results were as follows:

| | Pieces Examined | | | |
| | With Repeats | | Without Repeats | |
	No.	Percentage	No.	Percentage
Before 1780	128	98.5%	2	1.5%
1780–89	58	79.5%	15	20.5%
1790–99	35	37.0%	59	63.0%
1800–10	6	12.0%	44	88.0%

While this essay is not a statistical study per se, it is felt that enough works were investigated to verify the existence of a general trend away from repeating the second half in the late eighteenth and early nineteenth centuries.

Chapter 7

1. The loop connecting the end of *many* with the following indefinite article *a* is meant to indicate the poetic convention whereby two adjacent vowels may be counted as a single vowel. The process is called *elision*, and it occurs twice in line 8.

2. *Penta* is from the Greek root *penta* meaning 'five' and *meter* is from the Greek *metron* meaning 'measure'.

3. Not all metrists buy into the idea that the "generative" goal of metrical theory is to distinguish between metrical and unmetrical lines. For example, Reuven Tsur (1998, 25) asserts that

most theories attempt to discover those rules that would minimize the number of inadmissible "unmetrical," chaotic lines in major English poetry. They earnestly believe that it is possible and desirable to devise such a set of rules. . . . The present conception, by contrast, assumes that it is not possible to discover, nor desirable to devise, such a set of rules. If it were possible, it would impair the artistic foundation of poetic rhythm.

My goal in this chapter is to explore how repetition works within a generative theory of meter. It is not to argue for one theory over another. Therefore, I leave you with this caveat. What follows is an account of how repetition works assuming a generative metrical theory. I leave it to others to take up the baton of repetition in nongenerative systems.

4. This formulation, based on the work of Paul Kiparsky in metrical theory, is drawn from the excellent account of metrical theory and its development by Kristin Hanson (2023). The book is a readable and valuable resource for anyone interested in metrical studies. I have modified the formulation a bit for ease of presentation. Any problems that creates are on me.

5. I am indebted to Hanson 2023, 91, for this formulation.

6. Paul Kiparsky (1975) offers this constructed line as a counterargument to the theory proposed in Halle and Keyser 1972. In particular, Kiparsky notes that in Shakespeare's sonnets lines like *Pluck the keen teeth from the fierce tiger's jaws* never occur.

7. The reference is to an eighteenth-century prosodist, Edward Bysshe, who took the position that English verse is syllabic in nature and that stress matters little. This was an attempt to fit English stress-based verse into the Procrustean bed of French meter. Here, too, Fussell 1966 is an excellent reference.

Chapter 8

1. The double linking of *heaven* in (1a) represents Wright's (1988) reading of the word as a metrical monosyllable. This is both common and critical. Otherwise, the line would have to be deemed unmetrical in terms of correspondence rule (8) of chapter 7.

2. I say *identical* because from a metrical point view *heaven* and *youth* are monosyllables.

3. For a discussion of the transformation of poetry from an aural to a visual art form, see Keyser 2020.

4. In this regard it seems reasonable to suppose that one of the functions of end rhyme, apart from giving pleasure, is to enhance the meter's marking of the end of a metrical line. It isn't absolutely necessary, but it is very nice to have.

5. It should be noted that this kind of explicit parallel between the musical measure and the metrical line is not possible in metrical accounts that eschew the notion of an unmetrical line, for example, that of Tsur (1998).

6. See Keyser 2020, 105–120, for a detailed example. For an example of biblical parallelism in Modern English, see the discussion of "Rizal upon Hearing David Bowie's

'The Rise and Fall of Ziggy Stardust and the Spiders from Mars'" by Eugene Gloria in chapter 12 below.

7. It occurred to me that the abandonment of meter and rhyme at the turn of the twentieth century, with its concomitant loss of repetition as a source of pleasure, might have a side effect worth exploring. I wondered if repetition might have crept back in through another source. I asked a graduate student at MIT, Isabelle Quayle, to write a program that would take a sample of a poet's work and come up with a percentage representing the average number of times the poet repeated the same word within a poem. She did that with great skill. The following table shows the results:

	Works	Average number of repeated words	%
William Shakespeare (1564–1616)	Sonnets	4	8
Wallace Stevens (1879–1955)	30 poems*	15	18
Sir Phillip Sydney (1554–1586)	37 poems*	5	7
Ezra Pound (1885–1972)	18 poems*	34	15

*Random sample of the author's poems

I do not offer this as a definitive result. But it is suggestive that as rhyme and meter disappeared, the percentage of repeated words per poem increased. This is probably worth looking into.

Chapter 9

1. For a detailed account of Greek meter, including Homeric dactylic hexameter, see Fabb and Halle 2008. With respect to the Homeric language or dialect, as my friend and colleague Leonard Muellner writes (personal communication):

> It is not anyone's native language—it's an artificial, self-sustaining dialect (Homerists still use the 19th Century German term, *Kunstsprache* or 'art language') that includes forms from three "real" dialects, for instance, which represent evolutionary states of the poetic system and which enhance its flexibility, because different dialect forms, for example, of "to/for us" have different metrical values in the poetic language. So there is a remove in the poetic language from any particular natural language dialect in both time and multiplicity, but people learned it and understood it even so, at least most of it. Like any archaizing medium, there are bound to be elements that are preserved but synchronically obscure.

2. This is a reference to Parry's text, where he reproduces passages from the *Iliad* and the *Odyssey* and underlines the formulaic expressions that he finds there. The text with underlining can be found in chapter 10 below.

3. This term refers to the pause that occurs in much of dactylic hexameter verse between the fourth and the fifth foot. For a detailed discussion, see Bassett 1905.

The important point is that after the fourth foot, the noun + epithet formulas that Parry focuses on neatly fill out the metrical demands of the remaining two feet in the verse.

4. My friend and colleague Leonard Muellner (personal communication) writes informatively that αὐτὰρ ἐπεὶ are

> two words that begin roughly 250 lines in the Homeric corpus (Iliad, Odyssey, so-called Homeric Hymns, all composed in roughly the same formulaic system). The second word, ἐπεί, is easy—it means 'when' or 'since' and introduces a subordinate clause that usually completes the line. The word αὐτὰρ is more complex. Every Greek sentence that is not the first sentence of a speech has a word or words at the beginning (either the first or second word) that explains its logical or expressive relationship (sometimes both) to the previous sentence, and αὐτὰρ is one of those words, and it only occurs in Homeric poetry or poets who imitate Homeric poetry. The linguists who study pragmatics in Homer think that it introduces a change of viewpoint on the landscape of the narrative. It also often introduces a change of the grammatical subject. So it falls into the categories of disjoined visualization and narrative focus from what came before. If you wanted to put it into English you'd have to say something like "now picture this." There's an equally common variant on αὐτὰρ ἐπεὶ . . . , namely αὐτὰρ ἔπειτα, where the extra syllable -τα of the second word changes the meaning from 'when/since' to a simple 'then'.

Thus, αὐτὰρ appears to be the Homeric counterpart of "Now for something completely different."

The numbers to the right of the examples refer to books and lines in the original text. Thus, κατέπαυσα (δ 583) indicates that the form can be found in book IV, line 583.

5. The dactylic hexameter scansion in (3) using αὐτὰρ ἐπεὶ and the first verb on the right side of the bracket in (2) is illustrated below, but keep in mind that all the verbs in (2) have the phonological shape ABC:

	A	B	C
	⎰u u⎱	—	u
	⎱ — ⎰		
	kate	pau	se
	κατέ	παυ	σα
	oop	tee	se
	ὤπ	τη	σε
	ἐτέ	λεσ	σε
	ete	les	se
	ἐνέ	η	κε
	ene	ee	ke

> A is a sequence of two moras, either two light syllables or a heavy syllable. B is a heavy syllable, and C is a light syllable. These syllables fit into the dactylic hexameter in (3) as follows, using the first example as illustration:
>
> i. A is the second half of a foot,
> ii. B is the first half of a foot, and
> iii. C is the first half of the second half of a dactyl.

αὐτὰρ ἐ |πεὶ κατέ| παυ σε θε| ὰ γλαυ|κῶ πιϲ Ἀ|θή νη |

autar e |pei ka te| pau se the|aa glau|koo pi sa|thee nee |

— u u |— | u u |— u| u| — — |— u u| — — |

I am indebted to François Dell for providing me with this transliteration and metrical analysis. It illustrates how complicated the linkages are that the formulas fill in and therefore how skilled the oral poets are in manipulating them.

6. At the point where he references fixed phrases that the poet has heard from other poets, Parry cites Arnold van Gennep (1909, 52):

> Les poésies des guslars sont une juxtaposition de clichés, relativement peu nombreux et qu'il suffit de posséder. Le développement de chacun de ces clichés se fait automatiquement, suivant des règles fixes. Seul leur ordre peut varier. Un bon guslar est celui qui joue de ses clichés comme nous avec des cartes, qui les ordonne diversement suivant le parti qu'il en veut tirer.

> The poems of the guslars are a juxtaposition of clichés, relatively few in number but enough. The development of each of these pictures is done automatically, following fixed rules. Only their order can vary. A good guslar is the one who plays with his clichés as we do with cards, who orders them variously according to the use he wants to make of them.

Frankly, I find it puzzling that Parry would refer to the practice of Serbo-Croatian singers (guslars, after their accompanying instrument), where the number of fixed phrases is in marked contrast to his own "vast number." Here van Gennep seems to be implying that epics are composed of as few as fifty-two formulas, the number of cards in a deck.

7. Often these changes lead to unmetrical lines and ungrammaticality. Regarding this observation Nagy (2022) argues:

> If the poet in the passages I discuss commits what to a modern reader would count as a blemish, it is not necessarily from lack of ability, but because he did not care, and did not need to care. The Homeric poems were not created for readers or scholars. Nor should we forget that the listeners' thrill of hearing an impressive or dramatic passage repeated word for word would outweigh minor discrepancies introduced by the repetition.

8. I would love to have conducted this and some other experiments myself. Unfortunately, age and infirmity have ruled that out. Perhaps some reader will pick up the baton.

9. Seamus Heaney (http://www.somanybooks.org/eng205/Beowulf.pdf) translates figure 9.2 in this fashion:

(i) So. The Spear-Danes in days gone by

 And the kings who ruled them had courage and greatness.

 We have heard of those princes' heroic campaigns.

 There was Shield Sheafson, scourge of many tribes,

 A wrecker of mead-benches, rampaging among foes. 5

 This terror of the hall-troops had come far.

 A foundling to start with, he would flourish later on

 As his powers waxed and his worth was proved.

 In the end each clan on the outlying coasts

Beyond the whale-road had to yield to him 10
And begin to pay tribute. That was one good king.
Afterwards a boy-child was born to Shield,
A cub in the yard, a comfort sent
By God to that nation. He knew what they had tholed,
The long times and troubles they'd come through 15
Without a leader; so the Lord of Life
The glorious Almighty, made this man renowned.
Shield had fathered a famous son:
Beow's name was known through the north.
And a young prince must be prudent like that, 20
Giving freely while his father lives
So that afterwards in age when fighting starts
Steadfast companions will stand beside him
And hold the line. Behavior that's admired
Is the path to power among people everywhere. 25

Chapter 10

1. Gjerdingen adds the eighth-note runs in smaller notes because the completed exercise has been lost.

2. Figure 10.6 can be translated as follows:

 (i) Sing, goddess, the anger of Peleus' son Achilles
 And its devastation, which put pains thousandfold upon the Achaians,
 hurled in their multitude to the house of Hades strong souls
 of heroes, but gave their bodies to be the delicate feasting
 of dogs, of all birds, and the will of Zeus was accomplished 5
 since that time when first day of school the division of conflict
 Atreus' son the lord of men and brilliant Achilleus.
 What God was it then set them together in bitter collusion?
 Zeus' son and Leto's, Apollo. Who in anger at the king drove
 the foul pestilence along the host, and the people perished, 10
 since Atreus' son had dishonoured Chryses, priest of Apollo
 When he came beside the fast ships of the Achaians to ransom
 back his daughter, carrying gifts beyond count and holding
 in his hands wound on a staff of gold the ribbons of Apollo
 who strikes from afar, and supplicated all the Achaians, 15

but above all Atreus' two sons, the marshals of the people:

"Sons of Atreus and you other strong-greaved Achaians,

to you may the gods grant who have their homes on Olympos

Priam's city to be plundered and a fair homecoming thereafter,

but may you give me back my own daughter and take the ransom, 20

giving honor to Zeus' son who strikes from afar, Apollo."

 Then all the rest of the Achaians cried out in favour

that the priest be respected and the shining ransom be taken;

yet this pleased not the heart of Atreus' son Agamemnon,

but harshly he drove him away with a strong order upon him. 25

3. Harvard University now holds over 3,500 discs recorded in Yugoslavia in 1934 and 1935. All in all there are 132,500 texts in the collection.

Chapter 11

1. This is a hypothesis that is certainly testable, especially with tunes that work at a variety of tempos, for example, "On the Sunny Side of the Street."

Chapter 12

1. Readers interested in the details of how syllables are counted can consult Fabb and Halle 2008. To describe them here would be a technical distraction and, in any case, they are not at all controversial.

2. Grosser (2023, 5) says of Psalm 23:

> Biblical poems are typically lineated according to regular rhythms and parallelism—that is, correspondences of especially grammar or meaning between adjacent segments of text. Both the rhythms of Psalm 23 are irregular, and the only indisputable occurrence of parallelism in the psalm (and thus the only undisputed lineation) is verse 2:
>
> > He makes me to lie down in green pastures;
> > He leads me beside the quiet waters.
>
> What do we do with this conundrum: that Psalm 23 exhibits some of the most moving poetic and lyrical language in the psalter, but our default understanding of lines (regular rhythms and parallelism) cannot account for the verb shapes of this poem?

Given the analysis based on (2) and the following discussion, there is no conundrum. And it is hard to imagine that Bazak's (1987) analysis is wrong, given the complexity of the numerical artifice. Numbers don't lie. Consequently, Psalm 23 is not the best example to illustrate the assertion that "biblical verse-poetry is built from lines that fit to each other, not lines that fit to a meter" (Grosser 2023, 1) since this is one of the few poems in the biblical text that is metrical.

3. As Jacobson (2017, 1) notes:

> The art of chanting the Bible is called "cantillation," a word derived from the Latin cantare, meaning "to sing." In a traditional Jewish synagogue, cantillation is performed by a solo singer, appropriately qualified and prepared, who chants the sacred text for the congregation according to the ancient traditional melodies, unaccompanied, in a free, speech-like rhythm.

These melodies are graphically marked and are a major source of the boundaries that Kugel (1981) represents as / and //.

4. Notice that I have not included meter in this catalogue of ornamentational devices. That is because I do not consider meter an ornament; rather, it is a device for licensing two lines as valid repetitions of one another (see chapter 8).

5. Something like that has been proposed to explain why Shakespeare wrote 154 sonnets, and not 153 or 155. There are 11 letters in Shakespeare's name and 14 lines in a sonnet. 14 x 11 = . . . ; well, you do the math.

6. I find it interesting that ornamentation appears to have shifted away from poetry (and music) into abstract art as modernism unfolded. This kind of symbiosis is worth exploring but, unfortunately, not here.

Chapter 13

1. As Wallace Stevens comments (see appendix 1), "If the meaning of a poem is its essential characteristic, people would be putting themselves to a lot of trouble about nothing to set the meaning in a poetic form." This remark could just as easily have been made about painting: "If what a painting portrays is its essential characteristic, people would be putting themselves to a lot of trouble about nothing to put the image on canvas."

2. For discussion see Keyser 2020, 77–96.

3. I am grateful to William Scott, friend and colleague, who first brought the notion of parerga to my attention.

4. Notice how separating the two halves of the painting brings out, in the panel on the left, the triangle formed by the three men in the street echoed by the shape of the building behind them.

5. *Paris Street; Rainy Day* is noted for its multiple vanishing points. However, as I have tried to show, the vanishing points are an epiphenomenon arising from Caillebotte's exploitation of the triangle. To talk about vanishing points and not triangles is putting the cart before the horse.

6. It is also worth noting that the Rule of Three plays no role in the visual arts. The difference must surely reside in the fact that poetry and music of the kind examined above are linear art forms whereas painting is not.

7. When I came to this view of the photograph, I mentioned it to a friend, Jerome Weinstein, who has been a fan of photographic art for a very long time. He recognized the reading immediately, adding that he had always known the photograph under the subtitle "Laughing Dog." I concluded that although I had come up with this reading independently, so had others. However, neither of us have been able to find a "Laughing Dog" reference. This note serves as a placeholder until the reference surfaces.

I asked Friedlander, through his representative, if the dog belonged to him. According to the representative, he said it did not, although he was amused at the question. As to whether the interpretation given here is correct, he preferred—again through his representative—to leave such matters to others.

8. https://www.artsy.net/artwork/roni-horn-becoming-a-landscape.

9. I am grateful to Jenny Audring for bringing Ms. Horn's work to my attention. I am also deeply grateful to the Roni Horn studio for permission to reproduce these images from *Becoming a Landscape 1999–2001* and to Ms. Tiffany Wang for her deft facilitation of the permissions process.

10. The *New York Times* article, dated December 17, 2023, by Jason Zinoman, was entitled "Was a Scandal the Best Thing to Happen to Hassan Minhaj?" As I scrolled down, this ad suddenly appeared. I am dutifully referencing it here, even though pop-up ads change constantly. So, this is really a reference to where something used to be, an oddity of the online world.

11. For a fuller discussion of this logo and its history, see Keyser 2020, 20–21.

12. I am grateful to François Dell (personal communication) for pointing out this property of the FedEx logo.

Chapter 14

1. As we will see, this account can be extended quite straightforwardly to music and to the visual arts.

2. Hebrew is read from right to left. Even if you don't read Hebrew, you can see that the two half lines begin very much alike; that is, counting in from the right, words 1 and 2 are identical to words 4 and 5.

3. To pursue this topic, see Lerdahl and Jackendoff 1983b for an overview.

4. It is also possible that the proper representation for adjacency in rhyme schemes will show that the rhyming pairs are, in fact, adjacent. For an example of one such representation, see the discussion of the rhythm rule in Liberman and Prince 1977, 312–313. I will not attempt to argue for such a representation here.

5. Margulis (2012) offers an interesting discussion of what constitutes repetition in music and a useful set of references.

6. Working out the details would require some effort and would lead us astray. I leave that task for another time.

7. One possibility is that the areas of the brain processing these separate inputs are adjacent, but why that should make a difference is unclear. For a useful survey see Jenkins 2001.

8. For an interesting account of the major role performed by priming in human cognition in general and especially in the organization of memory, see Marcus 2008, 18ff.

9. Recall that Gjerdingen (2007) likens galant composition to figure skating, where the building blocks are called figures, axels, salchows, lutzes, camels, and so on. It is very likely that ballet and modern dance could be viewed similarly. There is a rich and varied literature on these topics, one that is beyond the scope of this book. But just to get an oar in, building blocks accompanied by repetition are a recipe for pleasure, whatever the art form.

10. As Katz and Pesetsky (2011) argue, "All formal differences between language and music are a consequence of differences in their fundamental building blocks [pitch and tonal intervals for music, words for language]. In all other respects, language and music are identical."

11. The advice that Gombrich refers to occurs in Cézanne's letter to Emile Bernard of April 15, 1904:

> May I repeat what I told you here: treat nature by means of the cylinder, the sphere, the cone, everything brought into proper perspective so that each side of an object or a plane is directed toward a central point.

12. It is interesting that Wornum, in his description, touches on what I earlier called the immutable triad of rhythm, melody, and harmony.

Appendix 1

1. Here are the relevant lines:

> The antechapel where the statue stood
> Of Newton with his prism and silent face,
> The marble index of a mind for ever
> Voyaging through strange seas of Thought, alone.

2. I am indebted to Ray Jackendoff for several conversations enlightening me on the character of "Jabberwocky."

References

Abrams, Meyer Howard. 1953. *The Mirror and the Lamp: Romantic Theory and the Critical Tradition*. Oxford: Oxford University Press.

Allman, John. 1999. *Evolving Brains*. New York: Scientific American Library. Distributed by W. H. Freeman.

Alter, Robert. 1985. *The Art of Biblical Poetry*. New York: Basic Books.

Andersen, Hans Christian, Peter Christen Asbjørnsen, Aleksander Chodźko, The Brothers Grimm, Joseph Jacob, Grace James, Andrew Lang, et al. 2019. *1500 Eternal Masterpieces of Fairy Tales*, edited by Aleksander Chodźko. Atheneum Classics. Kindle edition.

Ard, Alisha. 2001 "Carl Fontana: A Biography, and Study of Solo Transcriptions from the Album *The Hanna-Fontana Band; Live at Concord* (Concord Jazz, CCD-6011)." Master of Arts thesis, Brigham Young University, Rexburg, ID.

Aviv, Vered. 2014. "What Does the Brain Tell Us about Abstract Art?" *Frontiers in Human Neuroscience* 8. https://doi.org/10.3389/fnhum.2014.00085.

Bassett, Samuel Eliot. 1905. "Notes on the Bucolic Diaeresis." *Transactions and Proceedings of the American Philological Association* 36: 111–124.

Bazak, Jacob. 1987. "Numerical Devices in Biblical Poetry." *Vetus Testamentum* 38: 333–337.

Berliner, Paul. 1994. *Thinking in Jazz: The Infinite Art of Improvisation*. Chicago: University of Chicago Press.

Berg, Thomas. 1990. "Unreine Reime als Evidenz für die Organisation phonologischer Merkmale" [Slant rhymes as evidence for the organization of phonological features]. *Zeitschrift für Sprachwissenschaft* 9, 3-27.

Bernstein, Leonard. 1976. *The Unanswered Question: Six Talks at Harvard*. Cambridge, MA: Harvard University Press.

Bettelheim, Bruno. 1976. *The Uses of Enchantment*. London: Thames and Hudson.

Bever, Thomas G. 1986. "The Aesthetic Basis for Cognitive Structures." In *The Representation of Knowledge and Belief*, edited by Myles Brand and Robert M. Harnish, 314–356. Tucson: University of Arizona Press.

Bock, J. Kathryn. 1986. "Syntactic Persistence in Language Production." *Cognitive Psychology* 18: 355–387.

Booker, Christopher. 2004. *The Seven Basic Plots*. London: Bloomsbury Publishing. Kindle.

Broyles, Michael. 1980. "Organic Form and the Binary Repeat." *Musical Quarterly* 66: 339–360.

Calvino, Italo. 2002. *Collection of Sand*. Trans. by Martin McLaughlin (2013). Boston. Houghton Mifflin.

Caplin, William E. 1998. *Classical Form: A Theory of Formal Functions for the Instrumental Music of Haydn, Mozart, and Beethoven*. Oxford: Oxford University Press.

Chatterjee, Anjan. 2014. *The Aesthetic Brain*. Oxford: Oxford University Press.

Chomsky, Noam. 2009. *Cartesian Linguistics: A Chapter in the History of Rationalist Thought*, 3rd ed., with an introduction by James McGilvray. Cambridge: Cambridge University Press.

Cook, Nicholas. 1987. "The Perception of Large-Scale Tonal Closure." *Music Perception* 5: 197–205.

Culicover, Peter W., and Ray Jackendoff. 2012. "Same-Except: A Domain-General Cognitive Relation and How Language Expresses It." *Language* 88: 305–340.

cummings, e. e. 1950. ("dim/i/nu/tiv . . ."). *Poetry Magazine* 76: 187).

Cundall, Joseph. 1850. *A Treasury of Pleasure Books for Young Children*. London: Joseph Cundall, Old Bond Street.

Dalhaus, Carl. 1989. *The Idea of Absolute Music*, trans. by Roger Lustig. Chicago: University of Chicago Press.

Danto, Arthur. 1995. *After the End of Art*. Princeton, NJ: Princeton University Press.

Davies, Penelope J. E., Walter B. Denny, Frima Fox Hofrichter, Joseph Jacobs, Ann M. Roberts, and David L. Simon. 2010. *Janson's History of Art: The Western Tradition*. 8th ed. Upper Saddle River, NJ: Prentice Hall.

Derrida, Jacques. 1987. *The Truth in Painting*, edited by Geoffrey Bennington and Ian McLeod. Chicago: University of Chicago Press.

Deutsch, David. 2011. *The Beginning of Infinity*. Penguin. Kindle.

Deutsch, Diana, Trevor Henthorn, and Rachael Lapidis. 2011. "Illusory Transformation from Speech to Song." *Journal of the Acoustical Society of America* 129: 2245–2252.

Duro, Paul. 2019. "What Is a Parergon?" *Journal of Aesthetics and Art Criticism* 77: 23–33.

Endress, Ansgar D., Marina Nespor, and Jacques Mehler. 2009. "Perceptual and Memory Constraints on Language Acquisition." *Trends in Cognitive Sciences* 13: 348–353.

Fabb, Nigel, and Morris Halle. 2008. *Meter in Poetry: A New Theory.* Cambridge: Cambridge University Press.

Freeman, Donald, ed. 1981. *Essays in Modern Stylistics.* New York: Methuen.

Fussell, Paul. 1966. *The Theory of Prosody in the Eighteenth Century.* Hamden, CT: Achon Books.

Gervain, Judit, Francesco Macagno, Silvia Cogoi, and Jacques Mehler. 2008. "The Neonate Brain Detects Speech Structure." *Proceedings of the National Academy of Sciences USA* 105: 14222–14227.

Giurfa, Martin, Shaowu Zhang, Arnim Jenett, Randolf Menzel, and Mandyam V. Srinavasan. 2001. "The Concepts of 'Sameness' and 'Difference' in an Insect." *Nature* 410: 930–933.

Gjerdingen, Robert O. 2007. *Music in the Galant Style.* Oxford: Oxford University Press.

Gleason, Jean Berko. 1958. *The Wug Test.* Cambridge, MA: Larchwood Press.

Gombrich, E. H. 1979. *The Sense of Order: A Study in the Psychology of Decorative Art.* Ithaca, NY: Cornell University Press.

Gopnik, Alison. 1998. "Explanation as Orgasm." *Minds and Machines* 8: 101–118.

Grétry, André-Ernest-Modeste. 1789. *Mémoires, ou essais sur la musique.* Paris.

Grice, H. P. (2002). "Logic and Conversation." In *Foundations of Cognitive Psychology: Core Readings,* edited by Daniel J. Levitin, 719–732. Cambridge, MA: MIT Press.

Grosser, Emmylou J. 2023. *Unparalleled Poetry: A Cognitive Approach to the Free-Rhythm Verse of the Hebrew Bible.* New York: Oxford University Press.

Halle, Morris, and Samuel Jay Keyser. 1972. "The Iambic Pentameter." In *Versification: Major Language Types,* edited by William K. Wimsatt. New York: New York University Press. Reprinted in Freeman 1981, 217-237.

Halle, Morris, and Samuel Jay Keyser. 1999. "On Meter in General and on Robert Frost's Loose Iambics in Particular." In *Linguistics: In Search of the Human Mind. A*

Festschrift for Kazuko Inoue, edited by Masatake Muraki and Enoch Iwamoto, 130–153. Tokyo: Kaitakusha.

Hanson, Kristin. 2023. *An Art That Nature Makes: A Linguistic Perspective on Meter in English*. Ms.

Hindemith, Paul. 1952. *A Composer's World: Horizons and Limitations*. Cambridge, MA: Harvard University Press.

Hoffmann, Heinrich. 1844. *Struwwelpeter, Merry Stories and Funny Pictures*. New York: Frederick Warne.

Horn, Laurence R. 2022. "Contrast and Clausal Order: On beyond Behaghel." *Language* 98: 812–843.

Horn, Roni. 2001. *Ísland. To Place. Becoming a Landscape*. Denver, CO: Ginny Williams.

Huettig, Falk, Jenny Audring, and Ray Jackendoff. 2022. "A Parallel Architecture Perspective on Pre-activation and Prediction in Language Processing." *Cognition* 224. 105050.

Huron, David. 2007. *Sweet Anticipation: Music and the Psychology of Expectation*. Cambridge, MA: MIT Press.

Huron, David. 2015. "Aesthetics." In *The Oxford Handbook of Music Psychology*, 2nd ed., edited by Susan Hallam, Ian Cross, and Michael H. Thaut, 233–245. Oxford: Oxford University Press.

Huron, David, and Joy Ollen. 2004. "Musical Form and the Structure of Repetition: A Cross-Cultural Study." Unpublished ms.

Hutcheson, B. R. 1995. *Old English Poetic Metre*. Cambridge: D. S. Brewer.

Hyman, Dick. 1986. *Professional Chord Changes and Substitutions for 100 Tunes Every Musician Should Know*. Vero Beach, FL: EKay Music Publishers.

Jackendoff, Ray, and Jenny Audring. 2020. *The Texture of the Lexicon*. Oxford: Oxford University Press.

Jacobson, Joshua R. 2017. *Chanting the Hebrew Bible: The Art of Cantillation*. 2nd ed. Philadelphia: The Jewish Publication Society.

Jakobson, Roman. 1965. "Quest for the Essence of Language." *Diogenes* 51: 21–37.

Jakobson, Roman. 1966. "Grammatical Parallelism and Its Russian Facet." *Language* 42: 399–429.

Jakobson, Roman. 1987. *Language in Literature*. Edited by Krystyna Pomorska and Stephen Rudy. Cambridge, MA: Belknap Press of Harvard University Press.

James, William. 1890. *The Principles of Psychology, Vol. 1*. New York: Henry Holt. Reprinted, Mineola, NY: Dover Books (195

Jenkins, J. S. 2001. "The Mozart Effect." *Journal of the Royal Sociey of Medicine*. 94(4): 170–172.

Kahneman, Daniel. 2013. *Thinking, Fast and Slow*. Farrar, Straus and Giroux. Kindle.

Kaimal, Girija, Hasan Ayaza, Joanna Herres, Rebekka Dieterich-Hartwella, Bindal Makwana, Donna J. Kaiser, and Jennifer A. Nasser. 2017. "Functional Near-Infrared Spectroscopy Assessment of Reward Perception Based on Visual Self-Expression: Coloring, Doodling, and Free Drawing." *The Arts in Psychotherapy* 55: 85–92.

Kant, Immanuel. 1911. *Critique of Judgement*, translated by James Creed Meredith. Oxford: Oxford University Press. (Original work published 1790.)

Katz, Jonah, and David Pesetsky. 2011. "The Identity Thesis for Language and Music." Ms., MIT. http://www.sfu.ca/~hedberg/katzEtAl_11_The-Identity-.3.pdf.

Keyser, Samuel Jay. 2011. "Reversals in Poe and Stevens." *The Wallace Stevens Journal* 35: 224–239.

Keyser, Samuel Jay. 2012. *I Married a Travel Junkie*. Boston: GemmaMedia.

Keyser, Samuel Jay. 2020. *The Mental Life of Modernism*. Cambridge, MA: MIT Press.

Keyser, Samuel Jay. 2022. "The Story of Robert Southey and the Three Bears." *Berfrois*, May 6, 2022. https://www.berfrois.com/2022/05/samuel-jay-keyser-the-story-of-the -three-bears.

Kiparsky, Paul. 1975. "Stress, Syntax, and Meter." *Language* 51: 576–616.

Kirby-Smith, H. T. 1998. *The Origins of Free Verse*. Ann Arbor: University of Michigan Press.

Kirsch, Adam. 2021. "The Classicist Who Killed Homer: How Milman Parry Proved That the *Iliad* and the *Odyssey* Were Not Written by a Lone Genius." *New Yorker*, June 14.

Kivy, Peter. 1993. *The Fine Art of Repetition: Essays in the Philosophy of Music*. Cambridge: Cambridge University Press.

Knoop, Christine A., Stefan Blohm, Maria Kraxenberger, and Winfried Menninghaus. 2021. "How Perfect Are Imperfect Rhymes? Effects of Phonological Similarity and Verse Context on Rhyme Perception." *Psychology of Aesthetics, Creativity, and the Arts* 15: 560–572.

Kugel, James L. 1981. *The Idea of Biblical Poetry*. New Haven, CT: Yale University Press.

Kuhn, Thomas. 1970. *The Structure of Scientific Revolutions*. Chicago: University of Chicago Press.

Lerdahl, Fred, and Ray Jackendoff. 1983a. *A Generative Theory of Tonal Music*. Cambridge, MA: MIT Press.

Lerdahl, Fred, and Ray Jackendoff. 1983b. "An Overview of Hierarchical Structure in Music." *Music Perception* 1: 229–252.

Levelt, Willem J. M., and Stephanie Kelter. 1982. "Surface Form and Memory in Question Answering." *Cognitive Psychology* 14: 78–106. https://doi.org/10.1016/0010 -0285(82)90005-6.

Liberman, Mark, and Alan Prince. 1977. "On Stress and Linguistic Rhythm." *Linguistic Inquiry* 8: 249–336.

Longstreth, Everett. 1985. *Contemporary Arranging*. 2 vols. Published by the author.

Lord, Albert. 1960. *The Singer of Tales*. New York: Atheneum. Reprinted, Cambridge, MA: Harvard University Press, 2000. Online version of the 2nd ed., edited with an introduction by Stephen Mitchell and Gregory Nagy. http://nrs.harvard.edu/urn-3 :hul.ebook:CHS_LordA.The_Singer_of_Tales.2000.

Magoun, Francis P. Jr. 1953. "Oral-Formulaic Character of Anglo-Saxon Narrative Poetry." *Speculum* 28: 446–467.

Marcus, Gary. 2008. *Kluge: The Haphazard Construction of the Human Mind*. New York: HarperCollins. Kindle.

Margulis, Elizabeth Hellmuth. 2012. "Musical Repetition Detection across Multiple Exposures." *Music Perception* 29: 377–385.

Margulis, Elizabeth Hellmuth. 2013a. "Aesthetic Responses to Repetition in Unfamiliar Music." *Empirical Studies of the Arts* 31: 45–57.

Margulis, Elizabeth Hellmuth. 2013b. *On Repeat*. Oxford: Oxford University Press.

Marr, David, and H. K. Nishihara. 1978. "Representation and Recognition of the Spatial Organization of Three-Dimensional Shapes." *Proceedings of the Royal Society of London B* 200: 269–294.

Marr, David, and Lucia Vaina. 1982. "Representation and Recognition of the Movements of Shapes." *Proceedings of the Royal Society of London, Series B, Biological Sciences* 214: 501–524.

Matherne, Samantha. 2014. "Kant's Expressive Theory of Music." *Journal of Aesthetics and Art Criticism* 72: 129–145.

Mayeux, Henri. 1888. *A Manual of Decorative Composition*. Translated by J. Gonino. New York: D. Appleton.

McGinn, Colin. 1993. *Problems in Philosophy: The Limits of Inquiry*. Oxford: Blackwell.

McKie, Michael. 1997. "The Origins and Early Development of Rhyme in English Verse." *Modern Language Review* 92: 817–831.

Mégevand, Pierre, David M. Groppe, Matthew S. Goldfinger, Sean T. Hwang, Peter B. Kingsley, Ido Davidesco, and Ashesh D. Mehta. 2014. "Seeing Scenes: Topographic Visual Hallucinations Evoked by Direct Electrical Stimulation of the Parahippocampal Place Area." *Journal of Neuroscience* 34: 5399–5405.

Minkova, Donka. 2003. *Alliteration and Sound Change in Early English.* Cambridge: Cambridge University Press.

Murphy, Robin A., Esther Mondragón, and Victoria A. Murphy. 2008. "Rule Learning by Rats." *Science* 319: 1849–1851.

Nagy, Gregory. 2022. "Poetics of Repetition in Homer." Center for Hellenic Studies, Harvard University. https://chs.harvard.edu/curated-article/gregory-nagy-poetics-of -repetition-in-homer/.

Ollen, Joy, and David Huron. 2004. "Listener Preferences and Early Repetition in Musical Form." In *Proceedings of the Eighth International Conference on Music Perception and Cognition*, edited by Scott Lipscomb et al., 405–407. https://www.researchgate.net /publication/251193118_Listener_Preferences_and_Early_Repetition_in_Musical_Form.

Owens, Thomas. 1974. "Charlie Parker: Techniques of Improvisation." Vol. 1. Doctoral dissertation, UCLA, Department of Music.

Parry, Adam, ed. 1971. *The Making of Homeric Verse: The Collected Papers of Milman Parry.* Oxford: Oxford University Press.

Parry, Milman. 1928. "L'Epithète traditionnelle dans Homère: Essai sur un problème de style homérique." Paris: Société d'éditions "Les belles lettres." Translated as "The Traditional Epithet in Homer" in A. Parry 1971, 1–191.

Parry, Milman. 1930. "Studies in the Epic Technique of Oral Verse-Making: I. Homer and Homeric Style." *Harvard Studies in Classical Philology* 41: 73–148. Reprinted in A. Parry 1971, 266–324.

Parry, Milman. 1932. "Studies in the Epic Technique of Oral Verse-Making: II. The Homeric Language as the Language of an Oral Poetry." *Harvard Studies in Classical Philology* 43: 1–50. Reprinted in A. Parry 1971, 325–365.

Perloff, Marjorie. 1993. *The Poetics of Indeterminacy.* Evanston, IL: Northwestern University Press.

Pickering, Martin J., and Victor S. Ferreira. 2008. "Structural Priming: A Critical Review." *Psychology Bulletin* 134: 427–459.

Pinker, Steven. 2014. *The Sense of Style: The Thinking Person's Guide to Writing in the 21st Century.* New York: Viking.

Poe, Edgar Allan. 1850. *The Literati: Some Honest Opinions about Autorial Merits and Demerits, with Occasional Words of Personality Together with Marginalia, Suggestions, and Essays*. New York: J. S. Redfield, Boston: B. Mussey.

Primus, Beatrice. 2002. "Unreine Reime und phonologische Theorie [Off-rhymes and phonological theory]." In *Sounds and Systems: Studies in Structure and Change*, edited by David Restle and Dietmar Zaefferer, 269–298. Berlin: De Gruyter.

Propp, Vladimir. 1968. *Morphology of the Folktale*. Bloomington: Indiana University Research Center in Anthropology, Folklore, and Linguistics.

Rauscher, Frances H., Gordon L. Shaw, and Catherine N. Ky. 1993. "Music and Spatial Task Performance." *Nature* 365: 611.

Sablé-Meyer, Mathias, Kevin Ellis, Josh Tenenbaum, and Stanislas Dehaene. 2022. "A Language of Thought for the Mental Representation of Geometric Shapes." *Cognitive Psychology* 139, December, 101527.

Schenkein, Jim. 1980. "A Taxonomy for Repeating Action Sequences in Natural Conversation." In *Language Production*. Vol. 1, *Speech and Talk*, edited by Brian Butterworth, 21–47. London: Academic Press.

Schlegel, August Wilhelm. 1801. *Kritische Schriften und Briefe*. Teil 2, *Die Kunstlehre*. Stuttgart: W. Kohlhammer Verlag (1963).

Segal, David. 2023. "Is This the World's Highest-Grossing Photograph?" *New York Times*, November 24, New York edition.

Shanahan, Daniel, and Yuri Broze. 2019. *iRealPro Corpus of Jazz Standards (v1.0)*. https://doi.org/10.5281/zenodo.3546040.

Shelley, Percy Bysshe. 1821. *A Defence of Poetry and Other Essays*. Kindle Edition.

Sherrill, Paul Moravitz. 2011. Review of *Music in the Galant Style* by Robert O. Gjerdingen. *Theory and Practice* 36: 225–235.

Smee, Sebastian. 2021. "An Insider's Guide to Paris." *The Washington Post*, January 20.

Snow, C. P. *The Two Cultures and the Scientific Revolution*. New York: Cambridge University Press.

Sondheim, Stephen. 2010. *Finishing the Hat*. New York: Alfred A. Knopf.

Southey, Robert. 1848. *The Doctor, &c.* London: Longman, Brown, Green and Longmans.

Steel, Flora Annie. 1918. *English Fairy Tales, Illustrated by Arthur Rackham*. New York: Macmillan.

Sutherland, N. S. 1979. "The Representation of Three-Dimensional Objects." *Nature, Lond.* 278: 395–398.

Tatar, Maria. 2002. *The Annotated Classic Fairy Tales*. New York: W. W. Norton.

Tsur, Reuven. 1998. *Poetic Rhythm: Structure and Performance. An Empirical Study in Cognitive Poetics*. Berne: Peter Lang.

Updike, John. 1976. Review of Bettelheim's *The Uses of Enchantment*. *New York Times*, May 23.

van Gennep, Arnold. 1909. *La question d'Homère: Les poèmes homériques, l'archéologie et la poésie populaire*. Paris.

Vendler, Helen. 1997. *The Art of Shakespeare's Sonnets*. Cambridge, MA: Belknap Press of Harvard University Press.

Wikipedia, s.v. "Extrastriate Body Area," version of 20 January 2024, https://en.wikipedia.org/wiki/Extrastriate_body_area.

Wikipedia, s.v. "My Funny Valentine," version of 28 July 2024, https://en.wikipedia.org/wiki/My_Funny_Valentine.

Wikipedia, s.v. "Parahippocampal Gyrus," version of 29 April 2023, https://en.wikipedia.org/wiki/Parahippocampal_gyrus.

Wikipedia, s.v. "Rule of Three (Writing)," version of 24 June 2024, https://en.wikipedia.org/wiki/Rule_of_three_(writing).

Wornum, Ralph N. 1869. *Analysis of Ornament: The Characteristics of Styles. An Introduction to the Study of the History of Ornamental Art*. London: Chapman and Hall.

Wright, George T. 1988. *Shakespeare's Metrical Art*. Berkeley: University of California Press.

Yip, Moira. 2014. "Linguistic and Non-linguistic Identity Effects: Same or Different?" In *Identity Relations in Grammar*, edited by Kuniya Nasukawa and Henk van Riemsdijk, 323–340. Berlin: Walter de Gruyter.

Zajonc, Robert B. 1968. "Attitudinal Effects of Mere Exposure." *Journal of Personality and Social Psychology* 9: 1–27.

Index

Page numbers followed by an "f" indicate figures.